# BATTLE FOR THE MUSEUM

RACHEL SPENCE

# Battle for the Museum

## Cultural Institutions in Crisis

HURST & COMPANY, LONDON

First published in the United Kingdom in 2024 by
C. Hurst & Co. (Publishers) Ltd.,
New Wing, Somerset House, Strand, London, WC2R 1LA
© Rachel Spence, 2024
All rights reserved.

Distributed in the United States, Canada and Latin America by
Oxford University Press, 198 Madison Avenue, New York, NY 10016,
United States of America.

The right of Rachel Spence to be identified as the author of
this publication is asserted by her in accordance with the
Copyright, Designs and Patents Act, 1988.

A Cataloguing-in-Publication data record for this book
is available from the British Library.

ISBN: 9781787387751

This book is printed using paper from registered sustainable
and managed sources.

www.hurstpublishers.com

Printed in Great Britain by Bell & Bain Ltd, Glasgow

*For the change-makers*

# CONTENTS

# ACKNOWLEDGEMENTS

This book emerged out of many conversations, both past and present, with family, friends, colleagues, gallerists, curators, activists, artists and writers. Some were face-to-face; others via email; some were professional interviews; many were in my own head, as I grappled with ideas by writers and artists with whom I could learn and grow. This list is, inevitably, incomplete. Sometimes I disagreed with my interlocutors—but often, those conversations were the most fruitful, nudging me to change or defend a position and improving it as a result. I'm grateful to everyone who lent me their time and energy.

Shahidul Alam, Luca Massimo Barbero, Sutapa Biswas, Tania Bruguera, Zoe Cohen, Jane da Mosto, Jan Dalley, Nicola Durvasula, Liza Essers, Pauliina Feodoroff, Errol Francis, Shireen Gandhy, Chris Garrard, Terike Haapoja, Camilla Harrison, Lubaina Himid, Selina Jones, Nadia Kaabi-Linke, NayanTara Gurung Kakshapati, Sofia Karim, Joshua LeClair, Gary Lovering, Heath Lowndes; Christopher, Felicity and Diana Martin; Nan McElroy, Nick McGeehan, Ben Middleton, Jasone Miranda-Bilbao, Malcolm Murfett, Valeria Napoleone, Hammad Nasar, Clara Paillard, Lisa Panting, Cornelia Parker, Nina Paszkowski, Melanie Pocock, Michael Rosas Cobian, Maida Rosenstein, Andrew Ross, Ikuko Sawamoto, Dayanita Singh,

## ACKNOWLEDGEMENTS

Himali Singh Soin, Malin Ståhl, Emi Takahashi Tull, Alison Tickell Hajra Waheed, Steven Warwick.

I would also like to thank Farhaana Arefin and Lara Weisweiller-Wu for their brilliant, committed editing. If there is worth in this book, much of it is due to them. The errors and lacunae are mine.

# INTRODUCTION

VENICE, APRIL 2006. The inauguration of Palazzo Grassi under the new ownership of French fashion tycoon François Pinault. I'm excited to be here. After being closed for several years, the grand eighteenth-century palace has opened its doors to the public again. As the Grand Canal gleams beyond the huge windows, a shoal of glittering guests perambulate through the atrium and up the staircase. Designed by Jeff Koons, a spectacular stainlees steel heart complete with golden bow chimes with the buoyant mood.[1] Urs Fischer's waterfall of scarlet raindrops lifts the spirts despite its ominous title "Vintage Violence".[2]

When I finally arrive at one of the smaller galleries off the corridor, I stop in my tracks. Hanging on the wall is a small panel by the American artist Barbara Kruger. A photograph of a sign in a plain white font held by a hand. *I shop therefore I am.*

My career as an arts journalist is in its infancy. Only two years earlier I wrote my first review for the *Financial Times*. Since then, I've been on a vertical learning curve. I have lived in Venice since 2002, my days revolving through a swirl of events and exhibitions, often held in glorious palaces such as this one. Most mornings I rise at dawn in order to study the texts essential to my craft. As the months pass, I make my way through Ernst Gombrich's *Story of Art*, a stack of heavy monographs on old masters such as Bellini, Titian and Velázquez, plus as many artist biographies as I can lay my hands on. As Italy is my stamping ground, my knowledge is more tuned to the Renaissance painters. But my expertise in modern and contemporary art is steadily

growing and the presence of Monsieur Pinault's collection in Venice is surely going to enhance it. I know Barbara Kruger's name. She is an American artist, a committed feminist. Much of her work turns on the relationships between money, gender and power. Consumerism, Kruger believes, disempowers women. That is what *I shop therefore I am* is designed to express. The shallowness of material acquisition. The tragedy of believing a new dress or handbag will make you a happier person.

By displaying Kruger's work here in his sumptuous new Venetian palace, M. Pinault is sticking two fingers up at her values. You shop, he is saying, therefore *I* am. I can buy you and your precious, leftie idealism. I can reduce your art to an ironic, hollow yelp of despair. I can make a fool of you, Ms. Kruger, and look like a philanthropist while I'm doing it. Here your art will become decorative, quaint, cheeky. It will be no more political than a paint chart.

That evening marked the first heartbeat of this book. It was the moment when I understood that art is vulnerable to manipulation by wealth and by power, changed by the contexts in which it is bought, owned and displayed. We think of art as being a catalyst for personal and political empowerment. It feeds our imagination, inspires us to be better, to dream bigger. But that day in Venice, my faith in art's capacity to remain an autonomous creative force was shaken. As I walked home, the canals glimmering in the twilight, I was struggling with contradictory feelings. On the one hand, it was impossible not to feel exhilarated by the festival of imaginative expression unfurling in Palazzo Grassi. On the other, I was troubled by the way that work by an artist such as Kruger could be bent to the vision of a collector whose desire to accumulate profit seemed to be the antithesis of the creator's own impulse.

Some fifteen years later, my confusion has intensified. With every passing year, art infused with passionate social and political

commitment has proliferated. Yet at the same time, the institutions and mechanisms by which that art is circulated and displayed are ever more dependent on systems of power that are inimical to the artistic vision of a better, fairer, more equal future.

As I roamed the world from art fair to biennial, blockbuster exhibition to international museum expansion, I found myself convinced that the mainstream art world was trapped between a rock and a hard place, its beauty, energy and authenticity in danger of being snuffed out by the Faustian pacts necessary for its subsistence. The whiff of hypocrisy permeated space after space, from the international biennial themed around the environment with not so much as a nod to its own carbon footprint, to the art fair that lauded itself as a hub of dialogue and exchange while its patron allegedly kept his own daughters captive and his migrant labourers without passports.

I am far from alone in finding these contradictions intolerable. Since 2008, when a global recession caused chiefly by the moral and professional failures of the international banking system drove millions into poverty and homelessness, the culture sector has been a site of continued, ferocious protest against its perceived collusion with those destroying our collective wellbeing.

Before Covid-19, museums across the United States, the United Kingdom and continental Europe were assailed by a slew of demonstrations condemning the dirty money of their philanthropist patrons. Some of the world's most prominent art institutions were funded by weapons traders. Opioid dealers. Fossil-fuel billionaires. Concentration camp constructors.

Today, as the art sector does its best to emerge from the depredations of the pandemic, the panorama is more troubled and complex than ever. Like so many industries, the art world was profoundly affected by Covid-19. Institutions and galleries were obliged to close, and exhibitions, auctions and art fairs migrated to the digital sphere.

Mass staff dismissals were triggered throughout the culture sector in the UK and the US, particularly affecting people of colour, who are over-represented in insecure, poorly paid work. These job losses proved the catalyst for strikes and protests calling out not just unfair employment practices but also what they revealed of broader structures of racism inherent within the museum.

Resistance to racism in art institutions gathered energy in the summer of 2020, after the police murder of George Floyd catapulted racial justice into public discourse in a way unseen since the US civil rights movement of the 1960s. As well as criticising a lack of diversity in art collections and of people of colour in senior staff positions, the protests were also fuelled by calls for the restitution of objects stolen from Africa and Asia by colonial invaders and for the removal of statues glorifying slavers and imperialists.

At times, it felt as if the art world were under siege. At others it felt as if it were impregnable. Cultural leaders displayed an astonishing refusal to engage or change, preferring to trundle on with the status quo until forced into action by activists and wide-scale media coverage. But when this did happen, it sometimes felt as if one domino were pushing another until the whole game teetered on the brink of collapse.

It depended on the space you were in. Were you on the steps with the protesters? Or at the art fair or the museum enjoying the work on display? Could you be both?

PLANET ART

Compared to the world of business—pure business, that is, not business interbred with culture, as the art world is—the art world can seem like a gentle space for gentle people, somewhere for herbivores, not carnivores. I see you reading these words. I

see some of you nodding. And some of you shaking your heads. Are you joking? Gentle? Of course, there is no 'art world'. There are worlds within worlds. They criss-cross, overlap, contaminate, mingle, jostle for dominance. There are carnivores and herbivores roaming the worldwide forest of contemporary visual culture. Sometimes they are trapped in the same body. In the summer of 2022, I interviewed Ai Weiwei, the Chinese artist and political dissident who served nearly three months in a brutal Beijing prison before taking exile in Europe. When I asked him how he survived the experience, he said it was by discovering empathy for his guards. 'People can do good things and evil things. Sometimes the same people!'

Welcome to Planet Art. That's the name I have coined for this capricious, contradictory ecosystem. I believe it needs a special denomination because those of us who are within it, and you do feel as if you are *within it*, can feel entirely sealed off from reality. The shows open. The works sing to us or hit the wrong note. The reviews are churned out. We catch planes, trains, tubes, buses from one event to another. We stare at our phones, at the Instagram posts; we read of protests, sit-ins, demonstrations and Twitter storms against whichever institution is currently in the bullseye. We reel under a never-ending flood of emails advertising a new biennial, a new event, a new carbon-friendly initiative.

Day by day, we try to make sense of a space where people do amazing, beautiful, empowering, life-changing deeds. And terrible, destructive, cruel ones.

Here on Planet Art, I can sit on a plane en route to a Greek island where Antony Gormley is about to install his works amid classical ruins, a project that leaves me rapturous at how the sculptor taps into the timeless universal artery of figure in landscape, while next to me a blue-chip gallerist sits doing million-dollar deals on her phone. Behind us the carbon burns.

This book was born out of this friction, this abrasive, uncomfortable, yet occasionally fecund dialectic. It was born during those mornings I woke early to read of the artists I loved: Piero della Francesca, Henri Matisse, Nasreen Mohamedi, Dayanita Singh. In the blotted blue of dawn, I followed them in their quest for cosmic truths and sublime forms, timeless rendezvous between line and colour, light and shade, then moved to my computer to click on news stories about protests against museums taking money from oil companies, mining conglomerates and arms dealers, about strikes by gallery custodians, cleaners and catering staff.

The tension grew as I walked through an exhibition of stunning avant-garde French paintings collected by the Russian Morozov brothers in the early twentieth century, later suppressed by Stalin and now on loan from the Russian state to a wealthy businessman's foundation in Paris, and as I read of the French tycoon's 'gratitude' to Vladimir Putin—scourge to all political opposition and a free press, to artists such as Pussy Riot, to LGBTQ+ people, to the Chechens—for allowing these wonderful paintings to travel again. Putin even contributed his own text in the French catalogue, as did French President Emmanuel Macron.[3] Only months after the exhibition opened, Russia invaded Ukraine, and most of the art on show got shipped back to Russia before the French customs could impound it.

Was this cultural diplomacy at its most elegant and effective? Or a sinister example of the way that great art can wash even the filthiest political reputations?

On Planet Art, we often tell ourselves that these tensions are so established and so commonplace as not to be worth noting. Art has always been in service of the wealthy and powerful. Look at the Medici! But art has also always spoken truth to power. Look at Goya!

# INTRODUCTION

'Dialogue is better than boycott.' 'Make art, not war.' And, over and over, 'it's better to have art under an oppressive regime, even when censored, even when used as a laundromat for the dictator's reputation, than no art at all.' We believe that art makes a difference merely by its presence, opening a window for a different conversation, a new way of seeing. For more humane connections between adversaries.

But so much contemporary art demands that we extinguish such complacency. The number of radical political art practices has soared in the last decade. From Ai Weiwei's coruscating critique of the Chinese government, to the acute investigations of the Israeli–Palestinian conflict by Forensic Architecture, to Tania Bruguera's exposés of repression in her native Cuba, to Kara Walker's interrogations of colonial capitalism and its effect on Black identity, to Amar Kanwar's heartbreaking visual elegies for rural Indian communities destroyed by corporate land grabs, to Shahidul Alam's subtle yet unflinching spotlight on the killing squads employed by the government of Bangladesh.

Planet Art has become a place of encounter between insider and outsider. Have and have-not. Dissident and command centre. Protest and establishment. These collisions make Planet Art a bumpy, prickly, unnerving environment that fertilises far more questions than answers. One of the biggest interrogation marks that looms over political art practices is whether or not you can truly rebel from within. Isn't resistance most effective when its champions remain on the margins, outsiders on the rebel fringe? If you're biting the hand that feeds, aren't your teeth blunt from the outset?

Certainly institutions—museums, art fairs, galleries, auction houses—are happy to use their radical residents as a calling card for their own integrity and socially progressive attitude. 'Our role at Tate is to share art in all its complexity and diversity,' the museum's website declares, championing Black British artists

even as it has laid off hundreds of workers, a disproportionate number of whom are people of colour—a claim Tate denies—and though it has been lambasted in the media for a mural by Rex Whistler adorning the Tate Britain restaurant that depicts racist violence in colonial India as a witty jape. Meanwhile, the Whitney Museum of American Art confirms its commitment to being 'as experimental, responsive and risk-taking as the artists with whom we collaborate', all while fighting staff attempts to unionise to secure fair pay and conditions. The British Museum claims its approach is characterised by 'enlightenment ideals and values—critical scrutiny of all assumptions, open debate, scientific research, progress and tolerance', yet it steadfastly resists the return of looted objects in its collection and continues to accept funding from fossil fuel giant BP, having dashed hopes that it would not extend the relationship with its announcement of a new £50 million deal in December 2023.[4]

It isn't just museums claiming that their own high principles are reflected by the art they showcase. Art is being used as a symbol of commitment to civil liberties by entire nation-states—Turkey, Bangladesh, Russia, Uganda—even as their governments persecute and imprison dissidents, politicians, journalists and, yes, artists who are seen as threatening. When US President Donald Trump visited Saudi Arabia, Crown Prince Mohammed Bin Salman took him to a contemporary art exhibition.

Even when art is not explicitly a weapon of soft power, it is still of enormous significance to politicians. In Britain, the Tory government has even broken faith with the enshrined 'arm's-length' principle between museums and government to put its choice of trustees onto museum boards while forbidding institutions to manage their collections as they wish, including through the removal or retention of statues thought to glorify colonialism.

The problem is that once you begin to deconstruct the systems of power behind the art so many of us love, where do you

stop? What are you left with? Is any space truly ethical? Are any funding sources genuinely clean?

This book emerged out of these questions. It emerged from the claustrophobia of feeling squeezed between the activists, on the one hand, and love for art and the institutions that display it on the other. It emerged from my belief that art matters. Now. Still. More than ever.

Art matters because we are so desperately in need of imaginative possibilities. As acts of resistance. As solutions to acute challenges. As reasons for hope and joy.

Perhaps it is idealistic to say that art can change the world. But if art were powerless, why would the powerful go to such lengths to control it? To exploit it, trade it, manipulate it and politicise it?

When I investigated the commercial deals between Western museums and state-owned Chinese real-estate companies, Yaqui Wang, a senior China researcher for Human Rights Watch told me, 'The Chinese Communist party is using these prestigious alliances with global museums to validate its standing in the world and its ruling of China, including the horrendous human rights abuses.'[5] In December 2021, an independent London tribunal concluded that China's treatment of the Uyghur people constituted genocide. In light of this persecution, which has seen hundreds of thousands of Uyghur people 'disappeared', confined to concentration camps, tortured and sterilised, Wang believes it is time for international museums to pull out of China. She called on them to 'leverage' their power by taking 'a collective stand'.

If the powerful believe art is so important, we must believe it is too. Otherwise, they will co-opt it for their own ends and leave art's less cynical constituencies bereft.

Just because abuse of power is ubiquitous, just because no system is without flaws, it doesn't mean that it isn't worth trying to improve what we can, when and where we can.

This book is a cri de cœur that comes from the conviction that Planet Art—rather like Planet Earth—is too marvellous, too fer-

tile and ultimately too important not to clean up its act. The human imagination is one of the few qualities that separate us from the animal kingdom. We have a responsibility to nurture it.

# 1

# HOW DID WE GET HERE?

P ADUA, ITALY, 1992. Plunged into the blue of a Tuscan summer day, the sky's azure curve dotted with gold stars. I'm in the Arena Chapel painted by Giotto in the fourteenth century on the orders of Enrico Scrovegni. Giotto was a revolutionary painter. The first to understand how depth could be evoked in one dimension. So his Mary kneels in a proper doorway, the space behind her hollowed out, as she receives Gabriel's announcement. So that ecstatic sky arcs over the heads of the figures as they play out their eternal drama, over the donkey's ears flicking back and forth as he is led towards Egypt, over the wedding guests as they sit at the table in Cana where Christ will conjure their water into wine.

I was in my early twenties. A recent graduate in English literature, I'd never heard of Giotto. But I felt the numinous shiver of this universe as clearly as if I were a medieval girl. Only years later did a curator friend tell me that Scrovegni had commissioned the chapel to save his soul. 'He was a banker,' my friend explained. 'That was a sin in the Middle Ages. The chapel was his bid for redemption.'

Art was laundering reputations long before Enrico Scrovegni paid for Giotto's exultant frescoes. When the ancient Egyptians commissioned painters to decorate their tombs and temples, they hoped the images would open a doorway to the afterlife while stamping the memory of their achievements, rather than their misdeeds, on those who came afterwards. Lorenzo de' Medici is more famous for setting Michelangelo on his way during the Italian Renaissance than for the brutal suppression of the

people of Volterra who objected to his theft of revenue from their local mine. Even ancient history is whitewashed millennia later through appeals to art: modern Europeans remember classical Greece for the flowering of painting, sculpture and literature more than for its rulers' penchant for military expansion or slave labour.

These instances are the tip of an iceberg. The powerful have always invested in the arts and reaped returns in moral legitimacy; without such wealthy benefactors, our cultural heritage would be a mere shadow of what it is today. So, what has changed? Why now, in the 2020s, should it be worth reconsidering the relationship between money, power and the arts?

\* \* \*

In autumn 2022, British artist Damien Hirst burnt 1,000 paintings in public on the basis that their owners could 'keep' them as non-fungible tokens or NFTs—the digital 'collectibles' that had become Planet Art's latest get-rich-quick scheme (though their market has since wobbled).[1] Four years earlier, street artist Banksy sold for $1.4 million at auction a painting that had secretly been programmed to self-destruct on the podium. When it crumbled into fragments, Planet Art treated it as just another 'prank'.[2]

A few months before Hirst's stunt, at the Venice Biennale, I watched as Skolt Sámi artist Pauliina Feodoroff begged a group of collectors to buy her work. She had made her art in order to raise funds to re-acquire land taken from her community by successive governments for projects such as nickel mines and renewable energy plants. Even on Planet Art, this was a little raw. There was light applause; then, baring their teeth in rictus smiles, the collectors moved on to the British pavilion.

In the same year, auctioneers Christie's launched a collection of designer clothes emblazoned with the logo 'Art Handler' to sell for up to $125, even as their own real art handlers—the

people whose skills moving, installing and packing art keeps Planet Art turning—were protesting low pay and exploitative conditions.[3] Christie's ultimately had to issue a grovelling apology after being called out by angry, offended art handlers first on social media and then in the mainstream art press.

To work as an arts writer in the 2020s is to be a Janus. Looking both ways. Covering two fronts. On one side, it's the best of all possible worlds, where avant-garde artists can sell their provocative, ironic, irreverent works for eight-figure sums. They can even destroy their art and sell it anyway! On the other side, it's a place where protesters chant their fury on the stairs of the world's leading cultural institutions. 'They want the art, but not the people!' cried one banner outside the Met.[4]

It's a place where a campaign led by artist and recovering addict Nan Goldin forced museums across the globe to break long-standing, lucrative philanthropic ties with the billionaire Sackler family because some members had made a fortune from knowingly encouraging mass addiction to opioids they manufactured. Where other campaigners are, after decades of stasis, finally bringing about the return of precious objects such as the Benin Bronzes to their African homeland over a century after they were looted by the British army. Where the investigations of research agency Forensic Architecture into political violence and human rights abuse have been so thorough that their work has been co-opted by state bodies including the German parliament and the Colombian Truth Commission.[5]

It's a place where, as London teetered between Covid lockdowns, I walked through Tate Britain gazing at paintings by Lynette Yiadom-Boakye that plugged me viscerally back into the frail, resilient essence of my own body, even though I am white and the artist is Black. In spite of decades of rich work by Black artists in the UK, Yiadom-Boakye is the first Black British woman to have had a solo show at the country's most renowned art museum.

It's worth considering the relationship between art, power and money now because Planet Art has become a place that encapsulates how the value of objects, of money, of art, and of human beings ourselves has lost almost all rational meaning in contemporary society. Yet their value has never mattered more.

## WHERE SOME ARE MORE EQUAL THAN OTHERS

In October 2022, Perrotin, a top Paris gallery, invited me to write about MSCHF (pronounced 'mischief'), a group of 'anti-capitalist' artists developing 'elaborate interventions that expose and leverage the absurdity of our cultural, political, and monetary systems'. Their interventions included turning the gallery into a 'mall' and installing an ATM that would show visitors' bank balances. This work was sold at Miami Basel in 2022 for $75,000.[6]

The same gallery once sold a banana for $120,000.

Yes, a banana. In December 2019, the Italian artist Maurizio Cattelan taped the piece of fruit to the wall of Perrotin's booth at the Art Basel fair in Miami. In an edition of three. With two 'artist's proofs'. He and his gallerist slapped a price tag of $120,000 on it. This figure was considered a 'balance between an insignificant number that would trivialise the work and an outlandish one that would be completely ridiculous.'[7] Perrotin clearly found the right equilibrium, for business was brisk. The first two bananas sold so fast that Perrotin and Cattelan had a rethink and marked up the third to $150,000. They hoped to sell this one, Perrotin said, to a museum.[8]

In the event, that $150,000 was also paid by a private buyer, although one of the bananas was later gifted to the Guggenheim in New York. Speaking to *The New York Times*, Guggenheim director Richard Armstrong professed the museum to be 'grateful recipients' of *Comedian* (as Cattelan titled the work to show that yes, he was in on the joke) and stating that it made a 'deft

connection to the history of modern art.'[9] In keeping with the playful mood that almost everyone—journalists, artist, gallery and buyers—maintained when discussing the banana, Armstrong quipped that it also 'offers little stress to our storage'.

You wonder at Armstrong's failure to realise the joke had worn thin. Declaring its dedication to diversity and equitability, the Guggenheim insists that it is 'taking steps toward sustainable change in our professional practices to enact these values'. Yet the week after Cattelan's little jest at Art Basel Miami, a group of janitors marched through that city with bananas taped to their own chests. They were protesting the injustice of a situation whereby an artist could sell a piece of fruit for more than seven times their annual salary. At the time of the art fair, the average wage for a janitor in Miami was $8.50 an hour; the living wage in Miami-Dade County was set at $17.06 an hour.[10] As the janitors marched, they told reporters of trying to hold down two jobs at once to make ends meet yet still being unable to afford Christmas gifts for their children. They also spoke of being fired because, they suspected, they had championed union organising in a notoriously non-unionised industry.

'The *plátanito* protest is to illustrate the absurdity of someone spending tens of thousands on a banana taped to a wall in a city where janitors earn so little they can't afford to feed their families,' said Ana Tinsly, a spokeswoman for the Florida chapter of 32BJ SEIU union.[11] Her words nail a particular situation. Not only do they speak to the enormous wealth gap that blights society today, but they also illustrate how the contemporary art world has become a unique mirror onto that inequality and all its unjust, unnecessary absurdity.

'What is important is that all human beings should "have",' said British nature broadcaster David Attenborough on a BBC podcast in 2020. 'And what that means is that those who have a great deal should have a little less, and those that have very little

have a little more, and in that process, the natural world will begin to flourish again in the way it once did.'[12]

We are living at a time when the world's richest 0.01 per cent hold a staggering 11 per cent of its wealth, while the top 1 per cent hold 37.8 per cent, according to statistics from the 2022 World Inequality Report. Since the pandemic, the imbalance has intensified. Lucas Chancel, lead author of the report, explained that during the Covid-19 crisis, 'While the wealth of [all] billionaires rose by more than 3.6 trillion euros ($4 trillion), 100 million more people joined the ranks of extreme poverty.'[13]

One hundred million more people who cannot afford to feed themselves, their families. Who sit on street corners with placards that read *Ho Fame, Tengo hambre, Please help me*. Who work two jobs and still can't afford festive gifts for their children. The wealthy know they are there. They see them all the time. In London, New York, Johannesburg, Mumbai, Rio, Paris, Venice. How could they not see them? The poor make the clothes and clean the homes and wash the shit and build the museums of the rich, who will steal all that the poor have till they have no choice but to sell themselves, their labour, their sex, their organs. Of course, the rich see them.

And yet they behave as though the poor were invisible. As though they existed in parallel universes, behind sliding doors. The poor go in, the rich pop out. The poor exit, the rich enter. Now they see each other. Now they don't. Mostly they don't. Mostly the poor remain white noise in the background of the wealthy's quotidian routine. Dust in the corner. A hairline fracture they trust not to widen. Not to bring the house down.

But on Planet Art, that fissure is widening. The walls are starting to tremble. The poor are shimmying into view. The *plátanito* protest is just one example. At the art fair, the museum, the gallery, the studio, these two worlds are starting to collide.

# HOW DID WE GET HERE?

## THE RISE AND RISE OF THE ART MARKET

The explosion of the art market has been a crucial factor in the spread of the virus of inequality afflicting Planet Art today. Perhaps there is no better example of the market's baffling heights than the case of *Salvator Mundi*. The fifteenth-century Italian painting of Christ, which may or may not be by Leonardo da Vinci, broke records when it was sold via proxy to Mohammed bin Salman, Crown Prince of Saudi Arabia[14]—a country where 13.6 per cent of nationals live in poverty, despite the extreme wealth of their rulers.[15] The painting hasn't been seen since. Whatever its authorship and whereabouts, the tale of *Salvator Mundi* exemplifies the nebulous, abstract essence of the money—$67.8 billion in 2022[16]—that washes through the global art market in the twenty-first century.

It wasn't always thus. Although art has been commissioned and bought by the wealthy since the Pharaohs, there's little evidence that even those beady Medici bankers regarded art as a commodity or a speculative tool.

A 2015 study from Yale traces all record-breaking art auctions since the start of the eighteenth century, beginning with the sale of a painting by the Dutch master Gerrit Dou, *Interior with Woman and Child*, for £320 in 1701.[17] In the seventeenth century, the rise of the mercantile class, particularly in the Netherlands, had seen art production ramp up as a new breed of businessmen collectors created a demand for luxury goods, driving up prices even for public collections. Throughout the eighteenth century, art values rose slowly but steadily. Then, in 1852, a painting by Murillo sold to the Louvre for £24,600, 3.7 times the price of the previous best-seller, a Rembrandt that was knocked down for £5,250 in 1811.

The costly Murillo testifies to the social, geo-political and economic shifts that occurred with the Industrial Revolution.

The late nineteenth and early twentieth centuries saw a boom in both international migration and an opening up of global trade markets. Those profiting from the new economy eagerly bought up art and antiques to signify their status. (The Morozov brothers' hunger for French avant-garde painters is typical of this trend.) As the demand for art blossomed, a new tribe of bold, competitive art dealers was born.

The art market started to scale up after the Second World War. When the London auctioneers Sotheby's opened their first offices in New York in 1955, it was a sign that Planet Art's participants were going global. By 1964, when Sotheby's bought Parke-Bernet, then the biggest art auctioneers in the United States,[18] art itself had wised up to its own commodification, for in the Sixties the Pop Art movement, defined by the inflated hamburger sculptures of Claes Oldenburg and Andy Warhol's paintings of *Campbell's Soup Cans*, was born.

By the 1970s, no work under £2 million was going to find a place in the record books. Nevertheless, this decade marked the last chance to put the brakes on the art market. Thanks to a financial system still restrained by Keynesian mechanisms, the rise of an uber-wealthy elite in the three decades following the end of World War Two was slow.

According to Nicholas Shaxson, a financial journalist and expert on international tax evasion, this period was a 'golden age of capitalism, an era of widespread, fast-rising and relatively untroubled prosperity', characterised by widespread capital controls and high taxes.[19] These regulations meant wealth was distributed more equitably then than it is today because economic growth benefited more layers of society. This relatively healthy economic climate reached beyond the US and Europe to less wealthy nations. In the 1960s and 1970s, the per capita income of developing countries grew by 3.0 per cent per annum, a far higher rate than during the 1980s.

The art market meanwhile witnessed a mild slump in sky-high deals, with the record price of £2.31 million fetched by Velázquez's *Portrait of Juan de Pareja* in 1970 only bettered ten years later when, in 1980, a painting by Van Gogh, *Le Jardin du poète*, sold for just over £2.5 million at Christie's New York.[20] The art market began to boom in wealthy economies—and not in the poorer nations, whose growing prosperity had alarmed the Global North into "forcibly liberalis[ing]" Southern economies during the 1980s, through the World Bank and the International Monetary Fund. To retain their access "to the cheap labour, raw materials and captive markets" of the Global South, they slashed wages, environmental protections and public infrastructure in these countries.[21] Meanwhile, in the unaffected rich nations, people still had money to spare for luxury goods.

So, in the 1980s, Western art prices climbed along a sharp, upward curve. Just £200,000 spanned the difference between the two record-breaking art auctions of the 1970s. But by 1990, another Van Gogh painting had sold for a staggering £49,121,762.

That surge in value was caused by the financial deregulation ushered in by Margaret Thatcher and Ronald Reagan. Thanks to those leaders' embrace of laissez-faire capitalism, money and goods could flow more freely across borders than ever before. These looser boundaries instantly affected the art market; in the 1980s the biggest art buyers were Japanese, while the sellers, chiefly Christie's and Sotheby's, were in New York and London.

The 1990s were a push-me, pull-you decade for both art and money. The economic recession that afflicted much of the Global North in the early 1990s saw auction prices falter. No new records were set for twelve years, and even when the Van Gogh record was broken in 2002 by the sale of a Rubens for £49,506,650, the difference in price was relatively minor.

By now, a corrupt strand of DNA was entwined through Planet Art. Of those who bought the nine record-breaking art-

works between 1980 and 1990, at least two ended up with prison sentences for financial misdeeds. Australian businessman Alan Bond served four years for his part in corporate fraud. Despite being listed as the buyer of *The Irises*, a painting by Van Gogh, for $53.9 million in 1987, he never paid for the painting, even though Sotheby's themselves lent him $27 million to do so. When the money handover was discovered, the auctioneers were accused of manipulating the sale and falsely boosting confidence in the art market.[22] Japanese tycoon Ryoei Saito, who had bought Van Gogh's *Portrait of Dr. Gachet* for over $82.5 million in 1990, was given a suspended sentence for bribery in 1995. The painting disappeared.[23]

The Bond affair exemplifies the dubious ethics threading art and money into a single weave. Ten years after the *Irises* scandal, that culture was further exposed by the discovery of a price-fixing scheme cooked up between Sotheby's and Christie's. For much of the early 1990s, the world's two largest auction houses had been privately agreeing not to offer discounts, and to keep prices 'high and fixed'. The two chief protagonists at Sotheby's, CEO Diana D. Brooks and owner and former chairman A. Alfred Taubman, were both prosecuted and found guilty. (Brooks took a plea deal, in exchange for a fine and half a year's home detention;[24] Taubman served time in prison.) But Christie's CEO, Christopher M. Davidge, went unpunished because he had turned witness for the prosecution,[25] while Christie's chairman Sir Anthony Tennant never stood trial because he refused to go to the US where proceedings took place.

In 2002, after an investigation by the European Commission, Sotheby's was further punished with a £13 million fine. That this represented just 6 per cent of the company's annual turnover is indicative of the vast sums now floating through Planet Art.[26]

Over the next decades, the art market would become famous for a lack of regulation that permitted money laundering and tax

evasion on such a scale that one New York legislator described it as a 'carbuncle of distortion'.[27] In 2018, the European Union and the United Kingdom put some anti-laundering regulation in place—which some argue does little more than hurt the least wealthy dealers.[28] The US market remains largely unregulated.[29] In China—which, as we will see, has become a major market hub—the 'relaxed' regulatory environment, says one observer, has helped to fuel the market's massive surge.[30]

## THE IRONIC, ICONIC COMMODITY

Today, art's status as a commodity, beyond its aesthetic or sensory value, is undeniable. One of the first companies to perceive that art was a valid tool for investment or speculation was British Rail. In 1974, the United Kingdom's national train company invested £40 million of its pension fund in works of art. Advised by Sotheby's, its choice of painting and sculpture over, say, technology or energy stocks was an early instance of art's instrumentalisation as a financial asset, divorced from its creative substance.[31]

By 1989, the Australian critic Robert Hughes could moan, in a piece for *Time* magazine, that 'although art has always been a commodity, it loses its inherent value when it is treated only as such.

'To lock it into a market circus is to lock people out of contemplating it,' he continued, rounding off his complaint with a coruscating statement: 'What strip mining is to nature, the art market has become to culture.'[32]

Hughes' observations were prompted by the rocketing auction records of the 1980s. The prices paid for works today would surely make him turn in his grave. Works by living artists are now changing hands for eight-figure sums, making a mockery of the notion that an artwork's value can be judged partly on it having stood the test of time.

At the time of writing in early 2024, the second most expensive work ever sold at auction by a living artist is *Rabbit*, which

sold at Christie's in 2019 for $91 million (£69.8 million).[33] A stainless-steel bunny modelled in the smooth, goofy curves of a balloon toy, it typifies the work of its maker, American artist Jeff Koons. Bland, shiny, devoid of interior sentiment, and dependent on industrial production techniques like any other trinket of mass appeal, *Rabbit*'s bleak chill embodies a particular skein of international contemporary art that has both fuelled and been fuelled by the wolfish art market decried by Hughes.

Koons and his tribe, which includes Damien Hirst and Maurizio Cattelan, are part of a lineage first fertilised during the First World War by the French Dadaist Marcel Duchamp—with his readymade urinal entitled *Fountain* (showing, says philosopher Stephen Hicks, that 'art is something that you piss on').[34] Far more successful in popularising the consumption idea were the Pop Artists of the 1960s, such as Claes Oldenburger of the gargantuan burgers, and Andy Warhol, who immortalised all that soup.

It's no coincidence that Pop Artists, considerably less critical than their Neo-Dadaist predecessors, were making their consumer-friendly wares during an economic boom. Pop Art in turn was eclipsed through the 1970s by a new ethical impulse that animated much contemporary art, just when—surprise, surprise—the economic boom was on hold.[35]

Nevertheless, by the 1980s, the art market had boiled to temperatures never seen before. For young artists of that era, such as the Brit Damien Hirst, it was hardly rocket science to intuit that the children of Thatcher—city traders, advertising executives, entrepreneurs—were ready for a new kind of art as both object and commodity. A more straightforward, cheerier, immediate kind of art. Sexy, cheeky, apparently irreverent; yet, with a suave, icy refusal to evoke any feeling deeper than a smirk or a giggle, and certain not to question in any meaningful way the ethics of a world whose foundations had been laid by a prime minister who believed there was 'no such thing as society'.

# HOW DID WE GET HERE?

It's ironic that the virulent individualism inculcated by the dog-eat-dog culture of the 1980s should find its expression in a style of mass-produced art, much of which lacked imaginative flair and originality. But irony is one of the signatures of Planet Art, particularly when it comes to contemporary expression. Other words bandied around by artists, galleries, curators and critics are 'mischievous', 'provocative' and 'playful'. Artists are frequently referred to as 'jesters', 'pranksters' and 'tricksters'. As an arts writer, I'm as guilty as anyone of using this lexicon to attempt to give meaning to works—a hoover!, a pickled shark!, a multi-million dollar balloon toy!, a golden toilet!—that, if I stumbled over them in the street, would either slip under my radar entirely, have me calling the police, or prod me to shuttle them to the nearest Oxfam.

Don't get me wrong. I'm not a rabid conservative wedded to an antiquated view of art. Duchamp's invention of the readymade was a genuine stroke of genius. Carl Andre's pile of bricks is a sublime nudge to reconsider the geometry of our everyday world. When Tracey Emin reeled out her soiled sleeping-place, she opened our eyes to the intimate, chiaroscuro memories our bodies leave behind them as they move through the material world. Even that wretched, preserved fish had a touch of immanence in the way it obliged us to remember that death will checkmate us in the end.

Had contemporary art remained outside the grip of the marketplace, even its more outlandish offerings would have found a healthier spot in the history of art. Furthermore, had Hirst et al. made less money from their one-note, visual chords, they would have birthed fewer followers, who are almost always less inventive and original than their inspirations, among later generations.

One of the reasons that contemporary art's conveyor belt of factory-made, conceptual installations is so often insipid, transient and forgettable is because there's just too much of it. In

imitating life, art has merged with life—at its most commercial and dreary, at its big-brand, Amazon-warehoused worst. Perrotin's 'prankster' art collective 'provocatively' turning the gallery into a mall is over half a century late. In the early 1960s, Claes Oldenburg—he of the big burgers—was possibly the first artist to set up his studio as a shop, and artists including Tracey Emin, to a fanfare of publicity, have been doing it ever since.

However vacuous such art might be, the vast prices that it commands were crucial to the inflation of the market through the 2000s. Once dealers could make big money selling objects whose makers were still alive, and therefore productive, opportunities for profit mushroomed.

One measure of art's newfound fertility was the proliferation of international fairs. Fifty years ago, there was just one fair for modern and contemporary art. Opening in 1967, Art Cologne was launched precisely because a small group of dealers observed that the market for their own epoch, especially in West Germany, was weak. That today Art Cologne has over 200 competitors reveals those gallerists' prescience.

The two Leviathan entities in this galaxy are Frieze and Art Basel. At the time of writing in early 2024, the Frieze portfolio is an umbrella for seven fairs, two in London, two in New York, and the others in Los Angeles, Chicago and Seoul, plus two townhouses in Mayfair's Cork Street, one of the most high-end addresses for London dealers, which it rents out to galleries for temporary shows. Art Basel, meanwhile, presides over four 'shows' located in its eponymous Swiss birthplace, Miami, Hong Kong and, since 2022, Paris.

In 2003, the first edition of the Frieze Art Fair in London, which was dedicated to contemporary expression, consolidated Planet Art's reputation as a place where money, though so often the object of derision in 'ironic' works, was as material an element of modern art as paint, stone or film. With artworks

including a crystal fountain that spouted LSD[36] and an empty fair cubicle with two actual children inside, the overall blend of the knowing, the tacky and the morally dubious provoked one critic to write, under the headline 'One pair of children for sale, $6,000': 'Walking round the fair, one can be forgiven for thinking it is a mess, that this season's art all looks pretty horrible, that there's no way of telling good from bad.'[37]

But why does any of this matter? Why don't we just leave the metal rodents and the pickled fish to the ultra-rich and enjoy all the other art out there? After all, there is still a galaxy of art that is not made as a mischievous prank. Artists across the world are creating work that is tantalising, thrilling, touching, warm-hearted, cold-hearted but not in an 'ironic' way, and ironic but not in a hypocritical, watch-me-have-my-expensive-million-dollar-cake-and-eat-it kind of way. Why don't we just keep the trinkets in Planet Art's shopping mall of art fairs and mega-galleries, and the 'proper art' in the museums?

The problem is that these two systems are now intertwined. The shops in the mall are acting like mini-museums, and the museums are imitating the residents of the mall.

THE MONEY-MAKING MUSEUM

In many countries, the public and private sectors have always been intermeshed on Planet Art. In the United States, for example, museums have been dependent on philanthropy since their inception. In many European states, however, public museums continue to maintain boundaries between their operations and those of the private sphere. In Italy, private philanthropy, though by no means non-existent, has a far weaker foothold in the heritage sector than in the US. In Finland, it was the strong bond between the culture sector and the city council that saw off the bid for a new Guggenheim launched by

the American museum and supported by Finnish private corporations and right-wing politicians.

But the picture is always murkier than it first appears. In France, public museums were almost entirely funded by the state until the Louvre, run by the French Ministry of Culture, decided to accept millions from another government, the United Arab Emirates, to build, run and lend work to a museum in Abu Dhabi.[38] Given that the UAE is a royal autocracy with an abysmal human rights record, this situation shoots a hole in the black-and-white notion that if private funding is bad, public funding is good. The notion that in democracies, public funding is inherently cleaner, ethically speaking, looks increasingly problematic as countries like the United States and the United Kingdom are increasingly exposed for both their colonial-era abuses and their present-day disregard for civil rights.

A publicly funded culture sector does have the advantage of giving art a moment of liberty from market forces. But, where museums are dependent on state funding, the constant lament is that there isn't enough of it. In Italy, for example, the culture budget dwindles yearly, with dozens of museums being forced to shut for part of the week or closing down entirely. Meanwhile, across much of Africa, India and South America, museums emerged out of a model created by European colonisers. As such, these institutions face the challenge of reinventing themselves on their own independent terms. Here, too, state funding is always too little.

Across the world, not just in the poorest countries, public funding for culture is shoved to the bottom of the state's priorities on the basis that the arts are less important than food, housing, schools and health services. The error of considering the activity of the imagination any less fundamental to the state of being human than food or shelter was summed up by William Morris, the nineteenth-century British textile artist and com-

mitted socialist, when he castigated those who looked on art as 'a luxury incidental to a certain privileged position'. Instead, Morris endorsed socialism's regard for art as 'a necessity of human life which society has no right to withhold from any one of the citizens'.[39]

One of the symptoms of the rise of an uber-wealthy elite class has been a global surge in privately owned museums. Today there are over 400 worldwide.[40] The highest number are in Germany, followed by the United States and South Korea, which has enjoyed an art-market boom in recent years.[41] Often designed to showcase their founders' own collections, these institutions operate by a range of different systems. Some are born in a new building, perhaps designed by prestigious architects, like the Leeum Museum of Art in Seoul (founded by the Lee family, who also own Samsung).[42] Others evolve through a collaboration with public bodies. In Venice, for example, François Pinault leased his two buildings—Palazzo Grassi and Punta della Dogana—from the Venice City Council. (Even then, he also employed a swanky architect, Tadao Ando, to restore the Punta della Dogana.)[43]

There are myriad issues with private museums, from their use as a laundromat to wash an owner's reputation,[44] to the fact that the art displayed wins critical approval and visibility simply because it is owned by someone wealthy enough to display it in a handsome vitrine. But at least you know where you are with a private museum. Their founders claim that they wish to share their collections with the public, and this may well be the case; but even those who have poached highly regarded curators from public institutions, as some do, cannot hide their self-interested origins.

Far more alarming is the phenomenon by which ostensibly public museums have been covertly privatised. The issue is acute, for example, in the United Kingdom. Here, the combination of

drastic funding cuts by successive governments and the uptake of the concept of 'creative industries' as delineated by Tony Blair's Labour government in the late Nineties saw museums forced to start running themselves along corporate lines.[45]

Blair inherited a model fledged under the Thatcher administration, which set the wheels in motion for arts organisations to climb into bed with business through lobby groups like Arts & Business. Thatcher's system was enshrined by the government of her successor, John Major, when he turned national museums including the Tate, the British Museum and the National Gallery into what were called non-departmental public bodies (NDPBs). As such, they could no longer rely primarily on state finance and instead were obliged to balance their income so it was one third public, one third self-generated and one third private.[46]

This meant that institutions had to start bringing in revenue. It was essential to attract patrons to sponsor their spaces and events. The museums began to hire themselves out as venues for corporate galas and other events. Rather than vitrines for culture, they now had to become brands—their seductive vibe acting as catnip to visitors who fancied shopping and cappuccini along with their soupcon of art. Indeed, the shops became a hybrid of bazaar and gallery as artists' designs were slapped on more and more goods for sale. I will never forget seeing Anselm Kiefer's images printed on trinkets in the Royal Academy shop during his show there in 2014. His paintings explore the darkest heart of Germany—were those anguished, gestural marks really appropriate for a keyring?

As the institutions exploited the art for profit, so they exploited the workers. 'With the corporatisation of the arts came the casualisation of labour,' writes artist and activist Mel Evans, a turn that brought 'temporary contracts, frequent interning and freelancing.'[47] A key accelerant of this process was the fierce package of public funding cuts spearheaded by David Cameron's government and its successors. From 2010 to 2019, over sixty-

four British museums closed entirely, with huge numbers of concomitant job losses.[48] To counter the dip in government revenue, a number of national museums, including the British Museum, Tate and the National Gallery, started to save money by outsourcing staff—particularly lower-paid tiers, such as visitor services, catering, cleaning and security—to private contractors, on contracts that were more precarious and less remunerative than those still tied to civil service pay scales.[49]

The commercialisation of museums has run concomitantly with their expansionism. In 2017, Tate Modern unveiled a vast new wing designed by blue-chip architects Herzog & de Meuron. Much of the £260 million was funded by Ukraine-born American-British billionaire Len Blavatnik, who made his fortune from the privatisation of Russia's aluminium and oil assets after the collapse of the Soviet Union in a career shrouded by controversy. As a condition of his donation, the new Tate wing, originally pegged to be named Switch House, was renamed the Blavatnik Wing. In an open letter to an American think tank that accepted a sizeable donation by the billionaire in 2019, fifty-six of the world's anti-corruption experts described Blavatnik's philanthropy as part of a 'longstanding effort' to 'export Russian kleptocratic practices' and 'launder his image in the West'[50]—accusations which Blavatnik firmly denies.

The Tate story sums up the way that expansionism by ostensibly public entities ends up requiring funding from private sources, regardless of the potential for conflicts of interest. Wealthy trustees double as donors to museums, as well as allowing institutions to plug into their networks of philanthropy and profit. In 2016, New York's Whitney Museum moved into a new, bigger $422 million home in the trendy Meatpacking District. Another top architect, Renzo Piano, got the gig. Like many other big museums, the Whitney has a board studded with bankers, property developers and corporate tycoons, without whose financial support glamorous new architectural projects would be impossible.

This strategy of growth, dependent as it is on funding by a wealthy elite, has fed into the realisation that art, even institutions that were ostensibly for everyone, is becoming the handmaiden of a privileged few. The change has also seen museums lambasted for fuelling urban gentrification, as their arrival in an area brings property price hikes, increased tourism and a tide of new businesses such as hotels, restaurants, gyms, residential developments.[51] 'We must understand gentrification for what it is, it is modern-day colonialism,' stated one protester during an occupation of the Brooklyn Museum in 2018.[52] As the expensive, profitmaking newcomers settle in, long-established communities soon find themselves unable to afford to remain in their homes.

Museums have not just ballooned in their own backyard. Another symptom of the early twenty-first century's profitable zeitgeist has been the expansion of private galleries from one-off boutiques in their cities of origin into global chains linking their brand across Europe, the United States and Asia. (Africa remains woefully underrepresented in the market, despite growing efforts to monetise art on the world's poorest continent).[53] At the time of writing in early 2024, Gagosian, for example, has no fewer than nineteen galleries in cities including London, New York, Los Angeles, Athens, Paris, Rome, Basel and Hong Kong. Hauser & Wirth has twenty bases, including in Monaco, Zurich—where it has three—St Moritz and Hong Kong.

In a bid to up their revenue streams, some of the world's most well-known cultural institutions, including the Guggenheim, Tate, the Pompidou and the Louvre, have jumped on the bandwagon of setting up outposts in other countries. Given that their collaborators are often autocracies with fat budgets but dismal human rights records and labour practices, it's little surprise these projects have been much critiqued for exploitation of workers, particularly those on the construction sites, and for helping to launder the reputations of repressive regimes. Furthermore, some

activists complain that the expansion of hefty, international museum brands to foreign countries smacks of cultural imperialism. This was one of the reasons why a coalition of artists, art workers, environmentalists and left-wing politicians bandied together and stopped plans to open a Guggenheim in Helsinki.

This museum expansionism is part of a wider boom in cultural development. A report by the University of Lausanne found that, between 1990 and 2019, $84.6 billion was soaked up by the construction of major new arts venues either costing over $100 million, or covering 20,000 square metres, or offering a seated capacity over 1,500—opera houses, concert halls, theatres, museums. The most costly projects were all Western-driven, or West–East collaborations: the Getty Center in Los Angeles, London's Millennium Dome, the Louvre Abu Dhabi, the Fondation Louis Vuitton in Paris, and the Stavros Niarchos Foundation Cultural Center in Athens. But it is Asia that now builds by far the most museums. China accounted for 30 per cent of major venues opening between 2015 and 2019, and there are a 'raft of new projects' underway in the 2020s in the UAE, Qatar and Saudi Arabia—some, but not all of them, East–West partnerships.[54]

The ubiquity of international galleries in tax havens particularly is not, of course, a coincidence. Even as they showcase artists who rail against wealth inequality and social justice, Planet Art's most powerful dealers see no conflict of interest in following the money. Between 2000 and 2007, the art market expanded nearly threefold.[55] By 2002, the auction market alone was worth £2.5 billion a year.

Crucial to this growth was China. In 2000, Chinese buyers accounted for just 1 per cent of the global art market. In 2011, China accounted for 30 per cent, making it the world's leading art market.[56] By 2021, according to the art market report produced by Art Basel and UBS, 'Greater China'—meaning mainland China, Hong Kong and Taiwan—had lost its superiority,

but was still the second largest art market in the world, responsible for annual sales of $13.4 billion, a figure only topped by the United States (which, along with the UK, had bounced back from the post-2008 recession).[57]

Planet Art's relationship with China is a bellwether of all that's wrong—and some of what's right—with it today. Even before the post-Mao regime's new economic freedoms had begun to shift Western terms of engagement with the country, art's money-makers were already eyeing the East. Hong Kong, under British rule until 1999 and with its political and economic systems designed to facilitate financial deals, was a natural bridge. Sotheby's got in early, opening its first office in Hong Kong in 1973.[58] Christie's followed suit thirteen years later.[59] But mainland China was always on the radar. On its website, Sotheby's proudly announces that it was the first international art auction house to have a presence in China, from 2012. Christie's, meanwhile, boasts of having been the first non-Chinese auctioneer with permission to conduct auctions on the mainland.

Private galleries were also eager to tap into the new consumer base. In 2004, Italian gallery Continua became the first foreign dealer to open a branch in China—a state that, according to Ai Weiwei, is so censorious that the art which survives there is not worthy of the name.[60] Since then, several Western galleries have set up shop in the country, including Lisson and Pace—the latter closed its Chinese branch in 2019—while far more—Lehmann Maupin, Gagosian, White Cube, Pace again, and many others—have opened spaces in Hong Kong.

Hong Kong, of course, has changed radically since the early years of the art boom there. Its glory days were triggered by the arrival of the first international fair, Art HK, in 2008. Started by two British men, Sandy Angus and Tim Etchells, Art HK aimed to exploit the financial position of an island that was viewed as a bridge into the markets of China, Taiwan and Singapore, that

enjoyed proximity to Japan and Australia, and that offered a viable trading point to South Asia and the Gulf, both of which were areas where the art market was flourishing.

Hong Kong had other virtues. It was a free port. Essentially, this was a tax haven where goods could be bought, sold and, crucially for the art industry, stored without paying duty. Overall, it was enormously business-friendly thanks to low taxes, low regulation, a strong legal system and the presence of a dense, educated workforce.[61] To top it off, it was easy to access, with visa-free entry for 170 countries.

Art HK was a success from the get-go. With advance estimates of 15,000 visitors, its final haul of 19,185 showed how well the British entrepreneurs had judged their move. A total of US$65 million worth of art had gone on show at over 100 galleries from Asia, Europe and the US. Sales included $1.5 million to a gallery from Seoul for a painting by the Chinese artist Yue Minjun and $320,000 for a work by the Swiss artist Ugo Rondinone from a Swiss gallery. Some galleries sold their entire stand, including Gandhara Art from Karachi and The Drawing Room based in Manila.[62]

The moneymakers of Planet Art were satisfied. Here at Art HK, dealers, collectors, connoisseurs and artists from a melange of countries—rich, poor, democratic, tyrannical—could come together in a luxurious, duty-free, relatively safe space, to buy, sell, discuss and display.

Today, Hong Kong's art scene has felt the cold hand of China's censorious sensibility.[63] Yet even in 2008, few outside China were under any illusion about the regime's brutality. If Tiananmen Square hadn't shown that the post-Mao government was pitiless in its repression of dissent, Planet Art had their very own Job in the figure of Ai Weiwei. By 2008, the Chinese activist and artist was already making scathing critiques of the Hu Jintao regime.[64] Over a decade later, the long-awaited flagship museum M+ is

more famous for whom it can't show—Ai Weiwei—than for whom it can, and many artists and art workers have fled to less dangerous climes.

On Planet Art, the standard defence that doing business in autocratic countries is a form of creative and cultural exchange and dialogue is always reeled out to those who might question the ethics of taking the international art scene to Hong Kong. But when I pressed one of the Western figures who has been most active in expanding the global art market in East Asia, he replied frankly that he was not in the business of human rights.[65] His response sums up the gap between what Planet Art says about freedom and humanity, and what it actually does.

Art HK embodied an age of optimism for Planet Art. 'The success of ART HK 08 confirms the good health of the international art market,' observed Charles Merewether, chairman of the fair's advisory committee, adding that it was 'a timely event, capitalising on the shifting dynamics of the art world' and that Hong Kong 'is the place in Asia to stage an international art fair of this calibre.'[66] But in the very same year, the global financial market was thrown into crisis.

## TOO BIG TO FAIL

By the time Hong Kong was welcoming the international art world into its fold, the global economic downturn was already underway.[67] In September 2008, Western stock markets crashed. Predicated on deregulation, a shadow banking system and a toxic housing market that deliberately targeted low-income buyers to take on loans they could not afford, the US economy teetered on the verge of meltdown, and threatened to take the European banking system with it.[68]

Lehman Brothers collapsed, but the other banks were ultimately dubbed 'too big to fail' and saved by government bailouts.

The human cost of the banks' colossal mismanagement was vast.[69] It was estimated that the average American lost $70,000.[70] Ten million people in the United States lost their homes.[71] Black citizens were affected worse than white citizens. As delineated in a report commissioned by the American Civil Liberties Union, not only had they been particularly targeted as borrowers, but home equity accounts for more of their wealth overall. Prior to the financial downturn, the wealth gap between Black and white citizens was closing. Since 2008, it has widened again. By 2031, according to the report, all families will be poorer, but whereas white households will lose 31 per cent of their wealth, Black households are on course for a drop of 40 per cent.[72]

The effects of the bankers' mistakes bit into economies—and so also communities—across the world. In India, for example, monthly exports and imports reduced by an average of almost 20 per cent in the year following the crash.[73] India was also a country where the art market had briefly boomed, but 2008 burst that bubble.[74] Indian art has never recovered the market desirability it enjoyed in the mid-Noughties, though there are signs in the early 2020s that it may be finding a new stability.[75]

Homelessness after 2008 rose in European cities including Vienna, London, Stockholm, Berlin and Madrid, as well as in Auckland, New Zealand.[76] In Africa, too, the brunt of the economic recession was borne by the poor. According to a 2009 report by the Carnegie Endowment, 'The slowdown in growth [in Africa] will likely deepen the deprivation of the poor and of the large number of people clustered just above the poverty line, who are particularly vulnerable to economic volatility and temporary slowdowns.'[77]

On Planet Art, the market-makers braced themselves for meltdown. Yet on 15 September 2008, as the international money machine hurtled towards Armageddon, a remarkable auction began at Sotheby's in London. This was the moment when

Damien Hirst ditched his galleries, Gagosian and White Cube, to go it alone and sell his work directly through an auction house.

When Hirst's sale coincided with the looming financial crisis, many thought it would flatline. They were wrong. On the day that the *Financial Times* described events on Wall Street as 'turmoil', buyers at Sotheby's began what would ultimately amount to a two-day spend of $200.7 million on work by Hirst, ten times the previous highest price for a single-artist sale ($20 million paid out at an auction of Picasso works in 1993). The art knocked down over those two autumn days in 2008 included pickled animals, medical cabinets filled with medical supplies, cigarette butts or diamonds, and, the top seller of the day, *The Golden Calf*: a real bullock preserved in formaldehyde, with hooves and horns made of solid gold and a gold disc crowning his head. This tragic, mutilated memory of a living creature, its body cross-bred with precious metal, enticed somebody to pay the sum of $18.6 million.

The auction encapsulated everything that was wrong on Planet Art. Giving it the title 'Beautiful Inside My Head Forever', Hirst—who may be a latterday Frankenstein but who is also an astute commentator on the system that has enriched him—acknowledged the hermetically sealed world of privilege in which he and his art circulated so profitably. The golden calf is a sinister, tasteless jibe at a society so addled by capitalism that it cannot perceive that its apparent power—economic and social—has turned in on itself, rendered it abject, devoid of reason. It's a golden calf, for heaven's sake! The original symbol of a community whose values had gone astray, who were worshipping the wrong gods. Falling irrevocably into sin. What more did Sotheby's customers need to warn them off? But of course, to the uber-rich, jokes about the sinfulness of wealth are part of the game. Hirst is ironic and iconic all at the same time. How good an investment is that? We can own him, and also his attempt to turn us into figures of fun. Who's laughing now?

Everyone except the calf, perhaps. And, of course, the billions of people outside the lucre-perfumed auction room. Those for whom $18 million is unthinkable but $18 might mean an hour's work, or a week's work, or much more.[78] Eighteen dollars could buy a night in a hostel. Or food for the weekend. Or a child's Christmas presents. Or your entire budget for the next eighteen days.[79]

That Hirst proffers cigarette butts and diamonds to his 'clients' on the same economic and aesthetic level, and that they shell out without a qualm, reveals the amoral void curled in the belly of Planet Art, a void that mirrors the same emptiness in twenty-first century capitalist society.

Whoever paid almost $20 million for a gilded monster either had so much money that the figure was small change... Or they believed—not without some evidence—that Hirst was an artist whose work represented a good investment. Or they found that the work had some merit beyond its financial potential. Or perhaps they were motivated by a mix of all three factors. Whatever the truth, the Sotheby's auction room that night was a place where the meaning of value, for both art and money, had been hollowed out, debased, perhaps erased entirely.

It was a place where, as the poet Dionne Brand put it in *The Blue Clerk*, 'All the information about what a life might be, what a life might look like, how a life ought to be lived, what one must want and desire, all those roads are quite flattened out.' In such a place, says Brand, a human is 'someone who is striving not to think too deeply about very much.'[80] After all, here, in the world of the gold-horned bullock, as the buyers and sellers glance from the podium to their phones and tablets, as they side-eye the Rolex watches and Gucci loafers of their neighbours, as they check time zones and stock markets in New York, London, Tokyo, Beijing, 'All information is available, all history is available, all thought is available. Consuming is the obvious answer to life.'

If Planet Art were a Hollywood movie, 'Beautiful Inside My Head Forever' would have been the villain's last gasp. The excesses of the contemporary art market combined with the implosion of the global finance markets should have put an end to the wastefulness and vulgarity that had stained art's recent decades. This was why, as stock markets tumbled in the US and Europe, the art industry's major players prepared for apocalypse.

'People are being much more cautious,' observed gallerist Harry Blain when he was interviewed by the *Financial Times* in early October 2008.[81] 'I would expect certain sectors to be more subdued and the middle market is no longer there,' he continued, alluding to the fact that only the very richest buyers were still in the game, their wealth cushioning them from the crash. 'Collectors from India, Russia and the Middle East are still making money and there is enormous competition for the best things,' Blain went on, underscoring how globalisation was serving the market well.

In the end, the art market did take a hit. Between 2007 and 2009, it fell by 36 per cent to a low of $39.5 billion.[82] But in 2010, it bounced back, even though other commodities were still struggling to rebuild value.[83]

As detailed by arts economist Clare McAndrew, the key to the 2010 upswing was the new Chinese market. Speaking to *The Art Newspaper* about the 2008 bounce back, McAndrew observed that: 'Following the 1990s crash, it took about 15 years for the [art] market to get back to its late 1980s, pre-recession levels as it was just dependent on demand from the US and Europe.'[84]

Although the Chinese market's glory days only lasted until 2012, as sales picked up elsewhere, the market stayed buoyant to hit a peak of $68.2 billion in 2014.[85] Since then, it has dipped, standing at $67.8 billion in 2022, as downturns including that of the pandemic have left their mark.[86] But given what McAndrew describes as the 'geopolitical tensions and economic uncertainty'

that have afflicted our planet since the mid-2010s, art has remained an extremely inviting playground for the 1 per cent.

That night in September, Sotheby's was a paradigm of the wealth-cushioned galaxy where latitudes are set by commodity prices and longitudes by currency's shadow architecture—the speculative tools whose mismanagement caused the 2008 crash, towers of profitable possibility teetering on spectral foundations. But elsewhere on Planet Art—including in the auction house's own backrooms, where cleaners would go on to fight for a living wage—the concept of value was very real indeed.[87]

## OCCUPIED TERRITORIES

The 2008 financial crisis split a fault line through art's bubble of privilege that has widened ever since.

By the beginning of the new decade, it was clear that those bankers who were most responsible for the new wave of poverty and homelessness were not going to be held accountable. Although forty-seven financiers were ultimately jailed, just one of them was based in the US, the country where the bankers' misbehaviour had triggered the chaos.[88]

When the politicians refused to make the financial sector change its ways, ordinary people stepped up. By the autumn of 2011, anger at the business-as-usual state of affairs had coalesced into a collective movement of resistance. Known as Occupy Wall Street, and their message embodied by the slogan 'We Are The 99%', the protesters staged demonstrations and sit-ins in public parks, banks, corporate headquarters, college and university campuses. Zeroing in on inequality created by a capitalist economic system, their aims included the exposure of corporations' influence on political systems, better distribution of income, forgiveness of student loans and the alleviation of property foreclosures—homelessness, essentially—created by the 2008 crisis.

On 15 October 2011, Occupy Wall Street, in tandem with similar anti-austerity movements in Iceland, Spain, Portugal and Greece, and recognising their affinity with those in the Middle East who had marched for freedom and democracy earlier that year in what came to be dubbed the Arab Spring, announced events in 951 cities across eighty-two countries. In the UK, having been prevented from congregating in front of the London Stock Exchange, thousands of people gathered in front of St Paul's Cathedral to call out the behaviour and political influence of bankers.[89]

Much of Planet Art tried to keep its head down. As the anti-inequality protesters decried capitalism's depredations in front of St Paul's, over in Regent's Park, it was business as usual in the Frieze marquee.

Of course, a quorum of artists made 'cheeky', 'anti-capitalist' statements. Michael Landy installed a machine that swallowed credit cards at the stand of his Mayfair gallery, Thomas Dane. Meanwhile, Christian Jankowski, described in the *Financial Times* as a 'prankster', tried to sell a real yacht for €65 million.

At this point, it becomes relevant that since its inception, the main sponsor of the Frieze portfolio of art fairs has been Deutsche Bank. As the facts behind the 2008 crash were revealed, you might have expected questions to be raised about this pact.

No-one doubted that the banks were chiefly to blame for the crisis. But some were more to blame than others. Deutsche, it transpired, had not only sold tens of billions of dollars' worth of junk bonds—the toxic, mortgage-related securities—but also bet against them in the market, thereby profiting even further from their mis-selling. (One senior Deutsche employee actually described the securities as 'crap' in emails to colleagues, while flagging them as good investments to clients.)[90] In early 2017, the US Department of Justice finalised a settlement of $7.2 billion

with Deutsche, for the latter's part in the 2008 crash.[91] But the mortgage mis-selling scandal was just one of a plethora of blots on the bank's moral copybook, which also includes assisting Nazi Aryanisation of Jewish businesses;[92] financing Donald Trump and Jeffrey Epstein; fixing interest rates; and failing to crack down on money-laundering by Russian oligarchs.[93]

Yet the ethics of Deutsche Bank acting as Frieze's sponsor were rarely questioned in the mainstream art world, although there was a powerful article in *Hyperallergic* in 2020.[94] The latter has not spawned much furore—Deutsche Bank has continued to sponsor the fair.

In 2011, as Occupy protesters outside St Paul's expressed their fury at Deutsche and its peers, within Deutsche's VIP lounge at Frieze, all was serenity. Access to the bank's lounge is sold as a huge privilege to visitors, its entrance staffed by elegant young people who check passes assiduously before you are allowed to enter, sip champagne with the elite guests and admire whichever artworks are decorating it. As its 'Artist of the Year', that year, the German bank was showcasing the Slovak conceptualist Roman Ondák. In the lounge, Ondák's work consisted of trapping white curtains in the heavy glass doors, so that the guests could see Regent's Park outside. In a video interview, Ondák said the work spoke to the 'temporary situation of the tent, which looks like it landed in the middle of London', and to 'temporality ... a very brief moment which might happen anywhere, in any house.'[95] At a dealer's booth within the fair itself, Ondák had a piece called *Man, Art and Gold*. This consisted of a miniature replica of a Giacometti figure, with gold nuggets scattered nearby, encased in plexiglass.[96]

The gulf between those two artworks—one begging to be dubbed 'not art', the other invoking Giacometti's signature expression of human alienation—encapsulates the slippery values which make Planet Art such a difficult place to find an ethical

toehold. Was Ondák the 'subversive' conceptualist some critics claimed him to be? Or was he just taking the money and running? Or was he doing both at once?

Elsewhere, matters were less ambiguous. In the same month that saw the birth of Occupy Wall Street, a spin-off movement, Occupy Museums, was born. Its mission statement explains its aims: to draw attention to cultural institutions' role in 'spreading economic inequality', as well as 'to reclaim space for meaningful culture by and for the 99%'. Art is 'not a luxury', the statement continues, but the 'soul of the commons'.[97]

The flame was lit by the Brooklyn artist Noah Fischer, who observed in a manifesto posted on Tumblr that museum boards 'mount shows by living or dead artists whom they collect like bundles of packaged debt.' Fischer continued by noting that in recent decades, 'voices of dissent have been silenced by a fearful survivalist atmosphere and the hush, hush of BIG money.'[98]

Over the following months, Occupy Museums would stage demonstrations at various New York institutions including the Museum of Modern Art (MoMA), the Frick Collection and the New Museum. 'Museums, open your mind and your heart! Art is for everyone!' they declared.[99] At MoMA, protesters zeroed in on a couple of trustees connected to Sotheby's auction house. This, the activists observed, presented a conflict of interests. Artists chosen for museum shows regularly enjoy a hike in their work's prices, and if auctioneers are on the board, they can manipulate exhibition schedules to boost artists on their radar in the sale rooms. Furthermore, Sotheby's had recently locked out their own art handlers because of their efforts to unionise.[100]

Occupy Museums fizzled out, but several of those activists who participated, including Nitasha Dhillon and Amin Husain, were crucial to later art activist movements such as Decolonize This Place. The latter group is responsible for some of the most electrifying protests against US museums, including the

Whitney, MoMA and the American Natural History Museum. Another crucial body of resistance came from a coalition called Gulf Labor, which mounted a decade-long campaign against the plans of Western museums to open in Abu Dhabi, on the grounds that they were colluding in a system of labour so exploitative it was close to modern slavery. In the UK, fierce campaigns have also been waged against fossil-fuel sponsorship at the British Museum and Tate, among others. Meanwhile the Black Lives Matter and #MeToo movements have galvanised both art and protest around racial and gender inequality and violence on Planet Art.

Post-pandemic, the mood is different. The combination of Covid and the intensification of the movement for racial justice quietened some conversations but pried open a space for others. As museums, art fairs and galleries closed their doors through 2020 and artists and art workers found themselves suddenly without jobs or income streams, on one level, the challenge was simply to survive, rather than thrive by fighting for a fairer, more equitable environment.

In 2022, the Whitney Biennial opened without any protest from artists on show at the museum, while the year before, it had been stricken by demonstrations against the presence of arms dealer Warren Kanders on the board. Yes, Kanders had resigned, but the Whitney is still home to many bankers, property developers and Donald Trump donors, who are arguably just as damaging to our world.

But that's not the whole story. In truth, there were demonstrations at the Whitney in 2022. This time, however, they were not staged by activists outside the museum but rather by the museum's own workers, who were protesting for better pay and conditions.[101] Their struggle, strengthened by their decision to unionise the previous summer, embodies the phenomenon of collective labour organising that has been sweeping through the

US and the UK since the pandemic. That it has arrived also on Planet Art, where for so long working has been considered a 'privilege' for which one should be grateful, signifies a genuine shift in mood.

The resurgence of Black Lives Matter during 2020 has prompted demands for change—and a degree of change already—in terms of artist representation, staff diversity and inclusion, and the restitution of objects to nations in Africa and elsewhere across the world. The 'decolonisation of the museum', as this process is often described, is also making headway in raising the demands of Indigenous communities. In January 2022, Smithsonian appointed the first Native American director of one of its institutions, when Cynthia Chavez Lamar was named head of the National Museum of the American Indian. That it took so long, however, for a Native American to be chosen to lead a museum focused on Native American communities reveals the deficit still to be filled.

Russia's invasion of Ukraine has now created another site of conflict and embarrassment for museums, as Putin-friendly oligarchs, collectors and board members are hurriedly banished from their posts. But in spaces where the media spotlight remains dim, the uber-wealthy class continues to peregrinate from fair to gala to museum board without censure.[102] The failure of Planet Art to put its house in order of its own accord, rather than when it is named, shamed and harassed by less powerful participants, or outsiders, is indicative of how much work there is to do.

One of the fiercest and most painful recent controversies swirled around Documenta 2022. Held every five years, it ought to be a clever, thoughtful, ethical festival of international expression. In 2022, many thought it was all of those things and more. But the festival also combusted under accusations of xenophobia, antisemitism and Islamophobia. The gulf between what the artists and many of the art workers were saying, and the response in

the German media and political arena, was indicative of the 'culture wars' that are crackling explosively through Planet Art.

Many ingredients have gone into the cauldron of tension and possibility that is today's Planet Art. The question now is: what's coming next?

2

# DECOLONISE THIS PHILANTHROPY

'WE WANT WARREN KANDERS off the board of the Whitney! Because the Whitney profits from pain!' The words are yelled by a woman standing on the steps of New York's Whitney Museum of American Art. In black t-shirt and jeans, she is flanked by a group of women who are similarly dressed. The majority are either Black or Asian. The crowd at the bottom of the steps call her words back to her. 'Because the Whitney profits from pain!'[1]

It's 2019, a hazy day in early May. In a week's time, the Whitney Biennial is due to open at the museum. The longest-running survey of American art, the Biennial has been a flagship show for the New York institution since 1932. During this time, it has been a showcase for legendary figures including Andy Warhol, Mark Rothko and Jean-Michel Basquiat.

Founded in 1930 by the socialite, philanthropist and collector Gertrude Vanderbilt Whitney, the Whitney Museum boasts a 25,000-strong collection of chiefly modern and contemporary American artworks and is a cornerstone of the international art firmament. Rare is the artist whose work has made it into either the Whitney's collection or one of its temporary exhibitions who does not instantly update their CV to reflect the prestige. 'It's a huge deal, because it allows me to move forward in a greater way,' commented 2019 Biennial participant Brendan Fernandes, whose installations and performances combine visual art and dance.[2]

The Whitney is also a museum that prides itself on its radical pulse. Vanderbilt Whitney's first exhibitions, held in Greenwich Village, showcased US artists ignored by the canon, and the museum today is still known for embracing progressive, avant-

garde work. Citing another 'director colleague' from Planet Art, Whitney director Adam Weinberg expressed a belief in the contemporary museum as 'a safe space for unsafe ideas'.[3]

Until 2014, the museum was housed in a building on New York's Upper East Side designed by Bauhaus architect Marcel Breuer. The stark, inverted ziggurat was a landmark of Manhattan architecture, but in 2015, its collection having outgrown its home, the Whitney relocated into a brand-new edifice in the Meatpacking District. Designed by Renzo Piano, an architectural grandee who charged $422 million for the privilege, the new building boasted 50,000 square feet of gallery space. Clinging to the High Line, with one vast glass wall gazing over the Hudson River, it exemplifies the expansionism that has infected Planet Art in recent decades.

When Piano's Whitney opened in 2015, *The New York Times* applauded it as 'a deft, serious achievement ... both sanctuary and civic space.'[4] One *Financial Times* critic opined it was 'the best building by Genoese architect Renzo Piano for many years.'[5] However, another *FT* writer panned it for being 'an inert vault for increasingly expensive commodities, more bank than machine'.[6]

Certainly the protesters are immune to the building's charms. Planted on Piano's sleek, grey steps, they chant: 'Hey, hey, ho, ho, Warren Kanders got to go!'

Watching footage of the anti-Kanders demonstration was to witness a twenty-first-century David unleashing its catapult at an institutional Goliath. The number of protesters barely hit triple digits. Their banners were scrappy, their clothes casual and workaday. Behind them the museum loomed like a mute, indifferent Leviathan.

This is an institution so well connected that it succeeded in scooping together $760 million with which to run its new incarnation, raised through a capital campaign and private donations, including $131 million donated by the chair of the Whitney's

board of trustees, the billionaire Leonard A. Lauder.[7] Lauder's vice-chairman was Warren Kanders: the target of the demonstrators' ire.

The luxurious, exclusive orbit of Lauder and Kanders could not have been further from the experience of the objectors on the steps of the Whitney. As the latter expressed their anger, their cries seemed to bounce off the smooth, post-modern walls, leaving no trace.

But David won. Goliath crumpled. By July 2019, Kanders was gone. His resignation from the board of the Whitney was accompanied by a statement: 'The targeted campaign of attacks against me and my company that has been waged these past several months has threatened to undermine the important work of the Whitney. I joined this board to help the museum prosper. I do not wish to play a role, however inadvertent, in its demise.'[8]

Kanders' downfall is just one of a flush of victories won by a battalion of Davids against the Goliaths of institutional, international contemporary art. Others include the campaign headed by artist Nan Goldin to convince museums, including the Louvre, the Serpentine and the Metropolitan Museum of Art, to reject philanthropy and remove the name of the Sackler family from their buildings because its fortune came from opioid manufacture; the decision by Tate in 2016 to drop fossil-fuel giant BP as a sponsor after concerted pressure from British activists; and the resignation of Leon Black as chairman of MoMA in 2021 after his financial ties to sex offender Jeffrey Epstein were revealed.[9] But there has been substantial establishment pushback against tying funding to ethics. In 2019, Christopher Frayling—former rector of the Royal College of Art, former trustee of the Victoria & Albert Museum and former chairman of Arts Council England—told the BBC that such qualms 'will lead to a moral panic in the art world' and do 'a lot of damage'. The first rule of fundraising, he continued, is that the 'companies with an image problem are the ones you go to first of all.'[10]

I've chosen to focus on the Warren Kanders case because it embodies many of the elements that unite the wider struggle against unethical philanthropy on Planet Art. Moreover, the Whitney protests also illustrate another dynamic that for too long has remained below the mainstream radar: labour relations in the culture sector. In the story of Kanders' demise, we see how museum workers, if they unite, are a significant catalyst for change.

## THE BEGINNING OF THE END

Warren Kanders joined the board of the Whitney in 2006, at the invitation of Leonard Lauder. Prior to becoming a trustee, Kanders had served on the museum's executive committee for seven years. During this time, he established himself in the trade of militarised equipment. In 2019, when the demonstrators gathered on the Whitney steps, Kanders was CEO of Safariland, a Florida-based defence manufacturing company that produced a variety of military and law enforcement gear, including bullet-proof vests, bomb-defusing robots, gun holsters and tear gas.

It was the latter product that had fuelled the protests. Specifically, there had been reports that tear gas made by Kanders' companies had been turned on migrants at the US–Mexico border. Jasmine Weber broke the story of this possible link between a Whitney board member and the incident at the border on 27 November 2018 in *Hyperallergic*, an online arts publication launched explicitly to challenge the 'art world status quo'.[11] Weber spoke of a 'calamitous scene' in which families, including children, were allegedly fired upon with tear gas as they tried to cross the border between San Diego and Tijuana. Her piece cited an article by *The New York Times* reporting 'At least two dozen tear gas canisters' found on the Mexican side of the border after the migrants were forced to turn back, and attributing their use to border police.[12] Weber also referred to

'wrenching photographs' shared on social media by journalists on the ground, while *The New York Times* described the migrant families—mothers pushing strollers, fathers carrying infants in their arms, their faces drained by exhaustion as they made their long progress. Photographs included in Weber's article showed the canisters allegedly used on the migrants, which bore the logos of Safariland and one of Kanders' subsidiary companies, Defense Technology.[13]

Awareness of Kanders' commerce in law-enforcement equipment was not new. Back in July 2015, Al Jazeera America had reported on Defense Technology's sale of riot-control products to the Baltimore Police Department, noting Kanders' position on the Whitney board.[14] Earlier that year, the same police force had used tear gas to quell a massive civil uprising protesting the death of the twenty-five-year-old Black American Freddie Gray from critical injuries sustained to his neck and spine in police custody.[15] The Baltimore uprising, as it became known, soon became a byword for the violent, highly militarised response of US police forces to legitimate public demonstrations. Similarly troubling events had occurred the previous year in Ferguson, Missouri and New York after protesters gathered to call for justice for Michael Brown and Eric Garner, both Black men who had died at the hands of the police.

In 2015, the Al Jazeera op-ed gained little traction. But by 2019, Black Lives Matter had swollen into a global movement demanding acknowledgement and radical change to end systemic racism. Its work was at the vanguard of a rising tide of dynamic, intelligent, effective activism calling for equality and justice for diverse constituencies, including people of colour, women—thanks to a wave of contemporary feminism fuelled by #MeToo—and Indigenous communities. These protest movements went hand in hand with a new flowering of media outlets, including social media accounts, whose view of once hallowed

institutions was far more clear-eyed and less awed than their long-established mainstream counterparts. Simultaneously, a growing number of contemporary artists were creating work that doubled as political activism, while workers across the culture sector were joining efforts to unionise and demand collective change. The result was that the message borne by the art on show in museums and championed by its staff looked increasingly out of sync with the ethics of those who were paying for its showcase.

Kanders' downfall was brought about by an amalgam of all these elements. But among the artists and activists agitating for change, one organisation in particular was crucial to his toppling: Decolonize This Place.

## DECOLONIAL CONNECTIONS

Decolonize This Place (DCP) describes itself as an 'action-oriented, decolonial formation and a call to action'.[16] Started in 2016 by artists Amin Husain and Nitasha Dhillon, DCP has organised and collaborated on dozens of performances and protest actions that challenge the status quo in US museums, including calling for the removal of the Theodore Roosevelt statue outside the American Museum of Natural History, which showed the former US president on horseback, towering over an African man and a Native American man in an unequivocal racial hierarchy. The objections to this statue are just one in a raft of challenges to monuments in cultural spaces that glorify racist histories—including Confederate statues in the US South, images of Cecil Rhodes in South Africa and Oxford, England, and the statue of slaver Edward Colston in the city of Bristol.

DCP joined a coalition of artists to 'Strike MoMA' because of its board members' unethical ties and the museum's poor labour practices. They also demonstrated against the gentrification of Brooklyn and the occupation of Palestine outside the Brooklyn

Museum. So significant did its work become that in 2019, DCP was named nineteenth in the Art Power 100 of the influential *Art Review* magazine. (That Glenn Lowry, director of MoMA, came first that year gives an idea of just how furiously contested Planet Art was at that time.) Dhillon was also on the working group for Occupy Museums, her presence demonstrating the evolution of activism in the culture sector post 2008. However, since then Dhillon has identified the failure of the Occupy movement to encompass racial justice and equality as one of the motivating factors behind the evolution of DCP. She also questioned the notion of occupation as a viable strategy, saying: 'Why would you occupy already-occupied territories?'[17]

As its name implies, the key principle of Decolonize This Place is the decolonisation of society with a particular emphasis on the North American culture sector. Decolonisation is today a ubiquitous term on Planet Art, appearing in discussions ranging from demands for the return of African, Asian and Native American artefacts stolen by colonial invaders, to calls for museums to be restructured as more inclusive, equal and fair environments for artists, art workers and audiences.

For DCP, decolonisation must recognise that 'colonization is not a period sealed safely in the past, but an ongoing process inherent to the dynamics of contemporary racial capitalism.'[18] In a piece published after Warren Kanders' resignation, the group describes a decolonial perspective as one that 'approaches our present political condition by beginning with the occupied land on which we stand.' This statement is profoundly significant, for it links the specific, localised challenge launched at a modern weapons manufacturer with the greater, historic abuse perpetuated by those first white European settlers when they landed on the shores of North America over 400 years ago, dispossessed the Native Americans of their ancient, beloved land, and employed armies of slaves from Africa to turn that land into profit for the newcomers.

That profit-centred violence also animated European imperialism in the Global South, as it dispossessed African and Asian countries of sovereignty, people and resources. Perhaps most famously, museums in Germany, Britain and the US have faced repeated demands to restitute art and artefacts appropriated during those colonial depredations, such as the Bronzes looted by the British Army in Benin in 1897. These are big issues that call into question foundational structures of institutional power throughout the Global North while reminding us how the Global South still suffers the effects of slavery and colonialism.

For museums, observes DCP, 'decolonisation' has usually been understood as limited to diversifying their programming and exhibition displays to increase the representation of particular communities. 'By targeting board membership and sponsorship,' the group continues, the Kanders campaign joins other organising movements worldwide, including Sackler PAIN, BP or not BP?, and Liberate Tate (the latter two campaigns waged against fossil-fuel sponsors in British museums), all of which have broken through 'the firewall between cultural representation and economic power.'

'We are making the connections!' shouts one of the protesters on the steps of the Whitney, as another cries, 'This shit's connected. Abolish white supremacy!' Indeed, one of the striking characteristics of decolonial theory, as practised by DCP and its allies, is its effectiveness at showing how ostensibly different systems of oppression and dispossession fortify each other. As the great Black poet and activist Audre Lorde put it, 'We do not have single issue struggles, because we don't live single issue lives.'[19] Indeed, DCP rejects attempts to silo off the concept of protest itself. As Nitasha Dhillon put it in a public lecture she gave in April 2022, 'We don't think of ourselves as activists or protesters because we're not thinking about this as a specialised profession, right? Thinking about liberation should not be a specialised profession.'[20]

The campaign against Kanders included groups protesting urban cleansing in New York, violence against the working class, violence against queer people, racist policing, racist prisons, migrant rights abuses, land expropriation and oppression from Palestine to the Americas, and environmental injustice. These campaigns all came together at the Whitney because they each saw their 'own specific struggles amplified in the struggle against Kanders'.[21] That tear gas manufactured by Kanders' companies had been used against so many of these different communities in so many different parts of the world underscored the activists' observation that 'this shit's connected'. Indeed, systems of power—from real-estate developers in Brooklyn to oil and gas companies taking action to chase out local communities so they can frack and drill—frequently have each other's back. In order to combat such reinforced matrices of power, campaigners for justice and equality, even when apparently geographically or socially distant, are learning to unite too.

'Warren Kanders is only the beginning of the crisis at the Whitney,' declares DCP in a statement on its website. 'What about the occupied land? What about the pipeline buried next to the Whitney? What about working-class queer communities of colour displaced from the Meatpacking district? What about the rising rent prices in the neighbourhood leading to the gentrification of Chinatown and Bushwick?' For DCP, it is important to remember that the Kanders campaign 'has not just been about artwashing or toxic philanthropy—it has also been a fight against the violence directed at our communities and movements'.[22]

The ability to draw those connections from one violence to another, one dispossession to another, is a crucial cog in the wheel of resistance to twenty-first-century global capitalism and its injustices. In the words of art critic John Berger, 'The precondition for thinking politically on a global scale is to see the unity of the unnecessary suffering taking place.'[23] As the activists stood on those elegant grey steps in front of the Whitney's multi-

million-dollar new building to protest against its board's multi-millionaire vice-chairman, they helped to make visible the inseparability of multiple injustices and the interconnectedness of the structures that cause them.

Planet Art is proving a fertile place for such novel, transparent exposures. After all, part of the work of the artist is to employ their imagination to explore new territories, forge new connections. Museums themselves regularly claim to wish to foster the bold, original, creative activity that they are now finding ensnares them in such challenges as the Whitney faced in 2019.

'The essential activity of the rich today is the building of walls,' writes John Berger.[24] But the walls on Planet Art are thin. Artists, activists, campaigners and art workers keep leaning across them, grasping each other's hands, helping each other across borders that the elite would prefer remained firm. Bricks fall. Name plaques are taken down. Trustees resign. The Benin Bronzes start finding their way home. Warren Kanders. Leon Black. Sackler. BP. Shell. A clutch of Russian oligarchs since the invasion of Ukraine in spring 2022. On Planet Art, activists like Decolonize This Place are making connections time and again between the sins of the past and the suffering of the present. The privileges enjoyed by the rich and the lacks experienced by the poor. The wealth of white communities built on the theft of goods, bodies, time and energies from communities of colour.

MAKING WAVES

The protest outside the Whitney in May 2019 was just one in nine weeks of continuous action orchestrated by DCP and its collaborators. The activities included not only speeches on the steps but anti-tear gas banners draped from the top floor—'When We Breathe We Breathe Together'—and a sculpture of a tear-gas canister that belched out vapour and rolled about on wheels.

Passionate, articulate and visually striking, the protests made headlines. Central to the dissemination was *Hyperallergic*, whose thoroughly researched stories, grounded in cultural expertise and contact with grassroots activists and local organisations, were picked up by other outlets including *The New York Times*. Mentioning that Kanders' companies' tear gas had reportedly been used on Palestinians in Gaza, as well as at protests in Baltimore and Ferguson, such mainstream, international coverage was surely significant in bringing pressure to bear on the Whitney.[25]

Crucial too were the artists who decided that, if they were genuinely committed to supporting the oppressed and marginalised, it was untenable to exhibit at the Whitney with Kanders in situ. The first to speak out was Michael Rakowitz, an Iraqi-American conceptual practitioner whose oeuvre includes the installation *A Color Removed* in memory of Tamir Rice, shot dead at the age of twelve by a Cleveland police officer in 2014. As with so many police officers responsible for the deaths of Black citizens, the man who killed him, Timothy Loehmann, was never put on trial.[26]

'I felt like I'd be betraying everything that I've ever cared about in the work that I make,' said Rakowitz when asked why he pulled out from the 2019 Whitney Biennial.[27] 'You wouldn't compromise the integrity of a work on paper by showing it in unsafe conditions. You should not compromise the integrity of an artist and ask them to show with funding and permission from people that make conditions unsafe for others.'

After Rakowitz came four more artists: Korakrit Arunanondchai, Meriem Bennani, Nicole Eisenman and Nicholas Galanin.[28] Announcing their resignation in the culture journal *Artforum*, the quartet acknowledged the Whitney's reputation for showcasing radical, progressive art, saying that they 'care deeply' about the museum and that its shows 'have inspired and informed our art'. When they first learnt of Kanders' involvement in the weapons-manufacturing industry, they had initially decided to continue as

participants in the Biennial because their own production processes were so far underway. What tipped the balance, they said, was the museum's continued failure to respond to the artists' and activists' complaints about Kanders. This 'inertia ... turned the screw.'[29]

One Biennial participant decided to make Kanders the subject of the work they exhibited there. Entitled *Triple-Chaser*, the ten-minute video by Forensic Architecture, a collective renowned for its hard-hitting exposés of social and political injustice, focuses on the eponymous tear-gas grenades made by Safariland, which have been used in the US, Palestine, Israel, Iraq, Venezuela, Egypt, Bahrain, Canada, Turkey, Peru, Yemen and Guyana. The film opens with Kanders' own quote: 'While my company and the museum have distinct missions, both are important contributors to our society.' What follow are ten devastating minutes that leave the viewer in no doubt that, while Kanders claims to deal in 'less-lethal weapons', tear gas is a vile tool to unleash on human beings.[30] Indeed, it was actually banned for use in war by the United Nations in 1993, while remaining legal for law enforcement use such as riot control.[31] So dangerous were Safariland's crowd control grenades that a 'Safety Data Sheet' supplied by the company details side-effects including dangers of 'pulmonary edema', 'impaired breathing' and 'convulsions'—which it lists, without a hint of irony, under 'First-aid measures'.[32]

Ultimately, Forensic Architecture withdrew from the Biennial. The final straw for the London-based collective was the discovery by one of its researchers of a bullet close to a Palestinian refugee camp.[33] Finding that the bullet 'largely matche[d]' analysis previously conducted on those made by Sierra Bullets, an arms manufacturer partially owned by Kanders, the researcher alleged that this bullet linked the American tycoon to Israeli Defense Forces violence in Gaza which, the previous year, had been sufficiently severe to be classified by the UN as a potential war crime.[34]

Forensic Architecture's withdrawal from the Whitney Biennial was reported by *Hyperallergic* on 20 July 2019. Six days later,

Kanders' letter of resignation from the board made headlines across the world.

## MISSING THE POINT

Kanders' resignation prompted a variety of reactions. A statement from Decolonize This Place welcomed his departure as 'an act of good faith' from the museum leadership.[35] Kanders didn't see it like that. Speaking to the *Financial Times* about his resignation six months later, he criticised the Whitney's 'weak leaders', which suggested that he did not choose to go of his own volition.[36]

In his resignation letter, Kanders made clear how little sympathy he had with those who had challenged his methods of business and his place on the Whitney board. He accused his detractors of having a 'larger and more insidious agenda' as part of a wider, 'politicized and oftentimes toxic' public discourse that put the museum's 'vibrant art community' and work in 'great jeopardy'.[37] The letter is an illuminating example of how powerful individuals defend themselves and their interests when they are held to account. From Kanders' language, you might think the protesters were terrorists.

In truth, Husain and Dhillon are artists and academics, while those who aligned themselves with DCP's calls to remove Kanders included dozens more artists, intellectuals, writers and teachers. In April 2019, over 100 theorists, critics and scholars signed an open letter calling for Kanders' resignation that was published on the website of Verso Books.[38] And, as we will see, a crucial challenge to Kanders' position on the board came from the Whitney's own staff.[39] If Kanders genuinely believed that all those people posed such a dangerous threat to the social order, then he probably never belonged on the museum's board in the first place.

In the letter, Kanders also shares his views on art, whose purpose is 'to express, to push boundaries and to ask questions', not 'to force one-sided answers or to suppress independent thinking'.

The implication is that Kanders' independent thought, which has led him to believe selling tear gas to security forces is a legitimate activity, is what is being suppressed.

Whitney director Adam Weinberg laid out a similar set of arguments. Commenting on Kanders' departure, Weinberg said of his former trustee, 'Here's a man who has given a tremendous amount of his time and money to young, often edgy and radical artists—somebody who is very progressive—that's one of the ironies of all this.' Furthermore, he continued, the Whitney 'is one of the most progressive, the most diverse, the most engaged, open programs of any major institution in the country. Every museum director is looking at us right now and saying, "Gee, if the Whitney is being targeted, what's going to happen to us?"'[40]

What indeed? The Kanders crisis is emblematic of a bigger picture in which many public institutions are in the hands of trustees whose day jobs leave them at enormous risk of being 'targeted' too.

Kanders' and Weinberg's responses are paradigmatic of the attitude, so prevalent among the privileged elite who preside over Planet Art, that artists can be as radical, outspoken and revolutionary as they desire, as long as they confine themselves to the museum, gallery or art fair. It's one thing to call for equality and justice but quite another to actually start bringing it about. To make it happen would require systemic social change. It would require philanthropists and the museums who accept their money to ask themselves hard questions about whose interests they are really serving. It might require them to make some significant alterations to their lifestyles, ones that might entail the sacrifice of real, material power. For many of the elite, even those who consider themselves great philanthropists, that has never been part of the plan.

As I write these words, I'm suddenly taken back to Venice, where I look at the panel by Barbara Kruger defanged by its shopping magnate owner to be no more than a fashionable ornament.

In her book about the sterilisation of art within institutional spaces, philosopher Sinéad Murphy terms this process 'kettling', a phrase she has lifted from its original use to describe the activity of police forces corralling protesters into tiny spaces to subdue them. A similar kettling, she says, afflicts art in museums in neoliberal democracies. 'Art ... operates to physically and psychologically contain a growing population of allegedly "free" thinkers, speakers, movers and livers,' she writes. This takes place through art's regulation of 'our capacities for creativity, for inventiveness, for imagination, our capacities to interpret, to judge, to experience, seek and find', which leaves 'the rest of social, cultural and political life free of such unpredictable, such potentially revolutionary, capacities.'[41]

Sometimes, however, art escapes that fate. At the Whitney Biennial in 2019, art cut loose. It was sprung from its institutional prison by a cohort of forces both within and without the institutions. Outside were a variety of committed and collaborative activist organisations. Then there were the artists, like Rakowitz and Forensic Architecture, who started off inside, but whose decision to pull their work was not only crucial to the outcome but also boosts Sinéad Murphy's point that sometimes artists will only find liberty, and actually effect the revolutionary activity their art champions, by refusing participation entirely in compromised contexts of display. But arguably the most powerful trigger for Kanders' departure was pulled before the protests began. It was the museum's own workers who were the first to address their leadership and collectively demand change.

## WITHIN THESE WALLS

On 30 November 2018, *Hyperallergic* published an open letter to the Whitney leadership from staff responding to the allegation, made three days earlier in the same publication, that chemical

weapons made by Kanders' businesses were being used on migrants at the US–Mexico border. Signed by over 100 of the museum's workers, from curators to gallery assistants, the letter spoke of the staff's 'outrage' at the discovery of Kanders' business interests, an issue that they believed was 'demonstrative of the systemic injustice at the forefront of the Whitney's ongoing struggle to attract and retain a diverse staff and audience.'[42] The signatories pointed out that, while remote from the lives of the museum's leadership, these injustices were felt personally by staff. 'For many of us, the communities at the border, in Ferguson, in the Dakotas, are our communities. We read the *Hyperallergic* article and felt not annoyed, not intellectually upset—we felt sick to our stomachs, we shed tears, we felt unsafe.'

That visceral emotion reflects the museum workers' intimate affinity with the victims of tear gas. Contrast it with comments by Kanders in his interview with the *Financial Times*. There he explains that selling weapons makes sense in a world that he believes is 'getting smaller' and therefore prone to more conflict, requiring people to think about 'how we interact with each other and how we protect ourselves.'[43]

The 'we' is telling. Kanders assumes that his interlocutors—the *FT* journalist, the *FT* readers—will empathise with and share his need for protection against unruly, inimical forces. But the broad-based campaign against him illustrates that many people not very far from Kanders do not empathise at all. Are they unruly and inimical? Insidious? Toxically politicised? What if protection for some risks the safety of the rest? The museum workers explicitly didn't welcome Kanders' protection. On the contrary, his tear gas endangered them.

It was this letter by Whitney staffers that prompted the resignation of the first artist, Michael Rakowitz, from the Biennial in December 2018. Discussing his decision, Rakowitz described the letter as 'very brave ... this miracle of interdepartmental alliance

and solidarity ... There wasn't a hierarchy. It was all through the museum.'[44] His choice of words is revealing, pinpointing the democratic nature of the text. All for one and one for all. The letter is a space where a janitor is no more or less important than a senior curator. That democratic impulse extends into a wider circle of society. Its writers point out that they are connected, through shared ethnicities, communities and diasporas, to the many people outside the museum—Black Americans, Palestinians, Mexican migrants, Indigenous environmental activists—who have found themselves under attack from weapons sold by industrialists like Warren Kanders.

The workers operate as a link in the chain connecting what happens inside the museum and what happens outside. They are, if you like, a bridge. A window. A chink in those walls built so enthusiastically by the powerful, as Berger reminds us, through which the hypocrisy of museum leaders and philanthropists is suddenly visible. They confer transparency. They shed light on the obfuscation of the trustees who defend their day jobs—whether in high finance, fossil fuels, real estate development, chemical weapons or opioid manufacture—that act to produce and perpetuate inequality and injustice on the grounds that here, in the museum, they do good with their money by supporting the arts.

'We are making the connections!' cries the Decolonize This Place activist on the steps of the Whitney. So too are the Whitney staff, but they are speaking from inside the institution's own walls. Here they connect themselves to those outside the museum: Black people who protested police brutality in Ferguson, Native Americans who campaigned against a new oil pipeline in Dakota, and the South American migrants whose plight triggered the whole situation.

Their affirmation that these communities 'are our communities' encoded another statement: *they are not your communities.* Unwritten, implicit, silent—but deafening in its reproach to the

museum leaders. And because they are not your communities, because your wealth and power has disconnected you from empathy for those who find themselves gasping for breath after the canister explodes, or bruised by police beatings, or mourning those killed by those beatings, you have failed to comprehend why this issue matters. Why we, the Whitney staff, matter. Why we deserve to be addressed, acknowledged, comforted and given guidance as to how to do our job in the light of this new knowledge that one of our leaders is our enemy, that he is helping to suppress our people's rights and voices.

In, out, shake it all about. The staff letter broke down the barriers between the museum and the wider world. Of course, on a practical level, the museum doors are open to the public, some of whom, as the staff highlighted, would have questions about the situation with Kanders. 'Should protests from the public or questions from visitors arise, our visitor-facing staff will be the ones answering them. Leadership choosing not to give a public (or even internal) statement displaces the labor to our visitor-facing staff, who are, generally speaking, our most diverse and lowest paid staff.'

With these words, the letter writers were dismantling a series of frontiers between the institution and the commons. People come into the museum from various diverse communities. Inside they encounter, particularly among the room custodians, the security guards, the cleaners and the cafe staff, people from similarly diverse communities. Conversations occur. Dialogue. Exchange. Protest. Anger.

But the leadership remains elsewhere. Above. Beyond. Silent. Sealed behind boardroom doors on upper floors, frequently with big glass windows offering broad views of the cities they help to gentrify. They do not speak to their diverse, low-paid, public-facing staff, nor to their diverse, curious and perhaps outraged visitors. They expressed no consternation at how Kanders profited from these people's suppression.

Not only did this make the museum leaders appear heartless, but it also made them hypocrites. The Whitney has built its reputation on bringing outsiders in. Recall director Adam Weinberg's defence that the museum 'is one of the most progressive, the most diverse, the most engaged, open programs of any major institution in the country.' The letter writers made it clear that the Whitney was saying one thing while doing another. When its board includes arms dealers such as Kanders, the museum fails to live up to its professed high ideals. Instead, once again, it falls upon the staff to do this work.

'So many of us are working towards a more equitable and inclusive institution,' the staff continued. 'We work to bring in artists who are immigrants and artists of color to the collection. We create programming for youth and families who are affected by current immigration policy. Upon learning of Kanders' business dealings, many of us working on these initiatives feel uncomfortable in our positions. We cannot claim to serve these communities while accepting funding from individuals whose actions are at odds with that mission.' The letter concluded with a devastating sentence: 'This work which we are so proud of does not wash away these connections.'

On 2 December, three days after the staffers' letter was published, Weinberg responded with his own letter.[45] As usual, he fell back on the Whitney's reputation as a museum which has championed artists from marginalised backgrounds. He was proud, he said, of presenting 'progressive and challenging artists and exhibitions for vast audiences.' Among his list of recent examples were the queer photographer and AIDS activist David Wojnarowicz, geometric painter Mary Corse, whom Weinberg said had been 'overlooked because of her gender', and a group show of 'new Latinx voices' called *Pacha, Llaqta, Wasichay*. Beyond showing such disparate, rarely heard practitioners, Weinberg also celebrated the museum for 'a compelling array of

artist-centric educational and community programs that reach increasingly diverse publics from our neighbourhood and afar.'

What Weinberg's letter did not engage with was the staff's contention that Kanders' presence compromised the institution's relationship with those 'diverse publics'. He also failed to perceive that to celebrate the museum for showing artists who are, say, political activists, when its trustees were assisting in the suppression of political dissent was to render that art 'kettled'.[46]

For the Whitney, the staff letter was a disaster, exposing the museum's inherent contradictions and setting off the crisis of dissent that would unfold. Its stability as an institution depended on such links not being made. On the borders holding. The frontiers remaining firm. No, write the staff, we cannot wash away or clean up Kanders' toxic philanthropy by showcasing artists from the same communities being assaulted by his tear-gas grenades. It's not complicated. The connections are undeniable, unerasable. The very structure of the museum, the people who work within it, are links in the chain. The borders are porous, leaking, weakening by the day.

'WE HAVE LISTENED'

As I write in late 2023, prominently displayed on the homepage of the Whitney Museum's website is a link to a letter from the director: 'We Stand with Black Communities'.[47] The text was prompted by the killing of another Black American, George Floyd, by a police officer in May 2020, an event which triggered a wave of public statements of support for people of colour by businesses and institutions across the Global North.

It's a powerful missive. Weinberg reiterates the Whitney's commitment to illuminating and condemning 'injustice, systemic racism and violence against people of colour' through its work. He admits that the Whitney has made mistakes. But, he says,

'We have also listened and are always learning.' Not only has the museum 'increased the racial diversity of our collection, exhibitions, performances, educational programs, audience and staff', but it pledges to review its structures through 'a lens of racial equity', and its board of trustees will 'pursue the goals of adding greater diversity and reviewing its governance'.

How's that going? More than three years after Floyd's death, and more than four after Kanders' resignation, I click through the biographies of the Whitney board. The chairman emeritus is still Leonard Lauder.[48] Chairman of the executive committee is Robert J. Hurst, who has been a director of a company called Oxbow Carbon since 2007. Owned by William Koch, Oxbow trades in petrochemicals that belch sulphur dioxide into the atmosphere. Sulphur dioxide is environmentally damaging at the best of times. At its plant in Port Arthur, Texas, however, Oxbow were able to evade demands to clean up the waste thanks to a widely reported legal loophole.[49]

Some trustees are donors to the Republican Party, or to fossil-fuel production: Susan K. Hess is married to the CEO of oil and gas giant Hess Corporation. Some are still linked to weapons manufacturing: Julie Ostrover is married to the CEO of private equity firm Owl Rock, which invested in military equipment manufacturer AC&A Enterprises, while Nancy Carrington Crown married into a major shareholder in one of the United States' largest defence contractors, General Dynamics, which helped to sustain Trump's immigration detention centres.[50]

Despite the rhetoric of Weinberg's letter to Black citizens, the overwhelming majority of the Whitney's trustees were still white by late 2023. Among the handful of Black board members is long-time Wall Street executive Raymond J. McGuire, who served as vice-chairman of Citigroup until 2020. The investment bank and financial services corporation was held to be one of the companies most responsible for creating the subprime mortgage

crisis that triggered the 2008 economic crash.[51] Other trustees include Ethiopian American artist Julie Mehretu and Black American intellectual Henry Louis Gates, Jr. But the slant towards the world of business and finance illustrates the clash between the values of those on the board and those making art or working on the floor of the museum.

Of course, you could argue that it's crucial in a democracy that a major museum represent views from all sides of the spectrum. But if the museum claims that it is actively, intensely committed to dismantling the inequities in our society, is it not problematic to have so many leaders who, in their day jobs, appear to be perpetuating them?

It's no wonder the museum staff are angry. The museum's double standards are stamped on their wage packets and in their unsatisfactory working conditions, in the homes they struggle to maintain and find themselves evicted from as one or another of those real estate magnates builds yet another luxury development.

But one board member is no more. The first domino to set off the chain reaction leading to Warren Kanders' departure was the staff's electrifying missive. Kanders fell because the museum turned against him from within.

In the next chapter, I will look at how labour has played a significant role in other battles playing out across the art world over the last decade. Sometimes campaigners fighting for better, more equitable working conditions have won remarkable victories and effected radical change. Sometimes they have receded, exhausted, perhaps, by the sheer need to hang on to a job, pay bills, keep a roof over their heads.

3

# LABOUR OF LOSS

'TATE! 313 JOB CUTS is Not Modern Art!' 'Tate Abusive, Uninclusive!' 'Save Our Jobs!' Sprayed across white sheets, the messages are massive, messy and multi-coloured. Held aloft by people of different genders, ages and ethnicities gathered outside Tate Modern's looming brick edifice on London's South Bank, the banners decimate the claim of the UK's most important art gallery 'to want to create an inclusive, welcoming environment for visitors, artists and all those who work at Tate'.[1]

It's August 2020, and Planet Art is imploding. In the spring, the Covid pandemic forced museums and galleries to close their doors overnight. In European countries such as Germany and Italy, employees of public museums have protected job contracts.[2] But this commitment has been weakening in certain places and subsectors, as with the outsourcing of security staff at Paris' major galleries.[3] Some of these vulnerable European art workers, such as freelance art educators in Portugal, are being sacked.[4] And in the UK and the US, the job cuts are brutal.

By March 2022, the Museums Association in the UK had counted 4,824 redundancies across the sector.[5] Most of these job losses occurred in the first year of the pandemic: in April 2021, the Association reported 4,100 redundancies in the museum sector. That figure accounted for approximately 8 per cent of the original workforce.[6] As early as October 2020, a survey by the American Alliance of Museums found that Covid had caused 21 per cent of US museums to lay off full-time staff, 26 per cent to lay off part-time staff and 9 per cent to lay off contractual workers.[7] In another survey by the AAM in March 2021, over 40 per cent of US museum workers reported that they had lost

income during the first year of the pandemic, with an average loss of approximately 30 per cent of their total income.[8]

## PRIVATE, PALATIAL AND PRECARIOUS

'We love selling!' Who do you think said that? No, not airline magnate Michael O'Leary or celebrity billionaire Alan Sugar, but Tristram Hunt, director of the Victoria and Albert Museum in London. Hunt was speaking to a podcast audience in June 2020 of his longing for his museum to reopen so that he could fill its coffers once more from sales of tickets, designer scarves and fairy cakes.[9] Just months later, Hunt would preside over the dismissal of over a hundred workers, apparently oblivious of the connection between his dependence on profit and his workers' precarity.[10]

While the dismissals might have been triggered by Covid shutdowns, the real groundwork was laid by privatisation. Major museums and galleries in the UK and the US must now depend on private donations, sponsorships and commercial revenue from ticket sales, retail, cafés and venue hire, rather than public funding. The pandemic only revealed the fragility of this model, with museum closures exposing the insecurity of reliance on consumer sales. As Alistair Brown, policy manager of the Museums Association in the UK, reflected in April 2020, 'the more an organisation is dependent on earned income, the tougher this is in the immediate term.'[11]

The transfer of the UK's cultural institutions from the public sphere to that of profit-makers has been unofficial, but, if anything, this has made it all the more insidious.[12] In 1980, Margaret Thatcher's government published *The Arts Are Your Business*, a handbook designed to encourage corporate sponsorship of museums. In return, the sponsors burnished their own brands with recognition for their philanthropy. In the decades that followed,

museums including the British Museum, Tate and the National Gallery would start to accept money from businesses such as banks, car manufacturers and oil and gas companies. Museums also came under pressure to charge admission fees. Approximately one in two institutions acceded.[13] In 1992, John Major's administration turned the UK's major national museums into NDPBs (incorporated, non-departmental public bodies), which would be guaranteed one-third of their funding by the state as long as they generated a further third through ticket sales, shops and catering services and secured the final third from private sources.[14]

Essentially, British museums had to start making money. They started to woo the wealthy to sponsor galleries and exhibitions. They rented out spaces for corporate events and parties. They reinvented themselves as brands: trendy venues where visitors came to hang out in the café and peruse the gift shop as much as look at the art. Museums were becoming 'destinations', their vibe in synergy with the signature skin-deep allure of the Britart era of contemporary art.

On trips home from Italy during this period, I remember feeling dazzled when I visited museums such as the V&A, the National Gallery and Tate Modern. Italian museums took a fuddy-duddy approach to display. In Florence's Uffizi Galleries, the priceless masterpieces were stacked on top of each other in crowded, dimly lit rooms. Tiny labels offering a minimum of information hadn't been updated for decades. Basking in high-tech lighting, meanwhile, the art in the London museums was complemented by chatty, informative texts. In what were less shops than emporiums, you could buy artist-designed bags and scarves, avant-garde jewellery and the latest art books. As for the eateries, there were mounds of fancy coffees, tasty cakes and expensive salads—too pricey for less well-off visitors but so tempting, so Tripadvisor-friendly.

In 2001, the Labour government introduced a policy of free admission to the UK's national museums, in the interests of

broadening access to as many visitors as possible. While this decision closed a significant source of revenue from ticket sales for the institutions, the move was accompanied by increased public investment and was broadly supported within the cultural sector thanks to the resulting rises in footfall.[15] Far more culpable for the museums' precarious financial situation were the funding cuts announced by the Conservative–Liberal Democrat coalition government a decade later. Under Prime Minister David Cameron's austerity programme, between 2010 and 2014, the Department for Culture, Media and Sport's funding for national museums was reduced by 15 per cent, and it has continued to decline since. In 2011, 206 British arts organisations lost all of their state funding from the Arts Council overnight. Local authority funding between 2010 and 2020 was reduced by nearly a third.[16]

As public investment dried up, cultural institutions doubled down on their aims to attract more consumers and wealthy donors. Even under austerity, many of the UK's large museums and galleries underwent lavish refurbishments. In 2013, the Serpentine spent £14.5 million on a new gallery by world-famous architect Zaha Hadid. In 2016, Tate opened a £260 million new wing. In 2017, the V&A revealed a £55 million new entrance and underground gallery.

All these expansions required funding from philanthropists, whose repute is often complicated, to say the least. Tate's wing— as well as some of the V&A's project—was financed in part by Len Blavatnik. Said to have been the business partner of Viktor Vekselberg, an oligarch close to Putin, Blavatnik denies all associations with Putin and his regime.[17] He remains an active donor on Planet Art and has defended himself vigorously from allegations of misdeeds.[18] In the case of the Serpentine and the V&A, money came from Theresa and Mortimer Sackler. The Sackler family amassed its wealth as the founding owners of Purdue Pharma, a private pharmaceutical company that has pleaded

guilty to federal crimes in relation to the role it played in an epidemic of opioid addiction that has cost hundreds of thousands of lives across the US.[19] Through years of campaigning, artist and addict-in-recovery Nan Goldin has succeeded in having the Sacklers' name erased from almost all of the cultural institutions where they have funded projects, including at the V&A.

In accepting funding from corporate donors, the UK's museums and galleries allied themselves with big business. And just as in big business, workers became ripe for exploitation. Even long before Covid, little of those corporate funds ever reached staff pockets. Instead, museum leaders used their money to mount blockbuster exhibitions, buy new works and continue their policies of expansion.

In the US, cultural institutions have always been dependent on private philanthropy,[20] with 29.2 per cent of American museums' revenue found to come from wealthy benefactors in 2019.[21] In the decades before Covid, one major museum after another used this private revenue to transform itself into a megalith that multi-tasked as a shopping mall, party venue or conference centre. 'Museums went from being small, sleepy places to being tourist attractions,' observes Maida Rosenstein, director of organising for UAW Local 2110, a union representing 3,000 workers in the culture and education sectors.[22]

When so many trustees profit in their day jobs from real estate, either as developers or financiers, it's no surprise that museum boards decide to pour funds into construction, along with the gentrification that goes with it—not because they will profit directly, but because building bigger and more is simply what they do. Expansionism improves society, or so the capitalist argument goes, by creating jobs, lifting property prices, and, in the case of the museum, attracting more visitors. US institutions to have adopted these ambitious strategies include the Whitney, MoMA and the Solomon R. Guggenheim Museum.

The bolder the expansion, the more numerous the staff required. But in terms of labour remuneration, the bigger-is-better logic is only reflected in senior salaries. By the time of the pandemic, US museum directors were commanding six- and even seven-figure sums.[23] Further down the ladder, pay-scales did not match up. 'Workers are seeing the multi-million-dollar fundraising campaigns; they're seeing leadership salaries going up, yet many people are barely making it,' says Rosenstein. 'There's now a generation [of museum workers] in the big cities who can't afford to pay rent.'[24]

In May 2019, a group of US museum professionals launched an open-source Google spreadsheet inviting staff to post their salaries, job titles and institution. With over 3,000 respondents, it revealed that some museum leaders were earning eight times as much as their curatorial colleagues.[25] Workers in non-curatorial roles fared even worse. Glossy flagship museums were increasingly choosing to employ as many staff as possible on a freelance basis, a situation that was particularly common among museum educators and art handlers. Paid by the hour, usually at the minimum wage, these professionals were obliged to remain 'on call' at low wages with zero job security.[26] A visitor services worker who took home just $13.50 per hour commented, 'Hours per week varies [*sic*], so if out sick/ museum closed/ holiday/ hours randomly cut I don't get paid'.[27]

'This is my industry and it's being taken over by for-profits,' said Barbara Lenhardt to a reporter in 2014 after becoming president of the Museum Store Association, many of whose members had been outsourced to corporate company Event Network. 'We're nonprofits, mission-based. At the end of the day, to them, it's a dollar sign.'[28]

In the US, outsourcing had been widespread since the days of Ronald Reagan. In the early years of the twenty-first century, the UK's large national museums also started to outsource their

workers to private contractors. The latter were not bound by the terms and conditions provided by the original civil service contracts. As a result, workers could be paid less, put on temporary contracts and deprived of benefits such as sick pay, parental leave and pensions.[29] Among the earliest institutions to jump ship was Tate, lauded worldwide for its progressive, ground-breaking arts programming. Back in 2001, Tate Enterprises was established as a subsidiary company wholly owned by Tate that includes Tate's retail, events and catering teams.[30]

A spokesperson for Tate states that this decision to create a subsidiary meant that all profits were able 'to go directly to supporting Tate's work as a charity', whereas had they outsourced workers to a 'third-party business', this would not have been the case. Those profits helped ensure that, by the time the pandemic hit in early 2020, 70 per cent of Tate's funds were self-generated. But that position made the museum, and its workers, especially vulnerable when the doors shut overnight. Asked whether or not, should another pandemic occur, workers at the museum would still be vulnerable to sudden dismissal, the spokesperson says: 'I don't think we could speculate in that way.'[31]

Faced with cuts to government funding, through the first decades of the twenty-first century other museums would follow suit in outsourcing many of their workers to private companies, including the British Museum, the National Gallery and the Imperial War Museum.[32] In 2016, the V&A took the decision to outsource all of its new staff to its own specially created subsidiary V&A Enterprises.[33] In most cases, however, it was the worst-paid workers—security guards, porters, cleaners, shop workers—who were prey to outsourcing.

One of the most infamous examples was the British Museum's decision in 2013 to move its cleaners, porters and repair workers to the multinational outsourcing giant Carillion. Of 138 staff sent to Carillion, five years later, just sixty were being expected to do

the same amount of work. One cleaner, Rebecca Cartwright, said, 'Once Carillion took over, vacancies were unfilled, jobs disappeared, so we each covered bigger and bigger areas.'[34]

In 2018, Carillion collapsed. Outside the museum gates, the British Museum staff rallied to come back in house. The museum refused, claiming that it was 'not a viable option' on such short notice and with such 'limited resources within this small organization'[35]—even though museum trustee Ahdaf Soueif, who resigned over this and other matters, remarked that other museums had managed to rehire their workers.[36]

As the culture sector became more unequal and exploitative, workers were resisting. Through the 2010s, waves of strikes by museum workers testified to their unhappiness at the privatisation process.[37] But on Planet Art, these stories made little impact.

The year Carillion failed, *The Art Newspaper* ran a December feature entitled '2018 in Museums, big ethics questions dominate the field'.[38] It made no mention of the plight of the former British Museum workers. Instead, the article focused on the fallout from the #MeToo movement, which had obliged numerous museum employees to resign. Other stories included the pressure on museums to drop the Sackler family as donors, and Emmanuel Macron's decision to return artwork looted from Africa during the colonial period. All those stories were significant, but the absence of any mention of the Carillion fiasco epitomised the lack of interest in labour issues on Planet Art.

'Art in general has been an elitist thing for centuries,' says Clara Paillard, former president of the Public and Commercial Services Union Culture Group. She points out that today's museums did not originate as spaces of justice and equality. 'Most of them were created to house stolen artefacts, or the paintings of royalty, or those donated by rich people,' she observes. 'They were never places for the people.' While many museums have become more 'accessible to a wider number', she

continues, 'still they are not inclusive [of] people of colour and working-class people, for example.'[39]

Of course, Planet Art's corridors of power didn't hum with outrage at labour exploitation. Still mainly white, rich and middle-class, its residents were concerned with issues that they felt directly affected them, such as the risk of being accused of accepting or giving unethical donations, or having to return their 'property' to someone else.

## BLACK LIVES MATTER

The goalposts moved in 2020. With Covid having hit, the labour crisis now dominated *The Art Newspaper*'s Year in Review as thousands of culture workers lost their jobs.[40]

While the pandemic might have been enough to catapult labour rights onto the front page, it was after the police murder of African-American George Floyd that another wave of protests became impossible to ignore. In the summer of 2020, as the Black Lives Matter movement illuminated systemic racism in every sector of Western society, Planet Art's main protagonists scrambled to pledge their allegiance to the anti-racist cause. As discussed in the previous chapter, the Whitney Museum's online statement entitled 'We Stand with Black Communities' typified their rhetoric. But art institutions were on thin ice. The work held in galleries' collections was overwhelmingly by white artists, and white artists still had the majority of temporary exhibitions.[41]

The hasty messages of solidarity were met with scepticism. When Hartwig Fischer, director of the British Museum, tweeted that the museum was 'aligned with the spirit and soul of Black Lives Matter everywhere', author Stephanie Yeboah responded: 'Did our lives matter when your [*sic*] STOLE ALL OUR THINGS? If we matter that much to you, give it back.'[42]

'When George Floyd was murdered, museums became a target of community rage,' observes Maida Rosenstein. 'A lot of muse-

ums made efforts to address racism and inequality in the wake of Black Lives Matter,' she continues. 'But they often left the workers and the staff out. You can't talk about diversity, equity and inclusion and then mistreat your [Black] workers?'[43]

Not only were museum displays overwhelmingly white, but their staff, particularly at managerial level, were overwhelmingly white too. A 2018 survey by the Andrew W. Mellon Foundation found that just 16 per cent of US museum curators were non-white. Meanwhile a 2017 survey from the American Alliance of Museums found that 46 per cent of museums had 100 per cent white boards of trustees.[44] Furthermore, a disproportionate number of non-white culture workers lost their jobs during the pandemic.[45] At the Metropolitan Museum, for example, where the workforce was 43 per cent non-white, by August 2020, 48 per cent of those who had lost their jobs were people of colour.[46]

'I'm not angry,' says Carla Ford, as we speak over Zoom one afternoon in October 2022. 'But I am upset. I forgive, but I won't forget.' The only person of colour in a large department of a major British museum, Ford (not her real name) was required to undergo 'reselection'—in other words, to fight for her job—in 2020 as her museum made cuts due to Covid. Ford hated having to compete against colleagues who were also friends. 'I thought, why must I, a Black female, who works really hard, prove myself in a job I've been working for a really long time? It felt like, "here we go again!" They are trying to find reasons to push me out.' The reselection process was full of red flags, she says. 'There were racial comments.'

Although Ford managed to hold on to her job, the process left her under no illusion about the museum's hypocrisy around diversity practices. 'We are not a tick-box exercise. We are not just here to make you look good,' she says, referring to the way that people of colour have become statistics in institutions' diversity, equality and inclusion strategies. 'Museums need to educate themselves

and genuinely care about people from minority backgrounds.' She pauses, then says, 'Diversity is life! We live in a culture that is interracial. The museum should reflect that at all levels.'

When I ask Ford for her views on the surge in museum shows by Black artists and about Black culture since Black Lives Matter put diversity on the agenda, she replies: 'They are great initiatives. But don't do exhibitions like that just to attract Black people. You should do it because it's normal. You should do it from the heart.'

'I was the only Black woman in my department with a permanent job,' Ford tells me. As the Mellon Foundation report testified, that imbalance is ubiquitous in Western museums.

'Those lower-graded, less "museological" jobs are the only areas of the culture sector with good levels of diversity,' states PCS Culture Group secretary Steven Warwick. 'What you find is that the cleaning and security staff, for example, are extremely diverse with between 50 and 70 per cent Black colleagues.' Warwick notes that these same workers 'are the ones who have been outsourced', losing their job safety and security. 'If those roles were filled by white middle-class people, would the decision to make them redundant have been made? I think the answer is no.'[47]

Numerous factors contribute to racial wealth gaps in the US and the UK.[48] In Britain, white families are nine times as likely to be in the top quintile of wealth as those of Black African descent.[49] As Warwick notes, curatorial roles require 'the huge investment' of a university education.[50] 'People of colour tend to enter work earlier and find themselves confined to junior, speculative roles,' he says.

When Black candidates do have a shot at better jobs, structural racism blocks them. 'We find enormous bias in the recruitment process,' Warwick observes. He adds that disabled people fare worst in meeting the standard of 'exceeds expectations' in

culture-sector recruitment, followed by Black people, followed by women.

The racial inequality illuminated by the pandemic exposed the gap between what museums say and how they act. It fuelled demands for change from a cohort of workers and activists, many of whom used social media platforms to sidestep the official channels that had been deaf to their complaints.

For example, A Better Guggenheim is a coalition of current and former employees of the Solomon R. Guggenheim Museum in New York. An early salvo in their campaign included a letter to the museum board in June 2020. Signed by no fewer than 169 current and former Guggenheim workers, it asked the Guggenheim trustees to 'dismantle the systemic racism in our institution' and flagged up, in particular, alleged hostile treatment meted out to Black guest curator Chaédria LaBouvier.[51] The following month, the museum's chief curator, Nancy Spector, went on leave. That October, she resigned to 'pursue other curatorial endeavors and to finish her doctoral dissertation.' An independent investigation cleared the museum of treating LaBouvier adversely 'on the basis of her race'.[52] But, two months later, the Guggenheim announced a major overhaul of its diversity strategy, including guarantees that reports of discrimination would be addressed more effectively and that a new committee would examine acquisitions and exhibition programming from the point of view of diversity.[53]

Change the Museum, a group of artists, curators and art workers, offer an anonymous platform for workers across US museums to share experiences of racism. Reading through the comments and posts, many of which tell stories of acute personal trauma and abuse, is a visceral reminder that art is far from being 'above politics', as many would have us believe. In truth, it is entwined with a past and present of profound political injustice and struggle.

In 2020, Change the Museum broke the story when Gary Garrels, head curator at the San Francisco Museum of Modern Art, ended a presentation of a group of new works by artists of colour with the reassurance that the museum would 'definitely still continue to collect white artists' and, when challenged in a subsequent meeting, implied that not to do so was to be guilty of 'reverse discrimination'.[54] Garrels resigned within a week of expressing that view.[55]

These movements both illustrate and channel the anger of Black and Brown artists and culture workers for whom institutional hypocrisy has been a constant impediment to equality and change. Their wins exemplify a broader shift in staffing strategies by museums since campaigners have forced white-run institutions to tackle racism or risk ostracism. In 2022, a report by the Mellon Foundation found that in the US, the number of Black museum leaders had more than doubled since 2018. Furthermore, 40 per cent of new appointments and staff members under the age of thirty-five were people of colour. Meanwhile museum leaders put diversity, equality and inclusion at the heart of their strategy twice as often as they did in 2020.[56]

REVOLUTIONARY ROADS

'Directors of big institutions on the whole get paid 6-figures, Maria Balshaw is reported to be earning £165,000, and state regulation doesn't seem to be doing anything. Level it out: figure out an institution-wide average and pay everyone from bottom to top the same fucking thing. ... Could a whole enormous gallery be governed by collective co-operative, everyone that works there, from top to bottom, has equal amount of say in what happens; could the Tate just turn into a fucking co-op? Would it be chaos, and if yes, who cares?'[57]

These words were written by Zarina Muhammad, who, alongside her colleague Gabrielle de la Puente, makes up the duo

known as The White Pube. With over 90,000 followers on Instagram as of early 2024, The White Pube—like Change the Museum and A Better Guggenheim—are part of a generation of activists and theorists who use social media to evade mainstream structures that strangle full-throated critique. Muhammad and de la Puente are champions of intersectionality, weaving connections across disciplines, at once dreamy and fiercely grounded, fearlessly personal, ferociously political. And although they describe themselves as 'unprofessional, part-time critics,' in truth, they have become a force to be reckoned with on Planet Art.

The White Pube are neither entirely within nor entirely without the cultural ecosystem. They began as genuine outsiders, two former art students appalled at the 'boring, lifeless, overly academic, too polite' criticism written by 'middle-class white men'. Their posts are often anarchic, insightful, experimental annihilations of Planet Art's inequitable governance. Although they now partner with various institutions, and even participated in an online panel discussion at Art Basel Hong Kong in spring 2023, they also run a grant for working-class artists and provide help with funding applications. They are also the platform which broke the news of the 313 redundancies made by Tate during the first wave of the pandemic.

It's a measure of The White Pube's effectiveness as communicators, and their autonomy from Planet Art's orthodoxy, that workers at Tate chose to leak the story about the redundancies to them rather than to traditional media outlets. Including internal emails from Tate executives that raised questions about discriminatory practices, The White Pube's story highlighted how traditional arts media is failing to hold its sector to account.[58]

Muhammad's essay argues that a genuinely powerful contemporary art will be one of 'radical collectivity in politic and outcome' through the representation of 'mutual care [and] tenderness.'[59] To this end, she demands that Planet Art's 'organisational

structuring' create 'more collective working practices.' Muhammad has circled back to labour, understanding that if art workers are not freed from exploitation, art itself is not free.

Once equity has been established within Planet Art's workforce, it is more easily established within its production. It will open up the space to those who previously had no access. As Muhammad puts it: 'Maybe our ability to take a more collective and inclusive approach to programming and running an institution will become easier when everyone's got the same amount of monetary skin in the game.'[60]

## NO SYSTEM RESET—YET

The grand, systemic rethink of labour in the culture sector on which Muhammad muses is nowhere near happening. That survey by the Mellon Foundation found that, in 2022, more than 80 per cent of US museum staff in certain key roles were—still—white. Those optimistic figures for new hires only extended to Latinx, Asian and multi-racial populations. The percentage of Black museum workers remained unchanged from 2018, and had only improved by 0.11 per cent for Indigenous workers. What's more, when workplace roles were broken down, it turned out that most BIPOC employees were still in low-paid positions. They made up, for example, 47 per cent of buildings and operations staff and just 20 per cent of museum leadership and conversation staff.[61]

Even that renewed commitment to diversity, equality and inclusion by museum leaders is questionable. Of the raft of people of colour hired to senior museum positions in the wake of Black Lives Matter, many have resigned.[62] One of them was eunice bélidor, who became the first Black curator at the Montreal Museum of Fine Arts in April 2021. Interviewed after her resignation less than two years later, bélidor said: 'Institutions

don't care about Black employees' well-being. I was the Black Lives Matter hire, but Black Lives do not matter at institutions. The only thing that matters is money and power. Institutions don't want to make changes. They just want it to look like they're making changes'.[63]

Or, as the anarchist, transgender activist and lawyer Dean Spade put it, diversity hires are 'designed to quell an uprising.'[64] To Spade, most institutional diversity strategies are no more than virtue-signalling while acting to diminish the effectiveness of genuine campaigners. When professionalised, says Spade, diversity activism is in danger of becoming 'smaller, more orderly, no longer unruly.' In contrast, radical transformation can only be achieved through mass organising. In Spade's words, 'our opponents ... have the money and the guns. We can't win at that. We can only win at numbers. That's the only thing we've got.'[65]

## UNITED WE STAND

Labour matters, first and foremost because people matter. Workers deserve decent treatment as a human right. On Planet Art, you would think that was a given. This is supposed to be a world which contributes to the social good. As William Morris wrote, 'inequality of condition, whatever may have been the case in former ages of the world, has now become incompatible with the existence of a healthy art.'[66] If those who look after the art are mistreated, the art suffers too.

But labour also matters because it's the stuff of revolution. Sociologist Andrew Ross specialises in labour and the organisation of work. When I asked him about the importance of work in the social fabric, he said succinctly, 'Labour is indispensable.'[67] If you are essential to the running of an institution, then you are also powerful within it. However, you are only powerful if you act as a collective.

Collective organisation is occurring. Planet Art ignored its workers at its peril. Several years after the start of the pandemic, culture workers are unionising in numbers not seen for decades.[68]

In the US, museum workforces to have embraced unionisation include the Whitney, the Museum of Fine Arts in Boston and the Philadelphia Museum of Art.[69] In the UK, membership of two of the culture sector's main unions, PCS Culture Group and Prospect, saw significant increases from 2020 to 2022.[70] This shift maps a wider post-pandemic phenomenon of union drives that have swept through corporates including Google, Amazon and Starbucks.

The heyday of trade union membership lasted from the 1950s to the 1980s, although there was also a peak at the end of the First World War.[71] Yet even then, museums were never hubs of organised labour. This state of affairs was particularly true for the culture sector's white-collar workers such as curators and educators. Working in the arts has traditionally been seen as a privilege, an opportunity to work in a rarefied atmosphere with objects of beauty and value. Inevitably, the majority of curatorial staff were from relatively well-off backgrounds who could afford the higher education required for those positions. The notion that they might be vulnerable to systemic exploitation was foreign to them.

PCS Culture Group secretary Steven Warwick tells me that job dismissals during the pandemic led workers to see the value of trade unions again. 'We now have a core of new members,' he says. 'They were good at their jobs. They had always done well. They didn't think they needed a union. That has changed.'[72] However, as union organiser Maida Rosenstein observed earlier in this chapter, dissatisfaction was on the rise long before the pandemic. In her words, 'The pandemic drove it home that you had no control.'[73]

British trade unions have been severely criticised for racism within their structures.[74] Nevertheless, union membership in the

culture sector has also been boosted by workers protesting racial injustice and calling for decolonisation and diversity. For example, the 'retain and explain' policy adopted by Boris Johnson's Conservative government in 2021—to stop museums removing from their buildings and public spaces historic statues or other monuments that glorify perpetrators of slavery and imperialism—'triggered a surge in younger members', according to Prospect national secretary Ben Middleton. Prospect recently secured union recognition rights at the Museum of the Home in London, where museum director Sonia Solicari has admitted to feeling pressured by the government into retaining a statue of the slave trader Robert Geffrye above the museum entrance.[75]

## INSTITUTIONS V. THE WORKERS

March 2022, New York. The temperature is below zero, yet once again, protesters are massing outside the Whitney Museum. From educators, curators and archivists to custodians, front-desk workers and gallery attendants, all are staff at the museum.

While the workers shiver, chauffeur-driven limousines disgorge passengers draped in furs, jewels and designer clothes. As they make their way to the museum doors, these affluent individuals do their best to evade the demonstrators.

Three years after the Kanders furore exploded, a new edition of the Whitney Biennial is about to kick off. Those expensively dressed guests are en route to the VIP gala held every year for the museum's most generous patrons.[76]

But the Whitney workers would like the partygoers to pay them a modicum of attention. Holding banners—'Honk for Safe Working Conditions', 'Whitney Workers Want Fair Wages', 'Whitney Workers Build Biennials'—the staff are protesting about low wages and insecure contracts. They try to persuade the stylish arrivals to at least look at their flyers, which explain that

over half of the Whitney staff earn less than $20 an hour and are unentitled to benefits, despite having worked at the museum for months. It's worth noting here that Whitney director Adam Weinberg was salaried at more than $1 million in 2018, with a housing allowance on top.[77]

'Each and every one of us plays a critical role—and we just want our pay, our benefits, to reflect that,' said Lawrence Hernandez, a registration assistant at the Whitney, adding that 'there might be [packing] crates that cost more than what somebody makes [in a year]'.[78]

Low pay and job insecurity are nothing new for the Whitney staff. So why demonstrate outside the museum now? Why not in 2019, when staff were already enraged about the presence of Kanders on the board?

Behind the 2022 gala protests is the Whitney's failure not only to give workers decent contracts but also to negotiate with their new union.

Unionisation of the culture sector is the tip of an iceberg of collective labour organisation across the US and the UK. I write this paragraph the week before Christmas 2022. It's the day that English and Welsh nurses have chosen, for the first time in history, to go on strike. Next week the ambulance workers, rail workers and airport staff follow suit. These services are no longer prepared to accept dismal salaries; they are weary of being understaffed and overworked because recruitment has plummeted thanks to a combination of pitiful wages and Brexit. Health workers say that the government's failure to fund and manage the NHS properly is not only leading to their exploitation but putting patients in danger. The government is resisting. At a moment when the cost of living is prohibitive, it says that the workers are selfish to add to the national tax burden and that to raise public sector wages would increase inflation.[79]

The push-me, pull-you continues. The fabric of the country creaks and shudders. I am currently caring for my elderly father. Last night, I had to call 999 because he fell ill. There were no ambulances, I was told, but an elderly GP—exhausted yet kind—arrived after midnight with the antibiotics that brought down my father's temperature. I was so grateful, knowing that strikes are the resort of the desperate, not the greedy.

The strikes tell us that humans have limits. Push them too far and they break. Workers join unions. Down tools. Empower themselves. The Tory government squawks. The business leaders squawk. They push back. Refuse to negotiate. Work to get a pay deal down to the bone. But those tribes have never pretended to be socialists.

Museums, on the other hand, trumpet their commitment to the social good. Aside from the myriad individual socially engaged mission statements, like Weinberg's commitment to Black Lives Matter, in 2022, a new definition of a museum was released by the International Council of Museums (ICOM):

> A museum is a not-for-profit, permanent institution in the service of society that researches, collects, conserves, interprets and exhibits tangible and intangible heritage. Open to the public, accessible and inclusive, museums foster diversity and sustainability. They operate and communicate ethically, professionally and with the participation of communities, offering varied experiences for education, enjoyment, reflection and knowledge sharing.[80]

Given this guarantee of service to society as a whole, you wouldn't think that museums would resist unionisation, would you? Yet the Whitney debacle typifies cultural institutions' fierce pushback against their workers' labour campaigns.

'Very bitter,' is the phrase Steven Warwick chooses to describe PCS's negotiations with Tate over a deal for the workers dismissed in 2020.[81] (A spokesperson for Tate says that the

pandemic was a 'sad and difficult time for the whole organisa-
tion', but negotiations were 'constructive' and 'resulted in
enhanced redundancy payments, preferential re-employment
terms, an outplacement programme and redeployment where
possible.' They also mention that a reconciliation programme
between Tate Enterprises management, staff and unionists
resulted in 'cultural, structural and operational changes' after
the museum reopened.)[82]

During the pandemic, PCS also signed a recognition agree-
ment with V&A Enterprises, the subsidiary to which the V&A
now outsources all its new staff. The union, Warwick says, made
it clear that the agreement was 'a "temporary measure" to ensure
members would have representation during the [Covid-related]
restructure', on the mutual understanding that terms would be
renegotiated after pandemic restrictions had ended; but as of
early 2024, the V&A is again in talks with PCS—with no formal
agreement yet reached.[83]

Asked why, the museum replied simply that it 'regularly
engages' with unions and 'recognise[s] the value and importance
of maintaining a constructive and flexible working relationship
with open channels of communication'.[84] In other words, they
didn't answer the question.

Some museums have gone so far as to hire union-busting law
firms. The Philadelphia Museum of Art called in Morgan
Lewis,[85] whose infamous anti-union reputation was forged in
1981 when it was hired by the Reagan administration to break
the air traffic controllers' industrial action, an event that was
critical to the subsequent collapse of the US labour movement.[86]
More recently, Morgan Lewis was hired by McDonald's to smash
the workers' campaign for a $15 minimum hourly wage.[87]
Meanwhile, the firm's own top lawyers have been known to scoop
up to $1,200 an hour.[88]

The reality is that museums don't want to spend their money
on their labour force. This was evident during the pandemic

when, despite receiving government relief which could have been used to keep workers on the payroll, many museums instead used funds to acquire new artworks and hire senior staff.

At the Museum of Contemporary Art (MOCA) in Los Angeles, for example, ninety-seven part-time workers were laid off because of the Covid-enforced closures. These workers were already among the most poorly paid at the museum.[89]

As it turned out, in the same financial year that it laid off those ninety-seven workers, MOCA spent $1.1 million on new acquisitions. The museum director received annual compensation of $1.1 million, and MOCA was recruiting for a new co-director with an advertised salary of $700,000 per year excluding benefits. Meanwhile, the CWU reported, 'according to a recent pay audit, MOCA's exhibition department staff [were] among the lowest paid among all museums in Los Angeles'.[90]

MOCA rebutted these claims, saying that 'The figure of 97 cited in the report consists of part-time and temporary employees', some of whom 'were not actively working' for the museum 'at the time of the layoffs'. This spokesperson added, 'When layoffs cited by the report occurred, the PPP loan program had not yet been announced, and so MOCA had to make very difficult choices.'[91] Nevertheless, it's difficult not to perceive here the same attitude of prioritising art over people, and some people over others, as that shown by museums undertaking costly upgrades without improving pay. If these institutions can raise millions in funding for senior salaries, new wings and new art, why can't they find the money to pay their junior staff?

After years of fighting with museums for better pay and conditions for union members, Maida Rosenstein has no doubt that institutions could allocate funds differently if they so wished. 'They haven't prioritised resourcing their staff,' she says. She thinks museums could raise money to pay their staff just as they fundraise for other operating costs. 'You simply need to explain to donors

why this is important. For example, you could tell them that you want to endow positions so that the museum is staffed by people with expert knowledge, or you could emphasise the importance of diversity, equality and inclusion.' The unionist pauses, smiles, then adds that the fact that many donors and trustees are 'involved in things they shouldn't be involved in' might encourage them to become staff benefactors. 'They would probably love to say, look at my social justice bona fides,' she says.[92]

## UNIONS WORK

Despite the resistance, unionisation is achieving success for workers on Planet Art. Cultural Workers United found that during the pandemic, unionised workers in the US culture sector experienced 28 per cent fewer job cuts on average than non-unionised workers; that unionised museums specifically had smaller-than-average workforce reductions, compared to non-unionised institutions; and that even the unionised workers who did get laid off 'enjoyed contractually guaranteed recall rights ... health and safety committees to address COVID concerns, and the ability to negotiate hazard pay.'[93]

Unions were improving culture workers' rights before the pandemic. In Britain, negotiators had achieved the London Living Wage for virtually all workers in the capital's museums. During the Covid lockdowns, they won better health and safety conditions, including early closures. Job losses were also reduced and redundancy packages improved. After a fierce battle at the Victoria and Albert Museum, where around 100 jobs were cut during Covid, PCS union eventually won a much better package for those dismissed, including re-engagement guarantees, enhanced redundancy terms and an extended notice period.[94]

At the National Museums of Liverpool, recalls Clara Paillard, PCS succeeded in derailing plans to privatise workers' jobs over

the years. Via negotiations and protests, the union pushed alternative strategies involving weekend work and voluntary redundancies. That move brought in new workers, many of whom were 'younger, more diverse and more educated' than those they were replacing. Initially this new cohort came in on precarious fixed-term contracts, but after two years all were employed on a permanent basis.

'We managed to recruit 90 per cent of the new workers', says Paillard. She remembers the negotiations, which were complex but relatively benign. 'We put the right arguments and said let's negotiate solutions. Ultimately, it was positive for team spirit and union power throughout the institution.'[95]

Not all museums resist unionisation. At London's Museum of the Home, director Sonia Solicari says she 'welcomed' Prospect union's arrival. 'The conversations we have with Prospect are always really productive,' she says. 'The Prospect representative is particularly impressive. I'd want them fighting for me.'[96]

In the US too, unions are winning significant gains. After nearly three weeks of strikes in autumn 2022, workers at the Philadelphia Museum of Art won a 14 per cent raise over three years, an extra $500 for every five years of employment, and better health care and parental leave.[97]

In August 2022, a few months after the Whitney gala protests, Rosenstein wrote to me lamenting the 'painfully slow progress' with the museum. I asked the Whitney at the time if they wished to be interviewed regarding progress; they never responded. But seven months later, the Whitney too finally strikes a deal. Employee salaries would increase by an average of 30 per cent, with entry-level salaries rising by more than a third, and every employee would receive a $1,000 ratification bonus.[98]

'We're excited to have a contract that recognizes our contribution to the Museum,' says Sandy LaPorte, a facilities supervisor. 'We work out of the limelight and have sometimes felt underap-

preciated and unheard. With this contract, our jobs are protected and we have a voice at the Museum.'[99]

## THE FRAGILITY OF FREELANCING

Traditional unions are not the answer to every labour-related ill on Planet Art. Historically, unions have been user-unfriendly for the myriad art workers, including artists themselves, who are freelancers. At MoMA, union organiser Maida Rosenstein points out, none of the freelance educators were part of a union. 'And they got rid of them all.'[100]

Now, not only independent art workers but artists themselves are organising collectively. In 2008, W.A.G.E. was born. The New York-based organisation facilitates fairer economic relationships between artists and the institutions that employ them.[101] Today it offers museums and other non-profits certification for committing to baseline fees for artists. Almost 150 have already signed up. The fees are based on the size of the institution but, crucially, those with the largest operating budget (over $15 million) can't pay anyone more than a 'maximum' fee, pegged to their average employee's wage. Speaking via email to *Hyperallergic*, W.A.G.E. pointed out that if, for example, the Whitney were to join the certification programme, then the museum—whose operating budget is over $100 million—couldn't pay Jeff Koons more than $60,000 the next time they contracted him for a retrospective.[102]

The massive disparities in artist remuneration were nailed in the British report *Structurally F-cked*. Written by an artist duo who call themselves Industria, it found in 2023 that public-sector artists in the UK work for an average rate of £2.60 an hour.[103] (The legal minimum wage in 2023 was £10.42.)[104] Artists who do not come from a privileged background are either forced to do several jobs at once, or to abandon their creative practice. An

academic study of creative professionals and family wealth in the US found that there is the same barrier to those from lower-income households as in the UK.[105]

Industria say that transformation of the British sector could begin with 'greater transparency, solidarity, and joining a union-ised fight for a £15 hourly minimum wage'.[106] There are unions in the United Kingdom for visual artists—the Artists Union England, the Scottish Artists Union, and Praxis Artists' Union Northern Ireland—but their numbers pale in comparison to those of, say, musicians' and actors' unions. However, *Structurally F-cked* has helped to nourish a new focus on artists' pay;[107] so, it's possible that here too collective organisations will prove productive.

In Europe, freelance art workers are also organising. 'The campaign to raise our wages was very emotional,' Nina Paszkowski tells me on Zoom, her eyes misting a little.[108] A visual artist and part-time art educator based in Cologne, Germany, Paszkowski mobilised with her fellow art educators, all of whom are free-lance, in the years immediately preceding the pandemic. The educators, who are trained to run workshops and guided tours in the city museums, are represented by an agency which is itself an employee of the City of Cologne. In 2019, their wage was €35 an hour, with no time allowed for research or travel, nor any cancellation fee despite the frequent occurrence of last-minute cancellations. 'We were literally paid for the length of the work-shop,' recalls Paszkowski. Not only did the educators spend sev-eral unpaid hours preparing and travelling to every workshop, but they had had no pay rise for nine years.

Paszkowski and her colleagues had repeatedly raised their concerns with the agency. When no pay rise was forthcoming, they realised that it was necessary to take action on their own behalf. At first they organised openly, distributing flyers to the public which explained how their work was vital to the cultural health of the city.[109] But threats started to roll in from powerful

individuals in Cologne's culture sector implying that those educators involved in the campaign might be blacklisted from professional opportunities.

'We realised we had to be more guerilla about it,' says Paszkowski, her calm tone belying the brutal reality of a sector which obliges workers to go to such lengths for such reasonable demands. Wearing masks to disguise their identity, the group staged a demonstration outside the building where the city council was scheduled to discuss the pay and conditions of culture workers. 'Our posters reiterated that we are the face of the city. We mediate culture here,' Paszkowski tells me.

Their protest worked. 'We received wonderful responses from politicians!' Paszkowski smiles, adding that the mayor of Cologne, Henriette Reker, was among those to support them. 'Basically, the politicians all said that they were sorry that we had had no pay rise and that they didn't know how bad our working conditions were.'

The Cologne educators were awarded a pay rise of €13 an hour. Though still far from a high wage, this represented a massive increase of 37 per cent. 'It only took five months!' says Paszkowski, still astonished at how rapidly their efforts bore fruit.

The art educators' campaign in Cologne is part of a bigger picture of collective organisation by freelance artists and art workers in Germany. With 1,000 members, the Bundesverband Museumspädagogik (BVMP) is a federal association for museum educators nationwide. When the Cologne campaigners drew up their demands, they aligned themselves with the campaign for fair pay and conditions already underway with the BVMP on a national basis. (The BVMP, however, were asking for €86 per hour, double the amount conceded to Paszkowski and her fellows.)

Furthermore, traditional labour unions in Germany have recently opened their doors to self-employed workers, including

those in the art world. When the Cologne educators created their campaign for a wage rise, they did so with the active support of the labour union ver.di, which had recently started to accept freelance art workers as members.

## CULTURE + LABOUR = LEVERAGE

By February 2023, staff at the British Museum were reportedly using food banks. At half-term, the museum had to close its doors as its security and visitor services teams went on strike, in protest of the 4 per cent pay rise they had been offered at a moment when inflation was around 10 per cent.

The British Museum claimed it was bound by central government guidelines on pay. PCS union said that the museum could set its own rules.[110] Describing the situation as a 'farce', a PCS spokesman told me that:

> the government will not negotiate with us nationally on pay because they say it is a matter delegated to individual employers. Employers at delegated level claim they cannot negotiate with us because pay arrangements are set by the government centrally ... The left hand does not seem to know what the right hand is doing. Whoever is controlling the purse strings, this ridiculous situation needs to be brought to an end and our members need to be given the proper pay rise that they deserve.[111]

The museum could set new pay parameters, but it would risk punishment by its government paymasters. To do so then would be a radical gesture that could compromise the future of the museum. But that holds true only if the museum's future depends on maintaining its status as purely a vitrine, and if its notion of serving communities is circumscribed to the communities that visit it, rather than those who work for and within it.

What if our idea of the British Museum didn't look that? What would happen if the British public stood up for those

striking workers? What would happen if curators and artists stood up for museum and gallery staff, especially that small cohort of artists who sell their work for high prices? What would happen if we told the museum leaders to be brave? Dare the government to do its worst! Home to the Rosetta Stone and Parthenon Marbles, visited by over six million people a year, and a valuable national education resource, this is surely a cultural institution that would not easily be allowed to collapse.

It's telling that in the weeks leading up to and including the strike, if you Googled 'British Museum', the majority of articles focused not on the workers' dispute but on the potential return of the Parthenon Marbles to Greece, which was part of the Ottoman Empire at the time when Lord Elgin, the British Empire's ambassador to the Ottomans, removed the sculptures and, ultimately, sold them to his government. (Elgin said he had Ottoman permission to take them, but no evidence of this has survived.)[112] The lively debate spawned by the sculptures tells us that the institutional guardian of our cultural heritage (even when this heritage derives from and arguably still belongs to another country) is of crucial importance. Without the staff who keep the museum safe, open and functioning, no-one would be looking at the Marbles.

And yet, since the spike in attention in 2020, labour in the culture sector has, once more, slipped under the mainstream radar. In 2023, despite daily news reports about strikes across the UK, it was rare to hear a discussion that went beyond rehearsing government talking points to talk about genuine equity in the job market—as Britain's most famous unionist, Mick Lynch, has lamented. Most media coverage concentrates on whether or not higher wages will boost inflation, or attempts to shame the strikers with arguments that they are putting lives at risk, in the case of the NHS workers, or compromising the tourism industry and the education of Britain's youth, in the case of the museum employees.[113]

Nevertheless, the strikes continue. As we have seen, collective action effects change. It's slow, incremental, unshowy—a few pounds per hour here, the right to overtime there. It's not the stuff of headlines in a culture dazzled by objects—the Elgin Marbles, *Salvator Mundi*—fetishised to such excess that their value as 'art' or 'culture' has been lost in a swirl of fantasy around ownership and authorship.

Those successes reveal the power of mass labour movements. On Planet Art, that potency is intensified by its context. Culture can be labour's secret weapon. Its most valuable ally. Culture is powerful. We care about it. Our countries care about it. Our most powerful citizens care about it. The furore over the Parthenon Marbles proves it. The fact that a new generation of eco-activists is targeting masterpieces in museums in order to get the establishment's attention proves it. The fact that so many of the wealthy choose culture as the focus of their philanthropy proves it. Ditto the political rulers who instrumentalise art and culture for their own ends.

If art matters so much, then those who look after it and those who make it matter too. But here's the rub. If you devalue art's custodians, you devalue art too. If the woman who cleans the floor on which the Parthenon Marbles stand is forced to use a food bank because the museum exploits her labour, then the effect on me of those muscular, shining figures is diminished. As I stand there trying to hear the whisper of the lost Hellenic civilisation which believed that beauty was a conduit to God, I am deafened by the silent roar of social injustice. (I'm also deafened by the not unreasonable demand that those sculptures belong in Greece's national museum.)

Art may be a conduit to a higher goodness. What's certain is that it acts as a conduit to our own interior selves. Of course, art can take us into the shadows. Our dark side. Sometimes, as the poet Adrienne Rich said, that void is where the work of the

imagination starts. But the imagination is also a bedfellow—
uneasy, abrasive, yet fantastically fertile—of our consciences. It's
no coincidence that culture is inhabited by those who at least
purport to be on the more progressive wing of society. Yet even
the most conservative residents of Planet Art are prey to the deli-
cate, ineffable twitch of their imagination as it interacts with
their favourite works of art. That twitch is an act of empathy. Of
connection with the imagination of another. Generosity towards
that otherness lurks within it.

But if culture is exhibited in a context of injustice, it is
stunted. The viewer is plunged into a state of cognitive disso-
nance. Our imagination, our empathic processes, judder and
stumble like a faulty electric current.

In his essay *The Socialist Ideal*, William Morris meticulously
pinpoints the reciprocity between art and labour. Where work is
devoid of pleasure, says Morris, art itself is 'helpless and crippled'.
It will remain trapped until the 'direct and intimate exploitation'
of workers ceases. Socialism, unlike capitalism, which Morris
dubs Commerce, does not separate art and life. Anything manu-
factured—a cup, a steam engine—can be art. Indeed, writes
Morris, the 'expression of pleasure in the labour of production'
is itself art. In other words, Morris is making a case for treating
work as a form of art in its own right.[114]

It would be easy to write Morris off for outdated idealism. But
our epochs have much in common. In Morris' era the Industrial
Revolution had created a working class who suffered appalling
pay and conditions in factories that would make Britain's more
fortunate classes wealthy. Today, the ravages of laissez-faire capi-
talism have created a similar 'famine of inequality.'[115]

When hierarchies in the labour market are so pronounced,
when the differences between executive salaries and those at the
other end of the scale are so vast, the notion that all labour
should be a work of art in its own right seems absurd. The vision

of fools and dreamers. But art is a space for dreamers. And work is a space for change, especially for the collective organisation that is the only way of effecting systemic change.

In her book *Feminism, Interrupted: Disrupting Power*, Black feminist writer Lola Olufemi argues that art is a priori in a state of resistance to capital, misogyny and racism. 'Every time we engage our creative faculties, we are going against a logic that places work and nuclear family at the centre of our existence,' Olufemi writes. 'Art is threatening because when produced under the right conditions, it cannot be controlled.'[116] Olufemi also contributes a fine essay to *Structurally F-cked*, the report which analyses exploitation of UK artists' labour. Narrating the thought process of a creative thinker unable to afford creative work, she writes,

> She's heard some artists talk about creation as if it is sustenance—if they don't do it, if the idea does not reach its logical end, they simply won't survive. Really, she knows that she can't survive without the money from her jobs that keeps the lights on and her baby fed. She cannot afford to think of art in this way, her bank account won't allow it—and so she lets the idea run circles in her head until it is tired and fades away—she closes all the tabs, none of them are offering an amount she'd be able to survive on anyway.[117]

The extraction-driven racial capitalism that exploits the planet and dispossesses its inhabitants is the same mechanism that exploits the workers in the factories, warehouses and museums. It makes its money in the first two and launders its reputation at the board tables of the third. It is global, violent and extreme. Only global, mass resistance can combat it. If the workers on Planet Art continue to organise, challenge, protest and whistle-blow the walls of cultural institutions will crumble.

Planet Art is the soft underbelly of capitalism. It's where the wealthy and powerful come to soothe their consciences with philanthropy. It's where they want to be seen to be good. It's also

where they come to play and party. Some of the most effective protests by workers have been disrupting the VIP gala fundraisers by major museums.

The museum acts as a hinge between art and life, culture and business, compromised by its failure to be quite one or the other, yet also acting as a conduit through which activism, protest and a drive for greater equality and justice can be channelled.

Is radical social transformation possible? Can we limit global warming to 1.5°C? Could Tate pay everyone the same fucking thing? In the 2020s, as we see museum workers going hungry and the BBC forced to refute accusations of censoring a David Attenborough programme because of its 'extreme position' on climate change,[118] those visions seem unlikely.

Yet, below my desk, sparrows are pecking at the feeder in our garden. From below, a pigeon watches them as they perch on the flowerpots, each little brown bird taking its turn in the queue. The pigeon waits, hoping the sparrows will shake the feeder sufficiently to make the seeds fall to the ground. The sparrows are tiny compared to the pigeon. But they have the upper hand because the feeding contraption is made for them, and so the stronger, more powerful bird is at the mercy of the smaller ones. The impossible becomes possible. All that's required is an act of the imagination.

Imagination is Planet Art's speciality. Even when kettled within museums and galleries whose structures undermine their message, artists achieve extraordinary feats. Think of the collective Forensic Architecture whose evidence of civil rights abuses is both shown in museums yet used to prosecute human rights abuses in international courts.[119] Think of the Argentinian conceptualist Tomás Saraceno, who collaborated with scientists and environmental activists to create a hot-air balloon that has broken the world record for the longest flight by a solar-powered vehicle.[120] Or think of the countless artists, from that Hellenic

sculptor to contemporary Black figurative artist Claudette Johnson, whose renditions of the human body illuminate what we are and light the way to what we might be. As the artist Michael Rakowitz put it when he discussed his decision to pull out of the Whitney biennial, 'Demanding the impossible is something I feel an unapologetic draw towards.'[121]

I don't have a clear roadmap to an equal Planet Art. But I'm going to take a leaf from climate activist Greta Thunberg's book when she declares that even though she hasn't 'figured out yet' exactly how we can make the transition to a sustainable world, she knows 'we have to start treating the crisis like a crisis—and act even if we don't have all the solutions.'[122]

Labour on Planet Art is in crisis. The language of unhappy workers is freighted with their experience of acute suffering and trauma. This is not acceptable in any workplace. To find it in a museum speaks of a total failure of imagination, in what should be imagination's haven.

4

# BEHIND THE BILBAO EFFECT

D ARKNESS. IN FRONT, BEHIND, on all sides. Also in the pit of my belly as I realise I have no idea how to escape this nocturne-black cell.

It's April 2011. Just metres from me, a chic, diamond-sparkly crowd is chattering over a fancy dinner in the atrium of the Guggenheim Museum Bilbao. As panic creeps through my limbs, I spy a ghostly gleam ahead of me. *Hello!* The paleness resolves into a human silhouette. *Sorry, I'm lost.* The gentleman, whose name I never discovered, guides me down towards a sliver of light. Welcome to Planet Art as B-list horror movie. Or, to be more precise, *The Matter of Time*, a $20 million labyrinth of steel made by the US sculptor Richard Serra. With its undercurrent of menace humming under the official soundtrack of glamour and money, Serra's maze is an appropriately brutal embodiment of the Solomon R. Guggenheim Foundation's expansionist project.

Let me say here that I know there is always more than one narrative about works of art and their makers. In 2017, I described Richard Serra's films as 'visual haikus about what it means to be human' and lauded his 'fascinat[ion by] the business of labour', noting that he himself once worked in a steel mill.[1] Even now, I would never describe Serra as a 'bad artist'. Such monochrome judgements are empty. I would argue that he is more interesting and thoughtful than, say, Jeff Koons. And yet I also find it impossible not to be enchanted by *Puppy*, Koons' Leviathan West Highland terrier made of flowers that stands sentry outside the Guggenheim Bilbao.

Art depends on the fact that human beings are symbolic creatures, able to compare one thing to another and find the play of

difference and similarity delightful, fertile, intriguing. This is how the imagination works. This is art's lingua franca. The feelings we have when we encounter a work of art can't be 'right' or 'wrong'. You may think *Puppy* is a kitsch, saccharine inanity. You may think Serra's maze is a gripping outward expression of humanity's internal existential labyrinth. Surely the answer is that their work can be all these things and much more besides.

But for the purposes of this book, I am concerned with art as an instrument of power. Serra and Koons, with their penchant for inflated, flashy statements, are beloved of the politicians, monarchs, dealers and museum directors who wish to employ art in such a way, pursuing the idea that bigger is better.

One museum leader who embodied this impulse was Thomas Krens, director of the Solomon R. Guggenheim Foundation from 1988 to 2008, who presided over the opening of the Guggenheim Museum in Bilbao in 1997. Succeeding the Peggy Guggenheim Collection in Venice to become the New York art museum's second international outpost, the Bilbao venture was deemed by many to be a storming success.[2] Over the following decades, 'the Bilbao effect' would be touted to other cities across the world. The phrase became common parlance for the ostensible good fortune that the museum had showered on the port city in northern Spain, thanks to the visits of around 600,000 additional tourists a year.[3] In 2022, the Bilbao Guggenheim was estimated to have brought in €6.5 billion since its opening, though some economists have argued that it was less the museum that boosted the city's economy than the $4 billion public investment in urban infrastructure, the waterfront and real-estate opportunities.[4]

Whatever the reasons may be, the economic gains after the Guggenheim's arrival in Bilbao must be set in historical context. Architect Frank Gehry recollects that when he was commissioned to design the museum building (imagine a futuristic sub-

marine *sans* supporting walls for a sense of this titanium-shiny, angle-less barn), he was told, 'Mr Gehry, we need the Sydney Opera House. Our town is dying.'[5]

But why was Bilbao dying? In many ways, the modern history of the city can be read as a microcosm of the battle between capital and labour that has played out so ferociously across the globe since World War Two. Built on iron mining, steel manufacturing and the maritime businesses that swirled around the port, Bilbao was a thriving industrial city in the decades of Francoist dictatorship that followed the end of the Spanish Civil War. As demand for infrastructure boomed, migrant workers from other parts of Spain arrived in the city, many of whom were forced to live in slums. While the city and its economy grew, the people whose labour built Bilbao were not the ones who reaped the profits. In 1947, workers at the Euskalduna shipyard went on strike as part of a tide of resistance against the regime's suppression of civil rights and the industrialists' failure to share their wealth and power.

The port city continued to expand for most of the twentieth century, but by the 1990s, industrialisation was on the wane across the world. Businesses 'restructured' by paring away their staff costs yet maintaining productivity. In Bilbao, 60,000 manufacturing jobs were lost between 1975 and 1995.[6] Unions and workers resisted fiercely, but in the fifteen years from 1980, over 70,000 of Bilbao's inhabitants, who had included a substantial working-class community, moved elsewhere.[7]

In 2018, workers at Euskalduna were once again on strike. By now, it was no longer a shipyard but, guess what—a cultural centre!

The Euskalduna auditorium is run by the Bizkaia regional government, which, just like its UK and US counterparts, has outsourced some staff to an international company. The result, say the staff, has been poor wages, unpredictable working times, a failure to pay overtime and no pay rise for years.[8]

The Euskalduna strikers are not alone. The Guggenheim Bilbao has also faced resistance from its workers. In 2016, educators there embarked on a protracted strike. In 2021, the cleaners downed tools for nine months to demand that their employers—Ferrovial, another private contractor—close the gender pay gap by upping their wages in line with male colleagues; improving working conditions, including an end to part-time contracts; and modifying unpredictable, exhausting work timetables. Working through the Spanish union ELA, they achieved most of their aims.[9] However, a staff spokesperson claimed that the Guggenheim had 'wanted to disassociate itself completely from the protest ... At first we had two meetings with them, but ... they said that our problem was with the subcontractor'.[10] (The Guggenheim Bilbao has been approached for comment, but did not respond by the time of press.)

To see cultural development per se as a saviour for cities in economic decline is to erase the experience of those for whom it becomes just another mechanism of labour exploitation. One of capitalism's most insidious tricks is this eradication of those realities. Like the rabbit out of the hat, the investor or developer appears as if by magic as the only possible solution to social deprivation, and demands our applause.

Back in the 1990s, when the Guggenheim decided to go global, the prevailing neoliberal wisdom taught that economic growth was an unequivocally good thing. The money, said those who were making it, would trickle down to the less well-off because their investments would create jobs, and employment creates opportunity. At the time environmentalists were in a minority, written off as misguided Jeremiahs by the establishment. Thus, there was little mainstream discussion about the vast ecological damage triggered by economic growth and the concomitant energy costs brought about by the development of real estate, transport links and international tourism.

But the workers' strikes suggest that, even in Bilbao, the new museum wasn't necessarily advantageous for everyone. From its inception, naysayers baptised it the McGuggenheim, fearing that this US cultural megabrand could eclipse the city's local arts scene in the same way that the global burger chain stifles independent eateries.[11] Meanwhile, the structural engineers, landscape architects and construction workers who actually created Gehry's iconic building, with its sinuous metallic skin and aerodynamic curves, were erased from the museum's self-narrative, just like the labour that had built up the city under Franco. This point was made by architectural historian Mabel O. Wilson, who perused the museum's promotional materials.[12] Gehry himself said that when he visited the museum a month before it opened, his first thought was, 'What the fuck have I done to these people?'[13]

And yet the narrative of post-industrial urban development is so ubiquitous that media coverage of 'the Bilbao effect' is almost always entirely positive. Rarely is it mentioned that, arguably, the Guggenheim has also been guilty of depriving Bilbao of revenue. In 2009, the museum's financial director, Roberto Cearsolo Barrenetxea, was found guilty of defrauding the institution of more than $750,000.[14] Meanwhile the museum itself allegedly wasted around €7 million through 'a misjudged currency deal' when it purchased Richard Serra's $20 million maze.[15] The museum director, Juan Ignacio Vidarte, refuted this criticism, saying the prices had been based on market valuation and that the works had accrued value since; and claimed the museum was 'in perfect shape financially', saying that Cearsolo had paid back 80 per cent of the money he had embezzled. Behind the controversy over financial management, Vidarte continued, were Basque politics. His view was that, with regional elections coming up, opposition parties were gunning for the museum—considered a triumph for the government—in order to damage the latter's reputation, and 'looking for excuses for

the government to take greater control over management', as the museum was the only one in the Basque region to benefit from private as well as public finance.[16]

Whatever the truth, the fact that seven-figure sums are floating around for scary sculptures, flowery dogs and splashy blue paintings—however glorious those works might be—while museum cleaners are begging for a living wage suggests that something is rotten in the state of Planet Art, in Bilbao and beyond.

## THE ISLAND OF HAPPINESS

'I spent a few days flying around in a helicopter around the site, and I got a meeting with the Crown Prince ... [who said] "What would you do?" And so I did a drawing on a napkin at a hotel where we met. I said, "Here's the Guggenheim, here's the Louvre, here's the maritime museum, here's the national museum, here's the opera house." ... He took the drawing and said, "Okay, that's what we'll do."'[17]

This is how Thomas Krens, then director of the Guggenheim Foundation, remembers the birth of the arts hub on Saadiyat Island in Abu Dhabi. A natural island in the capital of the United Arab Emirates, Saadiyat, which means 'happiness', was being developed to serve as both sumptuous real-estate venture and cultural lodestone. To this end, world-class arts institutions were to be embedded in the island's infrastructure of luxury hotels, villas, beaches, restaurants and residential developments. Several of those institutions were to be outposts of Western museums and galleries, including the Louvre in Paris and the Guggenheim in New York. Meanwhile, the British Museum in London signed up to assist with the development of a national museum for Abu Dhabi.[18] A new Abu Dhabi branch of New York University (NYUAD) also opened on Saadiyat.

There were benefits to this plan for both sides of the partnership. For the UAE, museums like the Louvre and the

Guggenheim would bring a readymade cultural model to a country that had become ambitious to compete on the global socio-economic stage since the discovery of oil in the mid-twentieth century had kickstarted the transformation of its infrastructure. For the museums, there were financial advantages. The Louvre, which comes under the authority of the French Ministry of Culture, signed a deal in 2007 for $525 million to permit Abu Dhabi to use the French institution's name for thirty years; a further $750 million was agreed for management, consultancy and the loan of works from the Louvre's permanent collection.[19] In 2021, it was announced that France would receive a further $186 million to extend the deal for another decade until 2047.[20] The Guggenheim deal, meanwhile, is reported to have cost $800 million.[21]

But the museums' enthusiasm for opening branches in the UAE was about more than making money. As we have seen, the urge to create new, grand outposts of established institutions is part and parcel of their growth strategy, regardless of whether they are for-profit enterprises themselves. If an institution's trustees and donors spend their day jobs in banks or businesses that pursue an expansionist tendency, that's the approach they will take even when steering a non-profit entity.

Requiring an investment of $27 billion, Saadiyat Island was clearly a vast project.[22] But its birth has not been a particularly felicitous experience. Those who led it have found themselves in the eye of an international storm of criticism centred on the exploitation of migrant workers.

'Sometimes I feel I have no life,' says Shofi. 'From morning to evening, I am drenched in sweat. I see my mother in my dreams. Wake up in the middle of the night and cry.'[23] Shofi is very young, little more than twenty, and the apple of his mum's eye. 'She tells me to come home, we don't want the money.' He starts to cry. 'But I have to be here.'

Shofi is one of around 30 million migrant workers in the Arab Gulf.[24] He is speaking in a documentary called *Champ of the Camp*. Around him other men are hammering and cutting planks of wood. They are so fast, so skilled, even as waves of wood shavings billow into their faces, even as the hammerhead falls millimetres from their knuckles then flies up perilously close to their cheeks. They have no safety gear—no helmets, no gloves, only cloths wrapped around their noses to shield them from the dust clouds. The planks mutate into palettes, which are stacked with deft efficiency. Although leafy trees on the far side of the compound hint at shade, the vaporous light leaves you in no doubt of the crippling heat.

As someone who grew up in Bangladesh, Shofi is used to hot weather. He's used to hard work too. 'They told me I was a good worker, I should go to Dubai because I would earn twice as much,' he remembers. Shofi's parents sold their only plot of land to provide for him and his younger brothers. 'After that, I came here,' he murmurs.

In Dubai, Shofi may indeed be earning twice what he would make in his birth country, yet the average salary for migrant workers in the UAE's construction sector is only around $200 a month.[25] Furthermore, before Shofi can send any money home to his family, he must first pay his creditor. The employment agencies who recruit workers to go abroad charge a fee. Shofi paid $2,340.

As many as 10,000 migrant workers die in the Gulf every year.[26] They are employed under a system known as *kafala*, in use across the region to facilitate cheap, mass labour in countries with a high demand for new infrastructure—hotels, hospitals, factories, schools and, yes, museums. *Kafala*, which translates as 'sponsorship', excludes from the host countries' labour laws all migrant workers, most of whom come from South and Southeast Asia, and gives their employers total authority over their lives. With no legal protection, and certainly no unions, migrant work-

ers are condemned to atrocious pay, crowded and dangerous living and working conditions and total job insecurity: should they leave their post without their employer's permission, they risk imprisonment or deportation.

'It's entirely appropriate to talk about *kafala* in terms of slavery,' comments Nick McGeehan, spokesperson for international NGO FairSquare, which has campaigned against the system for years.[27] These undertones even appear in the language of recruitment; agencies competing for contracts in the Gulf advertise their workers as especially 'heat-resistant' and blessed with 'strength and stamina'.[28]

The seeds of *kafala* were sown in the early twentieth century when Gulf states required foreign workers for their pearl industry. With the discovery of oil in the mid-twentieth century, the system bedded in deeper. But only in 2011 did the lives of people like Shofi shimmer into view on Planet Art. In March that year, more than 130 artists, writers and curators released their pledge to boycott the Guggenheim Abu Dhabi until the museum and its Abu Dhabi partner, the Abu Dhabi Tourism and Development Investment Company (TDIC), took 'meaningful steps to safeguard the rights of the workers' building the new museum.[29]

The artists' objections had a back story. In 2010, after pressure from labour rights activists, the TDIC had made a guarantee to ensure improved labour standards, including 'safe working conditions', prompt monthly payment and no passport retention, for workers at the Guggenheim construction site. The Guggenheim Foundation had subsequently also issued a statement committing to those values.[30] However, as the campaigners pointed out, so far there had been no independent monitor overseeing these improvements, nor any method for enforcing them.[31]

I remember the adrenaline rush when I read of the Guggenheim boycott. 'Those working with bricks and mortar deserve the same kind of respect as those working with cameras and brushes,' said artist Walid Raad in a press statement.[32] Raad

and his peers, who titled themselves the Gulf Labor Coalition, had thrown down a gauntlet, marking the beginning of what would become a decade-long campaign.

Through a series of coordinated actions around the world, Gulf Labor shone a spotlight on the people who build and sustain Planet Art until its residents could no longer turn a blind eye to their exploitation and suffering. Little wonder that the group achieved this feat with verve. Many of them were artists. Making people look is what they do.

In 2014, a torrent of fake dollar bills rained down on the spiralled rotunda of the Guggenheim Museum in New York. Designed by Gulf Labor activist and artist Noah Fischer, the bills bore legends such as, 'What does an ethical global museum look like?' Meanwhile a pamphlet was distributed to the museum's hundreds of visitors with questions including, 'who is building guggenheim abu dhabi? ... who is visible in the arts and who is completely invisible?'[33]

A year later, in May 2015, activists occupied the Venetian outpost of the Guggenheim. For three hours, around forty protesters hoisted signs and flags. A banner stretching along the facade of the palace on the Grand Canal bore the words 'Meet Workers' Demands'. The protest was timed to coincide with the opening days of the Venice Biennale and focused on the plights of not only the workers building the Abu Dhabi museum but also those on other museums' construction sites at Saadiyat Island and those at Guggenheim museums elsewhere in the world, including the low-paid and precarious workers who comprised the bulk of the Biennale's workforce. The museum responded to the action by closing its doors to the public.[34]

## THE DISTANCE BETWEEN US

As I write this chapter in London in 2023, the cost of living in the UK is sky-high and the need for food banks has soared.[35]

The right to protest is being decimated by the British government; videos circulate on my newsfeed of activists being arrested during peaceful climate change demonstrations.[36] The year has been marked by strikes across sectors including health, education, transport and culture, and by new legislation from Rishi Sunak's government to curtail public-sector strikes in the name of public services, a more vigorous move towards outlawing industrial action than we have seen for decades.[37] This followed a high court ruling in April that a planned strike by nurses was illegal, after Health Secretary Steve Barclay took their union to court.[38]

If the labour abuses in European and American museums outlined in the last chapter are insufficient, the above snapshot should illustrate that the suppression of democratic rights is not confined to the Global South. And so, in telling the story of the Gulf Labor Coalition's campaign to improve workers' rights in the United Arab Emirates, I refute any notion of Western superiority or the nonsensical idea that neoliberal values are going to teach other regions how to be more ethical.

In fact, the drive by British and American politicians and business leaders to bust unions and pare workers' rights to the bone at home lays bare exactly where their interests lie abroad as well. To put it another way, Europe and the US actively benefit from and are complicit in the Gulf's contempt for labour laws. The budgets drawn up by Western museums to set up shop in Abu Dhabi were by definition predicated on the availability of cheap labour there. According to *The Observer*, 'At the outset the Louvre, Guggenheim and New York University paused before agreeing to become involved ... fearing the Gulf's reputation for harsh working conditions would cause uproar'.[39] However, Gulf Labor member and New York University social analysis professor Andrew Ross recalls that when NYU, the Louvre and the Guggenheim first announced their Emirati projects, Human Rights Watch wrote a letter to all three requesting evidence that

they were securing improvements for workers. According to him, none of the institutions replied.[40]

Although there are strong reasons to argue that the *kafala* system is modern slavery, framing it as such can risk feeding Western fantasies of the uncivil East. In their essay 'Gulf Dreams: Migrant Workers and New Political Futures', Paula Chakravarrty and Nitasha Dhillon argue instead that *kafala* is 'a modern, and especially lucrative, visa-trading system' that is part and parcel of a global neoliberal economic system which serves elites in the Gulf, South Asia and the wider world, including the US and Europe.[41] By outsourcing the recruitment of labour to middlemen in their home country, the Gulf construction firms perform a similar operation to that of the Western museums who outsource workers, particularly their lowest paid, to private contractors, as outlined in the previous chapter. Both cases illustrate the constant deferral of responsibility for employees. Whether in the Emirates or in Europe, the museums themselves claim they can't ensure decent rights for workers because it is the responsibility of someone else.

In 2013, for example, an investigation by the *Observer* found that workers on Saadiyat were destitute, housed in severely overcrowded rooms and deported for daring to strike. The reporters spoke to one man building the Louvre's spectacular edifice who said he had arrived on the island to find that he would have to work for almost a year just to obtain his wages to repay his recruitment agency fees.[42] That May, the UAE saw a strike by thousands of workers at Arabtec, then the country's biggest construction company and subcontracted to build the Louvre.[43] Hundreds were subsequently deported. When questioned by the *Observer* about workers' conditions, the Louvre and the Guggenheim spoke of their engagement in 'constructive and continuing dialogue with the TDIC'—Abu Dhabi's Tourism Development and Investment Company.[44]

As these strikes illustrate, the Gulf's migrant workers do not passively wait for foreign saviours. They regularly mount resis-

tance to their exploitation despite punitive consequences. Further strikes were staged that year, including a strike by 4,000 workers at BK Gulf, the largest subcontractor on the NYU's Abu Dhabi project, around wage- and conditions-related grievances.[45] The previous year, 145 workers employed by Al Reyami, also subcontracted to build the NYUAD, went on strike over pay and alleged mistreatment. Although the four workers chosen to lead negotiations with Al Reyami were all dismissed,[46] workers later interviewed by Nardello, a US firm employed by the Abu Dhabi authorities to investigate the allegations of labour rights abuses during the construction of the NYU campus, said the strike ultimately benefited them.[47]

The inextricability of Western and Gulf business interests is exemplified by the fact that some of the firms in the Gulf, including those accused of abusing workers, are based in North America or Europe. Until 2017, BK Gulf was a joint venture between UK-based multi-national construction group Balfour Beatty and Dubai-based Dutco.[48] Meanwhile Carillion, the British multi-national firm to whom the British Museum's porters and cleaners were outsourced with such unhappy results, had its own affiliate in the UAE: Al Futtaim Carillion. A key player on Saadiyat, AF Carillion was a leading contractor for the NYUAD main campus,[49] and placed a bid on the Guggenheim Abu Dhabi project.[50] The Nardello report alleges various abuses by companies subcontracted by AF Carillion, and which Carillion was supposed to be monitoring, including the withholding of wages, the extraction of signatures from workers falsely attesting that they had received their full wages, and the retention of passports.[51]

THE PRICE OF SUCCESS

Did Gulf Labor succeed? Certainly the Guggenheim hasn't. At the time of writing in early 2024, the museum in Abu Dhabi remains

unbuilt, its opening most recently postponed to 2025, more than ten years after it was originally supposed to welcome guests.[52]

Andrew Ross has no doubt that the activists' campaign has been responsible for slowing, if not stopping, the Guggenheim's Gulf plans. While admitting there were 'economic factors' that also hampered the new project, he tells me that 'We take full credit for that delay.'[53]

The Guggenheim Foundation doesn't acknowledge that the labour campaigns have impeded the museum. Instead a spokesperson put the delay down to the 'significant amount of planning and coordination ... required on an ongoing basis for a district [as] large and complex' as Saadiyat Island, which they described as 'an unparalleled centre for arts and culture'.[54]

I asked the museum what assurances it could give that the Guggenheim's construction workers will have safe conditions and fair wages, and be exempt from the *kafala* system, which continues to operate in the UAE and makes workers dependent on their employer for their legal status in the country. This is the response I received:

> We are committed to ensuring fair and equitable labour standards in the construction of the museum with a strong track record of working with our partners to safeguard the wellbeing, safety, and health of all workers onsite, which is our top priority.

> The conditions for all workers of contractors, sub-contractors, and their sub-contractors on the Guggenheim Abu Dhabi site are monitored by an independent auditor to ensure compliance with UAE Labour Law and the conventions of the International Labour Organization adopted by the UAE.

> PwC, the independent auditor, has issued a positive report which is published annually with updates quarterly with zero lost time injuries to date.[55]

When I asked to see the report itself, the Guggenheim Foundation said that DCT, Abu Dhabi's Department of Culture and Tourism,

refused to share it. However, the Foundation did share an extract which stated that the DCT is 'committed to ensuring fair and equitable labour standards in the construction of the museum', and to a 'sustained culture of health, safety and welfare across the Guggenheim Abu Dhabi project'. As evidence of these commitments, the report cited '9 million manhours safely achieved without any LTI (Lost Time Injury).' Furthermore, it claimed that DCT had 'adopted standards and best practices beyond the already stringent requirements of the UAE regulations.' For example, UAE regulations require shaded rest areas but the DCT's contractor provides air-conditioned spaces for rest. The UAE requires cool water to made available to workers; the DCT contractor provides individual water bottles. The UAE requires HSE training to be provided periodically while the DCT contractor requires training "pertinent to all stages of work."[56] The statement also said that random and formal checks are made of the labour camps and the building site, and that concerns or grievances 'if any' are 'promptly addressed and rectified.'

Yet when I shared this statement with Nick McGeehan of FairSquare, he responded:

Any system that outsources the protection of workers to a highly-remunerated client of the party doing the construction, and where there is no meaningful accountability mechanism or truly independent oversight of living and working conditions, is not going to effectively protect workers.

Time and time again, whether on previous construction on Saadiyat Island or in the construction of Qatar's 2022 World Cup or Dubai's EXPO, research has demonstrated that it's not possible for high-profile projects like this to use extra-legal codes of conduct to insulate themselves from the abuses that are rampant in the wider construction sector. The true purpose of these pockets of labour protection is to salve the consciences of nominally liberal institutions like the Guggenheim, while avoiding making any structural changes to a deeply abusive and exploitative labour system.[57]

McGeehan also drew attention to the 'woefully deficient' nature of UAE law in terms of protecting workers from the heat. 'The measures they have outlined in the email to you, if not supplemented by clear work to rest ratios commensurate with the risk at any time from heat and humidity, will not mitigate the risks to workers from the combination of the environmental heat and the nature of the work they are doing.'

Beyond McGeehan's reservations, what this new statement from the Guggenheim illustrates is the low bar at which labour conditions are set. You might think that cool resting conditions, plenty of water, and health and safety training in dangerous workplaces are clearly basic human rights, especially in countries subject to extreme heat—they would not merit a bullet-pointed statement showing how well you treat your workers.

What does it mean when our notion of fair treatment of our fellow humans has withered to the point that we celebrate their right to water on a hot day? The cool tenor of such monitor reports, which is echoed in the investigation by Nardello into conditions on the NYU campus, maps the detachment intrinsic to capitalism. This is a system which encourages the elite to regard the humans who create their wealth as commodities, designed to trade their labour at the lowest rate possible. In his book *Less Is More: How Degrowth Will Save the World*, Jason Hickel writes that the 'core principle of capitalism ... is that the world is not really alive, and it is certainly not our kin, but rather just stuff to be extracted and discarded—and that includes most of the human beings living here too ... capitalism has set us at war with life itself.'[58]

When the Guggenheim Foundation announced their plans to press ahead once more with their Abu Dhabi construction in 2021, most media articles did little more than brush the surface of the story of the migrant workers, even in the visual arts press. Oppressive power systems wager on the likelihood that news

cycles move on. Since Gulf Labor ceased their theatrical activism around the issue, arts journalists have lacked an obvious peg for articles. The recent lack of interest in UAE migrant labour illustrates that while art, when employed as a tool of activism, is enormously powerful, labour quickly becomes invisible without these visual champions.

At least the Guggenheim Foundation has tried to engage with both activists and journalists on the issue of labour rights. As the uproar swirled around labour exploitation in the Gulf, the Louvre kept shtum. FairSquare's Nick McGeehan remembers meeting with representatives of both the Louvre and the Guggenheim museums 'numerous times' to discuss labour conditions on Saadiyat. But he says the French Ministry of Culture—to which the Louvre reports, and which finances approximately 40 per cent of its budget[59]—'just didn't care.' Although the ministry 'professed to be committed to the issues we raised with them,' McGeehan says, 'their tone and attitude were openly dismissive of what we were saying.'[60] (The French Ministry of Culture has been approached for comment, but did not respond by the time of press.)

Silence has proved golden. The Louvre Abu Dhabi opened in 2017 to reviews lauding its architecture and exhibition-making. The migrant workers did get mentions. A couple of Swiss journalists trying to investigate the camps were arrested.[61] But by 2019, it announced, it had become the most visited museum in the Arab world, having welcomed over two million people since its inauguration.[62]

So, has the situation improved for migrant workers building Saadiyat Island? It's complicated. Conditions in the 'showpiece' living facilities of the Saadiyat Accommodation Village, a labour camp built for the workers according to International Labour Organisation standards, have been found to be acceptable.[63] The private organisations setting up on Saadiyat signed up to new

labour standards, including the refunding of recruitment fees.[64] That the UAE regime agreed to any kind of independent monitoring, however flawed, proves that even the richest, most powerful entities have to concede ground when faced with sufficient challenge. Andrew Ross writes: 'the campaign has even led the UAE grudgingly to adopt some legislative reforms, including electronic payment of wages, changes to the sponsorship system that allow workers to switch jobs under limited circumstances, and greater supervision of work conditions by a vastly expanded pool of government inspectors.'[65]

Nevertheless, the gains have been insufficient. The Nardello report found that 'approximately one third of the workforce' building the NYUAD campus 'was exempted from coverage by the enhanced standards' adopted by NYU and its government partners on fair wages, living conditions, and debt reimbursement, 'and that NYU and other parties were not aware of what became a *de facto* exemption policy.'[66] As for the guarantee of no 'retaliation [against] efforts to resolve work disputes', the report pointed out that, however much NYU might support the right to strike, 'Under then-prevailing and current UAE law, striking is illegal, [and] employers ... are required to notify the authorities of a strike.'

Meanwhile, the SAV's model facilities haven't mitigated residents' complaints of poor wages, terrible food and the sensation of being 'trapped in the desert'.[67] After visiting, a team from Gulf Labor 'were impressed by some aspects ... but concluded that the social isolation and high-security nature of the facility is not a good model to be followed in the UAE in general,' concluded Andrew Ross.[68] And, according to him, outside the heavily surveilled environments of SAV, Gulf Labor campaigners spoke to workers who 'offered ample testimony about violations of the TDIC and NYUAD labor values, including wage theft, substandard housing, confiscated passports, compulsory overtime, and harsh punishments for any expression of grievances.'[69]

The UAE has resorted to strong-arm tactics too. Journalists, activists and human rights workers who exposed the labour scandal have been arrested, denied entry to the country and deported.[70] 'We were stopped from going there,' recalls Ross when I ask if he has been able to verify the situation for migrant workers in recent years.[71] He himself was prevented from boarding a flight to Abu Dhabi in March 2015.[72]

Sara Ahmed, a British professor who resigned from Goldsmiths, University of London over British academia's alleged failure to address sexual harassment,[73] once said: 'It is a fundamentally life-affirming task to build institutions that are not dependent on the diminishment of the life-capacities of others.'[74] As well as building life-affirming institutions, you can also choose *not* to build the institutions that contribute to that diminishment. In saying no in solidarity with their fellow workers across the world, the artists boycotting the Saadiyat museums resisted in a way that was at once powerful yet straightforward. Their campaign would inspire similar resistance in a country that prided itself on its social democratic traditions: Finland.

## NEXT, WE TAKE HELSINKI (NOT)

As we accelerate ourselves towards climate apocalypse, the growth merchants are being challenged. For this and many other reasons, when the Guggenheim launched a proposal in 2011 to set up a museum in the capital of Finland, a cohort of critics had other ideas. The alternative to failed industrialisation did not have to be a glitzy, carbon-heavy, foreign cultural coup. It could be lighter, fleeter, more flexible, more local, more imaginative.

The writer James Baldwin once said, 'Art would not be important if life were not important, and life is important.'[75] Illustrating his words, the people of Finland chose an art that would nourish life as they wanted it—local over global, intimate over grandiose,

humane over humungous. In 2016, having already turned down an initial proposal four years earlier, Helsinki City Council definitively rejected the Guggenheim's offer to open a branch of the museum in the city.

The ghosts of migrant labourers in the Gulf—people like Shofi—are threaded through the fabric of that renunciation, which showed workers across the world, and their opportunities and oppressions, to be as tightly entwined as ever. The strength of these connections was best illustrated by a statement released by the Building and Wood Workers' International (BWI), an international federation of some 350 trade unions including the Finnish construction union Rakennusliitto, expressing 'deep concerns' about the Guggenheim's project in Helsinki. In a concise and powerful show of solidarity, BWI cited as the basis for their concerns 'the working and living conditions of migrant construction workers who will build the Guggenheim Abu Dhabi museum'.[76] They alleged that the Guggenheim Foundation had 'refused to have any future discussions with the BWI and other international organizations that have called on the Guggenheim to be better than the Louvre' with respect to the labourers on Saadiyat Island, concluding with a demand that the Foundation guard the welfare of all workers involved 'in the construction of all of its facilities whether it is in Finland or in the U.A.E.'

The BWI's objections were just the tip of an iceberg of concerns. According to the Helsinki City Council, these included 'excessive cost for the Finnish tax payer; inadequate private funding; and the proposed site' on the capital's South Harbour waterfront, a location 'considered too valuable for the project'.[77]

In the Guggenheim's initial proposal from 2011, the estimated cost of the Helsinki project was €140 million.[78] 'We were quite interested and excited by what we saw here—a population that is highly educated, which is very important for the success of the museum and for potential audience development,' commented

Ari Wiseman, the Guggenheim's deputy director, in January 2012.[79] The fee to the museum also sounded exciting: Helsinki's licence to use the Guggenheim's name and network would cost $20 million.[80]

By May 2012, the Guggenheim's first proposal had been voted down by the Helsinki City Council; media reporting on this defeat highlighted the city's debt crisis and the weakness of the Finnish economy, while the Finnish culture minister commented, 'It is also worth considering whether Finnish taxpayers should finance a rich, multinational foundation in the first place.'[81] The Americans didn't give up. In early 2014, the council approved the US museum's plans to hold an architectural competition to design the new building in the hope of winning support. By December that year, six firms were on the shortlist.[82]

By now, it was clear that Helsinki's residents were divided at the prospect of this cultural interloper. The first defeat in 2012 had been led by a coalition of green politicians, artists and art workers. Before the vote more than a hundred artists had presented the mayor with an alternative proposal, entitled Checkpoint Helsinki.[83]

Two years later, as plans for the international competition were announced, the opposition gathered steam. A trio of organisations—Checkpoint Helsinki, a Gulf Labor offshoot called G.U.L.F. (Global Ultra Luxury Faction) and the New York-based urban research NGO Terreform—united to launch their own competition. Entitled Next Helsinki, it called for design proposals that would offer an alternative to what the coalition described as 'blockbuster design' in 'the ultra-luxury marketplace of the art world'.[84] In their book *The Helsinki Effect*, the organisers outline local objections to the Helsinki Guggenheim, including 'distaste at the prospect of the imperial descent' of the Guggenheim brand; 'anxiety about the vagueness of the proposal itself; wounded local pride at the need for such an attraction to "revivify" an already great and singular city; horror at the giveaway of the superb location to a private entity and outrage at the

enormous subsidy (upwards of €130 million) requested by the Guggenheim and its advocates'.[85]

The language of this paragraph is striking. Though precise, it is full of emotion: people feel 'wounded', 'horror', 'outrage'. The Helsinki coalition were able to marry their professional skills as architects, urban planners, artists, academics and environmental scientists with their humanity. Their arguments hum with an authenticity missing in most of the dry, corporate rhetoric produced by the Guggenheim and its allies.

Once again, the campaign for migrant workers' rights in Abu Dhabi also fed directly into Finnish resistance to the Guggenheim. A key inspiration for the Next Helsinki competition was a spoof competition launched earlier by G.U.L.F. calling for proposals for the Guggenheim Abu Dhabi. On a website for the fictitious Global Guggenheim Foundation, G.U.L.F. asked for submissions for the Emirati museum based on 'principles of sustainability, accountability, and social justice'. Borrowing much from the real Guggenheim Museum's own website, the stunt included the redirection of ticket buyers to the website of Occupy Museums.[86]

G.U.L.F.'s competition was essentially an artistic performance designed to grab media headlines and draw attention to the cause. The Finnish spinoff, however, was real. Within six months of the announcement in September 2014, Next Helsinki had received over 200 commissions. Those proposals were whittled down to a shortlist of eight, with thirty commendations for 'special recognition'. There was no winner—the point of the callout was to show how creative minds could rapidly come up with nourishing, humane, sustainable possibilities for a particular city's culture when encouraged to do so.

NOTHING TO LOSE

Recently my yoga teacher asked us to practise in the space between cynicism and magic, the former being a scepticism that

allows for productive critical judgement and the latter a leap of blind faith, which is a belief, if you like, in miracles—the province of the imagination. The fantasy museums created for Next Helsinki are born from this dialectic between matter and spirit, the one so often heavy and unsatisfactory, damaged and/or damaging, and the other radically weightless, unbound, the engine of angels' wings, impossible feats, and, on good days, an artist's inner eye.

Few of the project submissions received by Next Helsinki are proposals for museums at all. Most wrest art from any man-made cage and set it loose in the big, wide world. One of my favourites is *The Muzooem*, by Tomáš Boroš in collaboration with Juraj Koban, which imagines art as a wild animal that needs to be returned to its natural habitat where it can roam at liberty. 'It should be set free among people,' writes Boroš, before asking: 'What would it be like if we did not have to go out to look at art but if art came into our lives?' Strikingly, Boroš admits this strategy 'would be dangerous but dangerous for both sides equally.'[87]

In other words, if art and humanity were to genuinely interact, there would be a risk to both. Things might get broken. But they also might be born. I'm again reminded of Lola Olufemi's observation: art is threatening because it cannot be controlled.[88] Here is a concept of art as genuine force—potent, possibly hazardous, certainly disruptive. At a moment when we need to change so much so fast, and when so few of the powerful appear to be committed to the transformation, doesn't that sound attractive? Wouldn't you like to walk through Boroš' forest, perhaps see a *Rabbit*, no longer steel and static, who has escaped his cage? The song of a Lynette Yiadom-Boakye as she soars above the trees? Perhaps the next time the banker-cum-philanthropist visits his penthouse, he may be startled by a strange crackle in his elevator. It may look like a painting, or a photograph, or a video. It may be invisible. Inaudible. He certainly hasn't bought it at auction or in an art fair. He can't control it at all.

During lockdown, when all museums and galleries closed, like so many people I spent as much time as possible in the city parks. To my surprise, I didn't miss those indoor art spaces. Nature offered so much. The birdsong! The green leaves! That scrubbed blue sky. What if we treated our forests as sensitively as we treat our art? What if we fetishised art less and celebrated nature more?

Another of the Next Helsinki anti-museums caught my eye. Entitled *A Baltic Tale of Nothingness*, this proposal was dreamt up by architects Constantinos Marcou and Costas Nicolaou, with support from their collaborator Stavros Marcou. The squad imagine a ship's captain who sails his vessel around the Baltic Sea for a year gathering objects from various museums. Docking for only seven days a year, the ship exhibits its artefacts in the ports where it anchors, generating, in the words of the creators, 'a public space, a festival, a poetic gesture'. The ship 'opens up a window of opportunities not only socially and politically but nevertheless spatially expanding itself within the city and most importantly within the port.'[89]

The architects evoke a Calvino-esque notion of an ambiguous, transient space, simultaneously of the ocean and the city, defined yet limitless, serving our human need for visual objects out of which we might evoke past, present and future possibilities. Here is a home for art that has no need to steal its residents from other countries or exploit those who build and staff it. This is a space of show-and-tell, somewhere where a feather and a cooking pot are valued as highly as an oil painting or a bronze statue of a God. It is a vision for a museum not of bricks and mortar but of the mind. At once collective and individual, personal and political, the ship of nothingness is born from a burgeoning awareness that what we need is less matter and more spirit.

\* \* \*

In truth, Helsinki's reality is eminently less weightless than that kind of utopia. Even in bastions of social democracy, urban development presses on. A New Museum of Architecture and Design is being proposed for the site where the Helsinki Guggenheim would have stood. Combining two existing museums, the Museum of Finnish Architecture and the Design Museum, if both the city council and the central government give it the go-ahead, its construction will be carried out by the winners of a design competition held in 2024.[90]

The museum will make its home in the Makasiiniranta area on the South Harbour waterfront. This zone is being transformed into a culture district with public squares facing the seafront, a pedestrianised area that feeds into surrounding districts, and the renovation of historic buildings into arts spaces, including a Baltic Sea museum, a gallery and workshops for artists. Beehives and vegetable and herb gardens are planned, as well as a food market, a restaurant, a hotel, and commercial and office spaces.[91]

Behind the Makasiiniranta project, which is called Saaret ('the islands'), is a coalition between K2S Architects, who are based in Helsinki, and White Arkitekter, who are based in Sweden. Had I read of the development's many virtues as recently as the late 2010s, including its promise to be in sync with the city's target of carbon neutrality by the early 2030s, I would not have questioned it. Surely a productive public space, in sympathy with its immediate and wider environment, and planned by at least some architects rooted in the locale, can only benefit a capital city.

Now, however, as I let go of the magical thinking inspired by my yoga teacher and step back into the space of critical thinking, my inner cynic is on alert.

In mid-2023, Finland elected its 'most right-wing government since World War II'.[92] Is there a danger that, here too, a neoliberal ethos will infect the country's longstanding commitment to social and environmental wellbeing? The new combined museum is

being funded by a quartet of private foundations, which, by late 2023, had almost reached their goal of raising €150 million in capital. Their mission is that 'the museum must be in a class of its own—globally.'[93] Is there a danger that the values of private capital will damage the public good?

Or can Helsinki, which has an international reputation for outstanding design and architecture, maintain its local heartbeat while boosting its global prestige? Kaarina Gould, CEO for the Foundation for the Finnish Museum of Architecture and Design, believes it can: 'The support from the local community comes through solid,' she writes to me via email. 'One argument supporting the project is that the new museum of architecture and design will merge two existing museums—the Design Museum and the Museum of Finnish Architecture—both with a strong following and known to have been in need of better facilities to better serve their communities.'[94]

EVERYTHING TO GAIN

Marcou and Nicolaou's ship of nothingness resonates with a project entitled *Architecture of Disappearance* by artist and architect Sofia Karim. In 2018, Karim's uncle Shahidul Alam, a photojournalist, teacher and human rights activist from Bangladesh, was jailed by the Bangladeshi government after he criticised it during a live TV interview on Al Jazeera. Aware that her beloved relative was being held, beaten and tortured in brutal, over-crowded, unsanitary conditions, Karim, who is based in London, began to dream a different set of poetics for her profession.

'If architecture is an embodiment of humanity, it must confront the pain of the past and present,' Karim writes.[95] Interspersed between her words are delicate, convoluted drawings of bodies—entwined, heaped, broken, solitary, suspended, caged. 'I draw the bodies in various ways,' the text continues, 'sometimes

as solids and sometimes as vectors projected in space. I draw the same thing for months. And after some time I realise that when I'm drawing the Amdani Cell, I'm not only drawing this instance, but every such instance: the stacking of bodies—dead, alive, or barely alive—the final phases of human subjugation. ... I draw till the lines dissolve beyond recognition. Then space breaks across my screen.'

What space? Whose space? Like Marcou and Nicolaou, Karim has touched down in nowheresville. A place that is at once walled and lightless yet also transparent and borderless. But a prison of the imagination can also be a haven. Many of us have surely shuttled between one and the other, especially in the small hours, that sinister netherworld when our greatest strength becomes our greatest weakness and vice versa. We find ourselves plunged into the void.

Terrifying in its lack of limits and unknowable core, the void is also, as Adrienne Rich points out, a place of untold fertility. 'We begin out of the void, out of darkness and emptiness,' writes Rich. 'It is part of the cycle understood by the old pagan religions, that materialism denies. Out of death, rebirth; out of nothing, something.' The void, she believes, is 'the creatrix, the matrix ... if we can risk it, the something born of that nothing is the beginning of our truth.'[96]

Karim's concept of 'an architecture of disappearance' has fed into her drawings of objects—weapons, crucifixes, planets, human figures—which float in fathomless darkness. These profoundly convincing voids are summoned thanks to Karim's gift with printing, paper and ink. At once menacing and healing, her blacknesses are even more ambivalent than the void in Rich's essay: a place to be 'disappeared' by your enemies yet also disappear when they are hunting you.

Is it fanciful to say that the people of Helsinki, by rejecting the bulky, carbon-heavy museum that wanted to fill up the

physical emptiness of their waterfront, chose such an ambiguous void, at once frightening in its emptiness yet healing in its endless possibility?

In declaring that their sea-facing nothingness was precious, not desolate and neglected at all, they chose rebirth, their own intimate and particular truth, something healthier, safer and more socially inclusive, even as it seemed that what they were embracing was an absence. Like Karim's negative chambers, the void left by the non-Guggenheim can be seen as a rejection of the imprisonment of their local imagination in a hefty American institution.

'After everything that happened, I'll never design buildings in the same way again,' writes Karim. 'While I make work, I think about power and abuse of power. This includes race and the history of subjugation of my people. I think of the politics of today. Too often architecture evades. ... I'm saying that as an architect, I need to engage with the politics of the lived experience, and interrogate my own relationship to power. Only then might a sense of liberation or transcendence emerge in my work, in any truthful sense.'[97]

On one level, there is a conceptual gulf between Marcou and Nicolaou's benign ship of stories and Karim's dark yet fecund carceral visions. But the connections are striking too. Karim's musings on the role of the architect in the twenty-first century tie her concerns to those of the anti-Guggenheim contingent in Finland, and to the people around the world who suffer to build new ultra-luxury museums, obliged by economic hardship to sell their labour cheaply and in bleak conditions. Many of these workers come from Bangladesh, the same country where political repression led to the imprisonment of Karim's uncle.

As my own imagination slips back and forth between the ship of nothingness and Karim's haunting drawings, between the resistance of workers in the UAE and those in Bilbao and

Helsinki, between prison cells in Dhaka, labour camps in the Gulf and air-conditioned art galleries all over the world, I realise that I am eliding the notion of a prison with that of a museum.

Is this where we are today? Between the men forced into dystopian intimacy in their jail cells and those crammed into crowded dormitories after back-breaking hours on the construction site while a white-collar executive from New York confirms there are sufficient centimetres between their bunks?[98] Are these our benchmarks for humanity? Where is the art in that?

Even before populism drove Finnish politics to the right, some Finns were always more equal than others. As the visceral performance by Skolt Sámi artist Pauliina Feodoroff in Venice showed, the deforestation of land inhabited by Indigenous communities and their reindeer herds speaks of a disequilibrium within Finland even when no American interloper is involved.

'Don't we have enough museums [in which] to see different kinds of objects?' Feodoroff, like so many activists, simmers with a weary yet undimmed conviction as she talks to me across a Zoom link against a backdrop of verdant trees in her garden. The filmmaker and theatre director has some positive words to say about the proposal for the new architecture and design museum. 'It's better than building homes for the wealthy,' she concedes, alluding to an earlier proposal for the site. Nevertheless, she points to the fragility of the Helsinki shoreline. 'The seabed has already been so heavily dug and managed. The first priority should be to protect it.'

Helsinki's coast is the first line of defence against the increasingly fierce winds that batter the city. Trees, points out Feodoroff, are the biggest 'counterforce' against those deadly gusts. 'Rather than a museum, I'd like to see a forest planted there.'

As we say goodbye, I ask Feodoroff where she is located. 'Helsinki,' she tells me, adding that she spends half of her time in the city and half 'up North' in her ancestral lands. She pauses

for a moment and a flicker of sadness passes across her face: 'Those trees behind me, they shouldn't be green at this time of year. They should be white.'[99]

As we will see in the next chapter, we may be moving into a world so urgently in need of carbon reduction that even the greenest and most ethical new projects are of questionable benefit. As all those fantasy projects of space and nothingness implied, over the next century on Planet Art and beyond, less may truly be more.

# DECARBONISE AND DEGROW

ART BASEL, MIAMI, December 2015. In the air-conditioned convention centre, I drift past the parakeet-green groves that are David Hockney's translation of East Yorkshire woods, pause at Alan Sonfist's photographs of himself climbing trees in the nude. This year, booth after booth at the international fair exhibits art begging us to conserve our planet.

We don't need art to tell us we're in trouble. This morning it was so smoggy, I was blinded by the glare hitting the sidewalks. The nightlife is a key element of Art Basel week, but tonight a torrential rainstorm will see glamorous partygoers flee the terraces of the smart hotels, restaurants and mansions with sopping trousers and ruined shoes.

This same month, political leaders meet in Paris to thrash out the famous accords that pledge to keep global warming to less than 2°C—and ideally no more than 1.5°C—above pre-industrial temperature levels.

In Miami, the art is on message, but the event raises questions. There will be 77,000 visitors to the fair this week, thousands of whom, including me, have flown in from all over the world, as have dealers, their staff and dozens of other fair workers.[1] The international flights are just part of a carbon-heavy package that includes transporting thousands of works of art across oceans, alongside the energy consumed by all the week's activities and events—for Art Basel spawns satellite fairs and exhibitions across the city. At a press conference, the mayor of Miami Beach, Philip Levine, says that the one thing Miami wants is fewer cars. Yet one of the fair's official partners is

German multi-national car manufacturer BMW, a longstanding sponsor on Planet Art.[2]

\* \* \*

Scientists have warned that the global temperature will likely rise to more than 1.5°C above pre-industrial levels in at least one year between 2023 and 2027.[3] By 2030, 530,000 people a year will be killed by the effects of global warming. Only 1 per cent of those deaths will happen in the Global North.[4]

But in the cultural sector, the conversation about climate change continues to revolve around the pros and cons of sponsorship by fossil-fuel companies like BP and Shell.[5] Thanks to over a decade of campaigns by organisations such as Culture Unstained, BP or Not BP?, Platform London and Art Not Oil, pressure on museums has been ramping up so fiercely that those companies have been steadily dropped by one institution after another.[6] As I write this in January 2024, the Science Museum and the British Museum are the only national museums in the UK that retain clear links to BP. (And, in the case of the Science Museum, coal mining company Adani, whose renewables subsidiary has provoked boycotts and criticisms of the museum by scientists, Indigenous leaders and teachers for its 'greenwashing' sponsorship of a new gallery).[7]

The victories won by the anti-oil lobby are enormously significant. But in the visual art world, critique of that sector's carbon footprint has remained feeble, despite the fact that it has been built around international networks of exchange, display and finance. The Guggenheim's journey outlined in the last chapter is the tip of an iceberg of global expansion which, over the last half century, and much accelerated since the turn of the millennium, has driven the strategies of museums, auction houses, private galleries and art fairs. In a single week in 2023, I was offered press trips from London to São Paulo in Brazil, Florence

in Italy, and Dublin in Ireland. All included return flights. None mentioned the carbon footprint of the trip or how they might offset it. They never do.[8]

There has been little sustained research into the overall emissions of the visual art sector. However, in April 2021, a report by Julie's Bicycle, a non-profit organisation which facilitates the decarbonisation of the culture sector, revealed that visual art was responsible globally for an estimated 70 million tonnes of $CO_2$ per annum.[9] To cancel out those 70 million tonnes—in other words, to get to so-called 'Net Zero'—Planet Art would need to plant 22 million hectares of forest per year—the equivalent of increasing the Amazon rainforest by about 3 or 4 per cent.

PLANET ART CLOCKS CLIMATE CHANGE

In late August 2018, as Greta Thunberg sat down alone outside the Swedish parliament to beg her country's politicians to give her a future,[10] I set off on a six-month itinerary through Venice, Buenos Aires, Berlin, Paris, Havana, Miami, St Petersburg and Kerala. I mostly didn't book my own flights, and although whenever I did I dutifully clicked the box marked carbon offsetting, I never asked those booking for me to make sure they did likewise. My carbon footprint went unmentioned by me and all those institutions—publications, public relations companies, art fairs, museums and biennials—that were 'facilitating' my travels.

A year later, the lonely schoolgirl was *Time* magazine's person of the year, and the Oxford English Dictionary made 'climate emergency' its word of the year. By then Thunberg had spoken at the United Nations, the European Parliament and the World Economic Forum. Her activism was one strand in a broader global movement, much of it led by young people, whose campaigns—including Friday school strikes and a 500,000-strong protest at COP25 in Madrid—helped shove the climate crisis

onto front pages across the world, as did a devastating report on the situation by the UN in autumn 2018.[11]

Global warming wasn't news to most of the world. The region known as the Global South—Asia, Latin America and Africa—had long understood the cataclysmic threat. Given that 92 per cent of global emissions that tip us over safe capacity are caused by the Global North (the US is to blame for 40 per cent, with the UK, Canada and Europe among other high polluters), it is shockingly unjust that the Global South has been suffering a problem not of its own making while those in the best position to effect real change remain indifferent.[12]

In September 2019, I flew to Istanbul for the city's biennial. Even without the climate crisis, the event encapsulates the ambivalent heartbeat of Planet Art. On the one hand, it is a blow struck for imaginative freedom, in a country held in the grip of a president bent on imprisoning anybody—journalists, intellectuals, writers and artists—who dissents from his authority. In 2023, Reporters Without Borders' World Press Freedom Index placed Turkey 165 out of 180 countries.[13] Given the constraints on artists, that the biennial takes place at all is surely laudable, particularly as it utilises venues all over the city and has a reputation for showcasing bold, political art.

On the other hand, questions have been raised about the ethical history of the biennial's chief sponsor, the cultural foundation attached to Koç Holding, the biggest industrial conglomerate in Turkey.[14] Furthermore, Istanbul's art scene is dominated by a handful of wealthy families, who control banking, media, industry and even higher education.[15] Their philanthropic enterprises have prompted concerns about reputational laundering and have fostered exclusiveness even as the exhibition sustains quality.

But the 2019 Istanbul Biennial would be the most paradoxical yet. Entitled 'The Seventh Continent' after the immense island of plastic waste—more than four times the size of Turkey—that

floated in the Pacific Ocean, the biennial was devoted to raising awareness of the environmental menace. Some art hit home with poignant intensity. I will never forget standing in the overgrown garden of a dilapidated palace on a secluded island listening to an ancient, stately fruit tree recite its own elegy—a sleight of ear dreamt up by the Turkish artist Hale Tenger.

Over 450,000 visitors were drawn to the biennial that year, many of them, like our tribe of foreign journalists, flying in for the occasion. (In the opening week alone, 4,000 international visitors attended.)[16] And what of the energy costs of the event: the shipping of work, the energy used by the venues, the travel of the artists and their teams? As we bustled from one venue to another, via bus, taxi and boat, as we were wined and dined in opulent palaces and restaurants and relaxed in a hotel with a rooftop pool, the irony was impossible to ignore.

When I asked the biennial's curator, Nicolas Bourriaud, if the event justified its carbon footprint, he replied: 'Guilt is not the answer ... The problem is mass tourism. It's not visitors to the Istanbul Biennial that are going to change the situation.'[17]

But Greta Thunberg wrote that 'every single emission counts'.[18] Given the nature of the biennial's message that year, given that its sponsors included energy and cars—huge sources of emissions— as key sectors of their business,[19] didn't the question of its own footprint at least deserve deeper consideration? Was Planet Art, as Bourriaud suggested in direct contrast to Thunberg's impassioned belief, really too small to make a difference?

In truth, this kind of thinking was behind the times. Laissez-faire dismissals of an event's environmental impact were the tail end of a culture that believed art got a free pass to pollute because it performed the emergency service of communicating the threat to the planet, rather as ambulances get a dispensation to break the speed limit because they're saving lives.

Elsewhere, the cultural sector seemed to be waking up to its responsibilities. 'Art world faces up to the reality of climate cri-

sis,' announced *The Art Newspaper* in a report on Frieze London and Frieze Masters, the two international fairs which take place every October in luxurious marquees stationed in each half of London's Regent's Park. Efforts to lower emissions included switching the fairs' energy source to 'a more effective renewable biofuel' and calling on gallerists to ship rather than fly their works to London. Gallerists pledged to attend fewer fairs and those that were closer to home.[20]

The momentum for change was intensifying. 'How can an industry that hinges on international travel confront climate change?' asked journalists at Artnet as they reported on the Art Basel fair in Miami. A spokesperson for the fair admitted that 'the environmental impact of the international art world is a pressing issue' and promised that the fair was undertaking 'long-term initiatives to improve its ecological footprint'.[21] An internal working group had been set up to tackle emissions. All the flights booked by Art Basel, including those by its in-house team, plus the journalists, guest speakers and 'VIP representatives', had been offset. There was a panel discussion on climate change denial.

Nevertheless, in 2019, environmental sustainability was ranked fourteenth out of sixteen important challenges faced by commercial galleries that year. The top three were finding new clients; the macro economy and demand for art and antiques; and participation in fairs.[22]

The visual art sector was learning the language of climate action, but, at least for some of its most wealthy, powerful entities, it seemed they were empty words.

## PLANET ART TAKES ACTION

The pandemic saw a massive reduction in Planet Art's carbon emissions, along with those of most sectors, as museums and

galleries were forced to close their doors and thousands of events were cancelled. Devastating though the Covid years were, carbon dioxide emissions fell by 5.4 per cent in 2020,[23] while emissions of nitrogen oxides—responsible for dangerous ozone formation—dropped by 15 per cent.[24]

Yet by 2022, the first full year of no lockdown restrictions in much of the world, carbon dioxide emissions were the highest on record.[25] The weather did not let up. Storm Eunice wreaked havoc in Europe. Floods in Pakistan displaced a staggering seven million. Hurricane Ian decimated Cuba and the southeastern United States.[26]

On Planet Art, as so often, the situation was ambiguous. Significant initiatives encouraging sustainability in the arts were springing up, like the aforementioned Julie's Bicycle, founded in 2007 by former cellist Alison Tickell, which supports arts organisations 'to act on the climate, nature and justice crisis'.[27] More recently, in April 2019, a woman wearing a long coat of grass clip-clopped into Tate Modern's Turbine Hall on a white horse. Behind her marched the campaigners responsible for Culture Declares Emergency, a group calling on creatives and cultural organisations to recognise the climate and nature crises and 'pledge immediate action'.[28] Three months later, Tate itself issued a press release declaring a climate emergency.[29]

In 2020, the Gallery Climate Coalition (GCC), an international non-profit association of arts organisations based in the UK, was set up by a group that included Victoria Siddall, then global director of the Frieze art fairs. The primary aim of the GCC is to assist the visual art sector in reducing its greenhouse gas emissions by at least 50 per cent by 2030, as laid out in the Paris Agreement.[30] Its approach for achieving this is two-pronged. On the one hand, it encourages its members to reduce their own emissions as much as possible. On the other, it suggests that they put money into pots that go towards carbon-

reduction processes, such as switching to renewable energy sources or subsidising eco-friendly travel, as well as to donate to organisations that are working effectively at the frontline of the climate crisis.[31]

Both Julie's Bicycle and the GCC recognise that 'carbon off-setting', the traditional method of fighting global warming, is a flawed process.[32] It's too slow, often relies on untested 'carbon-capture' technologies that don't work properly, and to be effective will require more land than our planet can offer. It is also a strategy often guilty of 'climate colonialism', in that land is wrested from Indigenous communities and people in the Global South for offsetting projects. Relatedly, these environmental arts organisations also challenge the concept of Net Zero. As the GCC points out in its policy document, Net Zero was never a scientific goal. Rather, it was a political compromise that emerged in the 2015 UN climate conference in Paris as a way of side-stepping the failure to hold individual countries down to specific reduction targets.[33]

Julie's Bicycle and the GCC are part of a shoal of initiatives that aim to lower the carbon footprint of the arts sector. In July 2021, a coalition group formed entitled Partners for Arts Climate Targets (PACTS). Its organisations include the GCC; Art to Acres, a non-profit founded by artists, galleries and institutions that conserves forests and supports Indigenous people; Art + Climate Action, a San Francisco Bay Area project that educates and supports arts institutions around emission reduction; Art/Switch, an initiative based in New York City and Amsterdam that acts as a knowledge-sharing hub on sustainability; Galleries Commit, a coalition of NY gallery workers and artists committed to sustainable practices; Artists Commit, an international group of artists that emerged out of Galleries Commit; and Ki Culture, an international non-profit based in Amsterdam that offers pro-grammes and tools to organisations across the culture sector—in

visual arts, heritage and the performing arts—that wish to improve their sustainability.[34]

There's no doubt these environmental strategists are having an impact on the arts. Emissions, at least in certain areas, are dropping.

In 2018, for example, Julie's Bicycle developed a new programme called Spotlight that focused on reducing the emissions of thirty of the largest organisations in Arts Council England's environmental programme, which encompassed 828 institutions in total, from libraries and dance companies to flagship museums and galleries. In previous research, Julie's Bicycle had discovered that these thirty institutions were responsible for a third of the portfolio's total emissions. Five of them are in the visual arts: the Baltic Centre for Contemporary Art; the Serpentine Galleries; the Hayward Gallery (Southbank Centre); the Whitechapel Gallery; and the Whitworth Art Gallery. By 2022, the Spotlight group had managed to lower its electricity usage by 20 per cent and its gas usage by 27 per cent.[35]

Meanwhile, as of early 2024, the GCC counts over 1,000 members worldwide, including in London, Berlin, Los Angeles, Taiwan, Mumbai and Madrid. Among them are big emitters such as Tate; the Bilbao branch of the Guggenheim; the megafairs Frieze and Art Basel; Christie's auction house; and multinational galleries such as Hauser & Wirth.[36]

If the majority of members are based in the Global North, that's not necessarily a cause for complaint. As in the wider world, there's little doubt that historically artists and their infrastructure in the US, Canada and Europe have unleashed the most carbon. It's also true, however, that now some of the heftiest cultural infrastructure is being constructed in China, Saudi

Arabia and, as we have seen, the UAE, whether in collaboration with Global North institutions or not.[37]

It's also possible that the new museum builders in Asia are putting environmental concerns top of their to-do list. China, for all its atrocious human rights, is from certain perspectives leading the way in green energy.[38] Saudi Arabia is regularly accused of using its artistic pursuits as a way of 'art washing' its oppressive rule and lucrative oil-based economy.[39] As to the environmental impact of its new cultural ecosystem, it's unlikely to be negligible. Yet Iwona Blazwick, a British curator who is now advising the Saudi Arabian government on its cultural development, says a new museum planned in conjunction with the Pompidou Centre in France will be 'carbon neutral'.[40]

As for the UAE, I put in a request to the Guggenheim Foundation for information about the carbon footprint of its Abu Dhabi branch. As the building was still under construction, the spokesperson said this was impossible to estimate. However, the new museum would be 'an environmentally friendly building created with sustainability in mind.' Sustainability features would include 'recycled water through condensate capture and reuse, passive design and cool building strategies, the use of sustainable materials in the building of the museum and the design of outdoor spaces for thermal comfort and protection against extreme climate.' It was expected to obtain 3 out of 5 under Abu Dhabi's system for rating a building's sustainability.[41]

In truth, holding organisations and governments, especially autocracies, to account for their emissions is a tall order. However, the Gallery Climate Coalition has come up with a way to at least prevent its members from green-washing their reputations by introducing 'active membership'. To qualify, members must complete a $CO_2$ audit; establish a 'green team' or 'green ambassador' in their organisation; and publish an environmental responsibility statement. As an incentive, they receive a badge

that singles them out on the list as being genuinely committed to the cause. Several powerful organisations, including the six GCC members listed above, now sport this accolade.[42]

Galleries are switching to renewables, buying electric vehicles, cutting back on air travel and swapping to LED lighting.[43] Some institutions are rethinking their entire approach. For example, since 2018, Kunsthal Gent, a contemporary art space in a Carmelite monastery in Belgium, has featured just one show, *Endless Exhibition*, devised by designer Prem Krishnamurthy and to which artists and curators contribute.[44] Such an approach removes the carbon-intensive merry-go-round of holding different shows one after another. The Biennale of Sao Paulo, among various other efforts, has built a rainwater reservoir.[45] Sutton PR, one of the major international arts communications companies, makes regular donations to Art into Acres, minimises its own travel as far as possible and—problematic though the strategy is—obliges all of its clients to offset all flights made as part of its project.[46]

These instances are just a miniscule proportion of the vast decarbonisation efforts being made by thousands of participants on Planet Art. When you concentrate on the wealth of positive steps being taken by so many organisations, it's hard not to feel optimistic. Perhaps it's possible that many members of the Gallery Climate Coalition will really meet those Paris Agreement obligations of a 50 per cent emissions reduction by 2030.

So what's the problem?

GREEN IS AS GREEN DOES

Venice, May 2022. The oldest biennial in the world; to many, still the most prestigious. This is its first edition after the enforced stasis of the pandemic, and Planet Art is on turbo-fuel. Thousands of visitors descend on the opening week's carnival of inaugurations, conferences and parties. The sun shines, and,

unusually for such a sprawling jamboree, the art does too. Outside the US pavilion, a sleek, dark sculptural visage by Simone Leigh reclaims the African mask for Black artists and audiences after over a century of appropriation by white Europeans like Picasso.[47] In the Arsenale, Lebanese artist Ali Cherri's film of a young man making mud bricks by Egypt's artificial Merowe Dam, then losing himself in dreams of monster-filled utopias, expresses the mutual exploitation of labour and landscape with chilling yet lyrical power.[48]

This year, the Nordic Pavilion has been renamed the Sámi Pavilion and is occupied by artists who belong to Northern Europe's only Indigenous people. Numbering around 80,000 across northern Norway, Finland, Sweden and Russia's Kola peninsula,[49] the Sámi people lead a way of life inextricable from the herds of reindeer that they follow for vast distances across uncompromising, snow-bound landscapes. Over the centuries, the Sámi have been colonised and suppressed by Christian authorities, governments, mining and logging companies, and the collectivisation policies pursued by the Soviet Union. They've had their culture suppressed and their languages wiped out. Now they are facing another threat: renewable energy. Yes, the systems said to be a solution to our climate crisis, in truth, wreak havoc. In Norway, for example, Sámi lands have been taken for hydropower, wind farms and nickel mining—nickel is required for the alloys needed for wind turbines. Furthermore, wind farms are devastating to the reindeer herds and their guardians, for they spook the animals away from their safe, centuries-old migration routes.[50]

The Sámi Pavilion includes paintings, sound installations, performances and sculptures made from wax and reindeer sinew that have been impregnated with odours including that of reindeers in fear. As the mysterious reek of those sculptures infiltrates my nose, I feel viscerally aware of the menace facing this

community, so long invisible on the international stage. In this way, the Sámi Pavilion embodies a Biennale that many critics acclaim for showcasing art at once faithful to the mysterious, transformative work of the imagination and committed to a better, fairer world.[51]

The Biennale's carbon footprint is the elephant in the room. By the end of the event in November 2022, over 800,000 tickets will have been sold, 59 per cent of which are from outside Italy.[52] If only half the visitors from abroad travel here by plane and the average flight is, say, a London to Venice return, then that's over 99,000 tonnes of $CO_2$, which means that the Biennale, through its visitor numbers alone, will have released roughly the amount of carbon into the atmosphere that it would take 4.26 million trees to remove in a year.[53]

When you add in the energy used to run all the events, plus emissions from staff transport, shipping goods and packaging materials, then the carbon cost is far higher. Given that carbon offsetting is an ineffective recompense, then even if most visitors and workers 'offset' their emissions, the environmental price of the event is surely up for question. Yet in the days I spend at the biennial and in the coverage I read, nobody mentions Venice's carbon footprint. Online, the Biennale's own website states that it is aiming in 2022 to achieve a certification of 'carbon neutrality' for all its activities including the International Art Exhibition, having already achieved certification for the 2021 film festival.[54] (At the time of going to press, I have still received no reply to my questions as to how the Biennale planned to achieve that goal, nor how Venice had achieved carbon neutrality for the film festival—another magnet for thousands of international visitors.).

My days in Venice help to crystallise my conviction that we have to focus our attention on the global system of racialised capitalism that is stopping Planet Art—and the wider world—from cleaning up, both environmentally and socially. This consciousness is there as a European journalist dubs me 'boring'

when, asked if I will be attending the 2023 Sharjah Biennial, I tell her I no longer fly very much. It is there as I watch Skolt Sámi artist Pauliina Feodoroff kneel before a group of collectors begging them to support her people's bid to buy back plots of their land. The collectors smile, a little awkwardly, and move on.

From the feral scent of those terrified reindeer to Feodoroff's own desperation, there is an urgency in the Sámi Pavilion, as if the gap between art and life is closing so tightly that it's hard to breathe. The Sámi presence at the Biennale was supposed to be a cause for celebration. Finally, the Sámi would have a platform to raise awareness about their plight as simultaneously the victims of capitalism, climate change and—with a grim irony—efforts by capitalist economies to tackle climate change through the creation of renewable energy sources. Feodoroff is just one of a new cohort of Indigenous people to have acquired heightened visibility in the art world as it struggles to reinvent itself as a space where marginalised communities are respected.[55]

Yet when I ask Feodoroff if she has received money to buy back any land yet, she says no and that she has only acquired 'promises'. Though her vigorous spirit is palpable, she sounds weary when she replies to my question as to how she got to Venice. 'I've no idea,' she murmurs. 'I just knew it would be a chance to try and save our land.'

The day after I speak with Feodoroff in Venice, I attend a conference on climate change and the arts. It is held in the palace of a woman with her own private jet. After listening to a quorum of artists, diplomats and curators championing art as a vehicle for changing the world with imagination and hope, I chat to a curator from Sweden, who says her daughters were furious with her for flying to Venice. 'They and their friends won't fly at all,' she tells me.

I find more hope in this tale of young people's resistance to a system they know is destructive than in any of the silky rhetoric uttered by the various speakers.

A few months later, I reach out to Feodoroff for an update on whether or not the Venetian exposure has helped her cause, but she doesn't reply. I write to her again. Just a few days before I am due to consign my manuscript, Feodoroff calls me. The next morning, we catch up on Zoom, Feodoroff in front of those lush green trees that should be covered by snow.

Has the Sámi Pavilion been worth the artists' efforts? 'I don't know yet,' she responds. 'I still haven't sold a single landscape.' Although many institutions have been interested, 'one of the lawyers of those institutions have come back and said we cannot purchase the art because "we are not sure what we are buying".'[56]

In truth, what Feodoroff is selling are the 'viewing rights' to plots of Sámi land. Buyers gain the right to visit the landscape and watch as it rewilds, a process made possible by their purchase, which would allow the Sámi to buy back the land and restore it to natural health. The viewing rights, explains Feodoroff, buy the collector 'twenty years' of gazing. That's 'the minimum timescale' for the environment to make any significant repair, and the minimum timescale to enjoy any 'meaningful dialogue' with the community.

Twenty years. Twenty years just watching trees and plants grow. I think of the timescales on Planet Art. The ticking of the watches in the auction rooms. My own frantic hopping from one time zone to another, from one biennale or art fair to another. Days when you saw so many artworks that you just longed to sit in a green field and stare at the sky.

Feodoroff doesn't write off her experience in Venice. Thanks to the visibility raised by the Sámi participation, certain 'US-based philanthropic organisations' have made contributions to Snow Change, a climate organisation which facilitates rewilding of Sámi lands and has permitted the acquisition of '600 to 700 hectares'. Feodoroff cites a family of reindeer herders who have been sustained by these funds; a Finnish scientist who was 'ecstatic' because, thanks to these land acquisitions, she discovered a valu-

able bog, as well as rare mosses. A lake is being restored to healthier water quality and its microplastics removed. The United Nations has also started to show a serious interest in the Sámi's struggle. Feodoroff is hoping the organisation might facilitate protection of their land for at least two hundred years.

But Venice has taken a serious toll. One of the reasons Feodoroff has been difficult to contact is because she has been ill. Accustomed as she is to the dry, clean air of Finland, the humidity of Italy's lagoon city, and particularly of the Sámi Pavilion, gave her asthma and ultimately pneumonia. She also suffered 'a small stroke'.

I think back to that moment when she was on her knees in the pavilion in front of people keen to stick to their itinerary—so much to see, so little time!

'In Venice I was present,' recalls Feodoroff, as she talks about the trauma of those 'performances'. 'A couple of thousand people went "through me". Those performances are not a symbol. You are actually doing it. You are begging. I have never done that in my life.

'It is humiliating when you have to beg for something. You become very upset. You become untouchable. I carry my shame, my anger. I am so bare naked that I have to submit myself publicly.' Her voice drops lower. 'I have been submitting all my life.'

Whatever the opportunities for art to act as a force for social change, Feodoroff's experience suggests that we—on Planet Art and beyond—have let things go very wrong, somewhere along the line.

Back in the real world, the Sámi fight on. They spent the second half of 2023 protesting (successfully) in Norway about the construction of wind farms that play havoc with their livelihood.[57]

ELITE EMISSIONS

'I only heard the term "biennial" three years ago,' says Zoe Cohen in September 2022. Cohen is an activist with Just Stop Oil, a

group calling for the British government to halt new oil, gas and coal licences. Its members have glued themselves to the frames of masterpieces in art galleries as one way of spreading their message. 'The art world is such a world of privilege,' Cohen continues. 'It's not about the art. It's about money and elitism.'[58]

A small woman with short grey hair, delicate bones, and eyes that are at once exhausted and vital, Cohen is remarkably composed given that she has spent much of the week in a prison cell after breaking an injunction which severely curtailed her and her fellow activists' right to demonstrate outside Kingsbury Oil Terminal near Tamworth, Leicestershire.[59]

'The worst part was being banged up for twenty-three hours a day within four small walls,' Cohen tells me, adding that she hasn't personally stuck herself to any master paintings, although she supports her colleagues who have. 'I'm not from the art world,' she explains. 'I'm a regular punter. But I love art galleries and museums,' she continues, before adding that she thinks art should be 'a public good rather than a private luxury.'

It's hard to argue that much of the work circulating on Planet Art is a public good. In the US, it costs $30 to enter the Metropolitan Museum in New York, $25 to enter MoMA. Britain's flagship museums are free to enter, but tickets to the temporary exhibitions rarely cost less than £20. Tickets to the Venice Biennale in 2022 cost €25 per person. Although not every visitor is a millionaire, the line of super-yachts—also terrifically carbon-intensive—that gleam on the quayside outside the venue announce the event as playtime for the super-rich.

If international biennials struggle to justify the carbon emissions created by their elite audience, the excuses are even thinner for art fairs. These events last a week at most, yet their carbon footprints encompass the transport, much of it by air, of hundreds of thousands of people and artworks, plus the packaging and energy costs of the events at the fair venues and satellite

events such as gala dinners and parties. No-one is pretending these events cater to every man or woman. In 2022, tickets to Art Basel, held in the eponymous city itself, cost the equivalent of around $65 each.[60] Nevertheless, 70,000 visitors descended on the Swiss city over the course of just four days.[61] The diary page of *The Art Newspaper* bemoaned the long queues that afflicted dealers and collectors flying into the nearby airport of Zurich, where a weekend of satellite art events pulled in crowds who then continued on to Basel.[62]

When they reached Basel, in addition to the cavernous, air-conditioned halls of the fair venue, which offered a temporary home to 289 galleries from all over the world, supplementary stimulation came in the form of twenty-one site-specific installations dotted around the city. It's now de rigueur for art fairs to include these pop-up outdoor sculpture shows, which are billed as 'public art' because the ordinary Joe can look at them without paying those exorbitant ticket prices. Almost without exception, these sculptures fail to linger in the collective memory. Yet the environmental cost of shipping, constructing and deconstructing art that is sometimes hefty—for it must stand out in a public park or on a busy traffic roundabout—is high.

The carbon-heavy privilege of international art fairs is exemplified by their longstanding partnerships with private jet companies. Frieze, it appears, has finally detached from its deal with VistaJet,[63] but Art Basel maintains an alliance with NetJets, its sponsors of over twenty years. At the 2023 fair, the private lounge where NetJets hosts its clients sported vast blue paintings of lions and cheetahs by Conor Mccreedy, a South African-born, Swiss-based British artist. According to NetJets, these paintings focus 'on the complex relationship between oneself and the natural world as well as the artist's passion for conservation.'[64] Given that taking a private jet generates ten to twenty times the emissions of taking a commercial flight, the irony of that statement needs no elaboration.[65]

Art Basel partners with NetJets because many of the super-rich individuals who frequent the fair are accustomed to travelling in these eye-wateringly expensive, high-polluting capsules—it costs between $1,300 and $13,000 per hour to charter a private jet, and anywhere between $2 million and over $100 million to buy one.[66] And it's not just art collectors who shell out these sums. The most powerful art dealers, such as Larry Gagosian, also use private planes.[67]

Yet Planet Art's penchant for private planes is no more worrying than its ongoing love affair with high finance. Art Basel partners with Swiss bank UBS.[68] Frieze is sponsored by Deutsche Bank.[69] Without the financial sector's investments in the fossil-fuel industry, not to mention myriad other corporations that are big polluters, the climate crisis would not have occurred in the first place. Nor have the funds stopped flowing since the planetary emergency became common knowledge. Between 2016 and 2022, UBS invested over $45 billion in fossil-fuel industries; Deutsche Bank invested $96.49 billion.[70]

When I share some of this information with Zoe Cohen, she gets angry. 'Flying around the world to see fucking paintings? It's disgusting,' she says. I can understand her anger. 'The people who do that are the HNW [high net worth], the top 1 per cent,' she adds. 'We know they have a massively disproportionate impact on carbon emissions, and they also have a massively disproportionate voice in power.'[71]

## HARD CHOICES

Cohen makes an important point. Although Greta Thunberg argues that no-one is too small to make a difference, she and many other climate activists also point out that real change must come from above, through choices made by politicians, corporations and banks. For example, in the first six months of 2023,

deforestation in the Amazon dropped by a third after President Luiz Inácio Lula da Silva took power in Brazil, because Lula chose to prioritise the enforcement of environmental laws that had been weakened by his predecessor, Jair Bolsonaro.[72]

As Mikaela Loach puts it:

> It is a choice to continue to burn, fund and extract fossil fuels when there are alternative energy sources available. It is a choice to make 'net zero' targets that are dependent upon future technologies and dodgy carbon offsets rather than creating legislation which will actually get us to 'real zero' emissions. It is a choice to pay workers poverty wages, whilst bosses are making millions from their labour. When we remember that, and frame all of these things that impact our lives as choices, we can realise that other choices are entirely possible and should be demanded and made.[73]

Surely different choices are also possible within the ecosystem of international galleries and art fairs, whose boards and booths are graced by the political and economic leaders with the power to change our planet's fate? During the Covid pandemic, for example, art fairs were forced to close but continued to sell through online viewing rooms. In 2020, the year when Covid had the most impact, the art market fell by 22 per cent. Many market observers reported this as a cause for dismay, but in truth, $50.1 billion of art and antiques were still sold globally—more than the GDP of many countries.[74] Is it not time that fair managers, dealers and auctioneers decide they have made sufficient money? When is enough enough?

Briefly, the pandemic seemed to hail a new era. In the Art Market 2021 report produced by Art Basel and UBS, Noah Horowitz, then director for the Americas and later CEO of Art Basel, said the year 2020 had 'marked a transformative period of innovation, restructuring, and new consumer behaviors, especially online—all of which have the potential to significantly redefine the shape of the art business in the coming period.'[75]

Yet by 2022, it was back to business as usual. Collectors, it transpired, had wearied of buying online. In its coverage of a survey of 388 collectors in New York City, 88 per cent of whom were millionaires or more, Artnet News described these poor folk as suffering from 'a feeling of utter exhaustion' thanks to a tide of online art vitrines. 'It's just visual overkill and emotional overkill [that] demands too much screen time,' complained one Manhattan-based art advisor and collector.[76]

Dealers at Art Basel 2022 professed delight at Planet Art's return to 'old normal'. One New York gallerist enthused about 'a whirlwind spring' which saw 'the European art scene roaring back to life'. Another with spaces in several countries said they and their colleagues 'valued these in-person meetings so much more.' A third, also with spaces in multiple countries, hailed the 'atmosphere in the opening hours' for being 'just like the good old pre-pandemic days.'[77]

But those good old days were bad for the natural world. When interviewed before the pandemic for the Art Market 2020 report, 67 per cent of collectors said they planned to travel to even more art events in the year to come than they had travelled to in the previous year. Just 9 per cent said they intended to reduce their art-related travel, and only 9 per cent of that 9 per cent cited environmental factors as their motivation for change. Fascinatingly, and alarmingly, the younger cohort were the least green of all, with 80 per cent of wealthy millennial collectors planning to travel more in 2020 than they had travelled in 2019.[78]

In a pull-quote, the report highlighted the statistic that 'the majority of HNW collectors are concerned about the sustainability of the art market'. Yet in reality, that majority turned out to be just 58 per cent of the sample. In other words, nearly half of collectors were not concerned at all. And, as the report drily observed, 'concerns regarding the environment have not filtered down into changing actual travel plans for most collectors.'[79]

# BATTLE FOR THE MUSEUM

September 2023. In London I write wedged between two fans in 33°C heat. That's nothing compared to the crippling 40°+ temperatures which scorched Mediterranean Europe and North Africa earlier in the summer, reducing forests to ash, killing humans and wildlife, and displacing hundreds of thousands. In Maui, Hawaii, they are still recovering bodies, rebuilding homes as the dispossessed shelter in hotels.[80] In the Moroccan mountains, they are digging bodies out of the rubble after an earthquake that has already killed 2,100.[81] 'The era of global warming has ended, the era of global boiling has arrived,' said UN Secretary-General António Guterres in July, the hottest month on record.[82] Scientists warn that the landmark limit of 1.5°C will be exceeded in the next decade.[83]

Still the emails from art's market-makers roll in. One invites me to take part in a competition to predict auction prices.[84] The Frieze group celebrates the second edition of its new event in Seoul, South Korea, announcing that it has welcomed 70,000 visitors over four days, including 'a strong international audience of visitors from throughout the wider Asia region'. A painting by Georg Baselitz sells there for $1.3 million, another by Nicolas Party for $1.25 million.[85] South Korea is Planet Art's new playground because of the post-pandemic explosion in its art market, which hit '1 trillion won ($750.85 million) in revenue for the first time in 2022', though in 2023 it slumped again.[86] Such rollercoasters are always a threat when countries are trumpeted as Art's Next Big Thing.[87] But right now, the dealers are happy. Nick Simunovic, senior director at Gagosian Asia, said how 'proud' the gallery was 'to be playing an ever-growing role in the development of the city's cultural ecosystem.'[88]

Surely this year, the Art Market 2023 report will exhibit concern about the real ecosystem? I type 'sustainability' into the

search field scanning the report. The word appears just once in the 260-page document, alongside a graph showing that just 25 per cent of dealers in 2022 considered sustainability and the carbon footprint of the art market to be of serious or moderate concern. As such, the climate crisis came ninth out of ten issues of concern, below political and economic volatility (71%); barriers to cross-border trade (57%); increased identification requirements (50%); finding new clients (50%); overheads for business premises (38%); participation at fairs (36%); competition with auction houses (32%) and disintermediation—artists dispensing with galleries altogether—(29%).[89]

These dealers are delighted to trade in art that begs us to care about the climate crisis. But that crisis does not affect their plans. What they care about is economic growth. 'Political and economic volatility'—in other words, the war in Ukraine and the concomitant fluctuations through the financial markets—that's the biggest danger to profits. Floods and droughts, not so much.

Of course, this cohort are cossetted from the worst of environmental fallout. Climate change disproportionately affects poorer people, and furthermore, it's the world's poorer regions, such as Asia, Latin America and Africa, often referred to as the Global South, that suffer the most, even though their countries are responsible for a tiny proportion of emissions.[90] Certainly wildfires, floods and heatwaves are also tormenting North America and Europe with a new intensity, but the super-rich individuals at the helm of big institutions and events on Planet Art, even those who do come from countries within the Global South, can protect themselves from much of the damage.

But are those globe-trotting gallerists and collectors right to feel that their priorities—making money, growing the art market—are so little affected by climate change?

Remember the activists on the steps of the Whitney shouting, 'This shit's connected!' Economic anthropologist Jason Hickel

describes environmental catastrophe as 'the loose thread on the sweater'—pull it and the whole garment unravels. He writes:

> This is the thing about ecology: everything is interconnected. It's difficult for us to grasp how this works, because we're used to thinking of the world in terms of individual parts rather than complex wholes. In fact, that's even how we've been taught to think of ourselves—as individuals. We've forgotten how to pay attention to the relationships between things. Insects necessary for pollination; birds that control crop pests, grubs and worms essential to soil fertility; mangroves that purify water; the corals on which fish populations depend: these living systems are not 'out there', disconnected from humanity. On the contrary: our fates are intertwined. They are, in a real sense, us.[91]

Whether it's the ego of the artist striving for a great work and/or lots of money, or that of the dealer or collector eager for profit or purchase respectively, individualism is common currency on Planet Art. It feeds an obsession with economic growth that acts to cut us off from the collective needs of humanity and nature, blinding us to the business of sustaining the planet.

SIGNS OF CHANGE

But this shit is connected. In the end, environmental catastrophes will engulf even the 1 per cent. Even though some billionaires are investing in spaceships, they can't all go and live on Mars.

As I've said, Planet Art is a place where frontiers are especially porous, where opposites attract—north and south; rich and poor; minority and majority;[92] money and imagination; profit and ethics. Out of those multiple frictions come new sounds, different songs, calls for change.

Even within the commercial sector, there is dissent. In all the years I've worked in the world of visual arts, I can count on the fingers of one hand the times someone has told me they love the

art market. An ex-gallerist, who wishes to remain anonymous, recently said to me: 'The industry is elitist, incredibly unregulated and profits in ways that are incredibly immoral. There are very few people in the commercial art world who are really moral.'

The world's addiction to financial growth benefits the few and neglects the many, even within the relatively privileged tribe of art dealers and artists. Indeed, Art Basel's Art Market 2023 report described the market as 'hierarchical'. The pandemic, it observed, saw some diminutive dealers thrive better than their leviathan peers because they could adapt more quickly to the challenges and had lower costs to offset when all trade suddenly migrated online. But as the world opened up again, 'hopes of these trends creating a more level playing field and a more significant or long-term restructuring of the art market did not materialize'. Instead, 'the poorest performance ... was reported by the smallest dealers'.[93]

The mega-galleries have long been lambasted for poaching artists from smaller dealerships as their careers take off after the smaller gallery has invested years of time and money into supporting them. This threat of losing artists to more powerful galleries obliges the smaller outfits to expand too.

'One of the big reasons for opening in London was to protect us from poaching.' Liza Essers pushes her long dark hair behind her ears as she talks to me from her home in Johannesburg. 'If we hadn't opened in London, Goodman Gallery would have shut down.'[94] Essers bought Goodman in 2008, after a career as a filmmaker. The Johannesburg gallery was already a legend in South Africa and beyond for its refusal to bow to the Apartheid regime. It had shown Black artists since its inception in 1966, when few spaces did, and never shied away from art critical of the white-supremacist government.

Essers, the daughter of a refugee from Libya, has the mind of an entrepreneur and the heart of an activist. 'What gets me up

every day is social change, and challenging power structures, and how to shift them,' she says. Since taking over Goodman, she has built on the gallery's history of supporting civil rights. Goodman's current project focuses on getting clean water into South African villages. 'Our first village in KwaZulu-Natal will give 3,500 people water,' she tells me, adding that that programme alone has required funding of $100,000. Unlike some other dealers, who send out a press release every time they work with a charity, the Goodman Gallery has kept this activity quiet.

Essers is also the founder of South South, an online platform for artists, galleries, non-profit institutions, curators and collectors invested in the Global South. Her broad vision, as she straddles both south and north, with interests in both private and non-profit sectors, makes her a valuable witness to the challenges facing Planet Art. She makes no bones about the pressure facing galleries and artists in the Global South to play the mega-dealers at their own game. Not only has she opened a gallery in London, but as we speak, she is also about to open an office and viewing room in New York. 'I have to give our artists the opportunity to be present in the US and make curators there aware of their incredible work; otherwise, I risk losing those artists to bigger international galleries,' she explains.

Other pressures include the cost of taking a booth at the prestigious global art fairs, which are now essential for any gallery wishing to compete on the international arena. 'Around 40 to 50 per cent of any gallery's income now comes from art fairs,' says Essers. But for galleries in Africa, like the Goodman, the fairs are too expensive to attend. 'In Johannesburg, where there isn't a big collector base, we might price an artist at $2,000, but on the international market no artist under $50,000 is taken seriously. Also, those kinds of prices don't bring in enough revenue to let us get to the art fairs. All the younger galleries in the Global South are facing the same problem.'

Essers doubts this cycle of economic and geographic growth is sustainable either for our planet or for its people. 'We have to shift a global consciousness in the art world about what is important and meaningful,' she says. Bear in mind that Essers speaks as a dealer who runs her Johannesburg gallery despite frequently being without electricity for six to eight hours a day, as a result of South Africa's energy crisis.[95] 'We have solar panels on our gallery,' she tells me, adding that they also have their own vegetable garden, where they grow tomatoes, spinach and carrots. As I listen to her, her young son calling for her attention from another room, we feel a long way from the Planet Art of private jets and $25 sandwiches.

The pandemic, perceives Essers, was a lost opportunity. 'We should have seen this as a moment to regroup and not just go back to the old structures of art fairs and exhibition runs,' she observes. 'But it does feel as if the art world has.'

The radical gulf in wealth and power between the dealers and auctioneers at the top of the ladder and those further down means that real, meaningful transformation is only possible, as Mikaela Loach observes, when those with the most influence decide to make changes.

'The key players must step up,' says Essers. 'The billionaire collectors, the top galleries, the Basels and Friezes. The shift has to come from them. Or from the leading artists. The artists could say, "We no longer want to be part of this system. It doesn't match what art means." Or the very wealthy could say, "This doesn't work anymore," and, "Let's think about alternative inclusive models that make sense for all!" It would mean they would lose power—if power is simply equated with money and prestige—but art shouldn't be just about selling stuff to billionaires.'[96]

Essers is not alone in calling on Planet Art's ruling classes to clean up their act. In September 2023, journalist Anny Shaw, a champion of a fairer, more ethical Planet Art, interviewed a vari-

ety of artists, curators and gallerists who did not come from privileged backgrounds for an article in *The Art Newspaper* entitled 'The art world still favours the rich—how do we fix that?'[97] Among those profiled was British-Ghanaian artist Larry Achiampong, whose work has been exhibited at the Liverpool Biennial and as part of Frieze Art Fair's Focus section for emerging artists and galleries. Achiampong observed that were he starting out now, he could not afford art school. 'The game has completely changed,' he said, referring to the way the UK government has decimated higher-education grants. 'Those with extreme privileges are the ones who can make ... changes—we're talking about power structures that exist within those ivory towers.'[98]

WHO PROFITS?

When I first conceived this book in the winter before the pandemic, I had some doubts about the excesses of art's commercial sector. I wanted to call it *Cui Bono*—who profits? Increasingly, it seemed to me that the way to unravel many of the contradictions that weave Planet Art into its baffling tangle of brilliance, fury, generosity, greed, exploitation and munificence was to follow the money—either the real money, or the currency of prestige, reputation and status. Who really benefits from those gallery exhibitions where workers struggle to pay their bills because they are so poorly paid? Why do the art fairs have to exact such a punitive price from small galleries? And who comes out on top when those mega-dealers seduce yet another newly fashionable artist away from their longstanding source of support?

Yet despite my reservations, back then I still had a different book in mind. Broader, less angry, more reflective. I thought that as well as weighing up the darker side of Planet Art, I would look at the gains that have been made over the last decades as well as the losses.

My intention was to consider those brave, effective battles against unethical philanthropy waged by artists and activists such as Culture Unstained, Gulf Labor, Decolonize This Place and P.A.I.N., which helped to expose the Sackler family's links to the opioid addiction epidemic, thereby rendering their philanthropy untenable for cultural institutions. I hoped to look at the growing demand for the restitution of stolen objects to their countries of origin, and the long, arduous struggle for better labour rights in the Gulf, where so much of the new cultural infrastructure is being built. I thought I would explore the critical risks facing artistic expression, not just those in countries known for their oppressive attitude, such as Saudi Arabia, Bangladesh and Egypt, but also the grim efforts of the British government, for example, to control our visual culture, from the shoehorning of conservative thinkers onto museum boards to the threat of cutting funding that menaces museum leaders should they step out of line.[99]

I also hoped to highlight many positive changes in the sector, such as the increasing diversity of artists finding mainstream visibility; the growth of a raft of small, independent spaces, from Delhi to Derry, that have flourished with integrity and imagination despite the constant fight for funding; and the burgeoning networks of artistic exchange—including market networks—between the Global North and the Global South, as countries in Asia, Africa and Latin America have developed different systems of display and played a more prominent role in the international market.

There's nothing intrinsically wrong with selling art, I thought. Artists need to make a living. They are still, save for a tiny handful, drastically underpaid.[100] It was impossible not to empathise with artists and dealers all over the world in their wish to have their share of the vast sums circulating through the elite wing of the visual art sector.

I still don't think there's anything wrong, intrinsically, with selling art. But since the pandemic unleashed those terrible waves

of unemployment, since the renewed spotlight on the lack of meaningful diversity in cultural institutions, since the threat to our planet has ramped up year on year—I began drafting this chapter as earthquakes shook Morocco and finished it as Libyans begged for disaster relief—my concerns shifted.

The market infects everything it touches. With its champions on the boards of museums, it infects the non-profit sector with the desire for expansionism, which is predicated on a destructive carbon footprint and a cheap, exploited, racialised labour force. Thanks to the cash-strapped nature of the public sector, commercial galleries now regularly sponsor shows in the major non-profit art galleries, surely skewing opportunities towards commercially represented artists, whose prices are hiked up in turn as a result of being exhibited in these prestigious spaces.[101]

## CHANGING REPUTATIONS

About twenty-five years ago, one of the first features I ever wrote was about reputation risk management. I interviewed the communications directors of a fossil-fuel company, a soft-drinks conglomerate and a major investment bank. The first two spoke openly about the problems they faced when their products posed a threat to society and had strategies in place to deal with such situations. The third refused to speak on the record. It turned out he had entirely misunderstood the thrust of my interview. He thought I wanted to speak about financial risk, which, of course, his bank had a plethora of complex policies for managing. No, I explained, I'm interested in whether or not you have systems in place should, for example, an oil company in which you have invested suffer a spill that damages the environment. He looked baffled. Of course not, he replied. That's nothing to do with us.

In 2019, the British Museum chairman, Richard Lambert, defended the museum's sponsorship deal with BP, renewed in

December 2023: 'You can't put a line around BP. If you don't take money from BP, would you take money from banks who support oil companies?'[102]

Lambert's question was rhetorical, intended to highlight the absurdity of holding banks to ethical account. But times change. Bankers, finally, are being hammered for pretending that their investment strategy is an ethics-free zone.

Thanks in large part to the acuity of the climate emergency, there are a growing number of organisations with a laser focus on the financiers behind the oil and gas companies. For the most part, Planet Art is turning a blind eye to the raft of banks that underpin both profitable and non-profit institutions. However, in 2023, a group of climate activists rampaged around the Parrish Art Museum in the wealthy beachside enclave of the Hamptons, New York, to protest funding from Bank of America for the museum's midsummer gala.[103] The protesters were basing their claims on a new report, 'Banking on Climate Chaos 2022', which revealed the fossil fuel investments of the world's top sixty banks.[104] That report was produced in conjunction with various groups, including the Indigenous Environmental Network, a coalition of communities who have been, as Pauliina Feodoroff testifies, worst affected by the violent, extractive strategies of the fossil-fuel industry. As Indigenous people gain more traction in the visual art sector, it seems likely that the Hamptons art museum will not be the last to be targeted for its links to the industries creating the situation.

Once again, people are making the connections. Not just between art and oil but between art, oil, money and land. What is signified by the gain of a vitrine for your work in a museum when your native land has been stolen? Cui bono? The artist who is seen at last? The museum washing its reputation for long being blind to the work of Indigenous people? Or the bank that ponies up for the whole caboodle while profiting from the oil

drilled after the Indigenous communities have been driven off their land?

## LESS IS MORE

In Libya, up to 20,000 are believed dead.[105] It's only mid-September, but the month has already seen catastrophic flooding in Libya, Greece, Turkey and Brazil.[106] Meanwhile from Art Basel comes a newsletter applauding the 'breakneck speed' with which the Paris gallery scene has reinvented itself. (Art Basel's latest acquisition is an international fair in the French capital.)[107] Econometrics warn me that the market for Jean-Michel Basquiat, whom they describe as an 'absolute icon of of Contemporary Art' [sic] has 'plateaued' since the pandemic but expanded in Asia, where a recent painting just sold in Hong Kong for $7.99 million.[108] In New York, billionaire financier and art collector Leon Black, is under investigation by the US Senate Finance Committee over tax advisory work he commissioned from Jeffrey Epstein before the latter was arrested for sex trafficking.[109] After objections by over 150 artists, Black stepped down as chair of the MoMA board, yet, at the time of writing, he remains a trustee at the museum.[110]

There's nothing intrinsically unethical about selling art. There's certainly nothing intrinsically wrong with displaying it in museums. But there is something wrong with a system in which the trade and display of art are inextricable from the exploitation of people and the natural world because money has more clout than morals.

The problem with being so focused on emission reduction is not just that, as those market report statistics suggest, many on Planet Art are simply not doing it. It's also that even when those emissions do drop—all those serious efforts to ship rather than fly and to switch to renewable energy—we are at

risk of cleaning up a system which is fundamentally broken. We're 'greening' capitalism.

As Naomi Klein puts it:

> Consuming green just means substituting one power source for another, or one model of consumer goods for a more efficient one. The reason we have placed all of our eggs in the green tech and green efficiency basket is precisely because these changes are safely within market logic—indeed, they encourage us to go out and buy more new, efficient, green cars and washing machines.[111]

And art. If that sounds trite—because surely a painting is more elevating than a car or a washing machine—let me quote the press release that the private sales team at Christie's auction house sent to me a few days ago. Was I on the hunt 'for something specific?' it asked. 'Whether it's a particular artist, rare watch model or handbag, tell us your criteria and our specialists will track it down for you.'[112]

In the course of researching this book, I've become convinced that the future for both Planet Art and Planet Earth is a different kind of economic system, one based not on full-throttle growth but rather on its opposite. A slow, circular, redistributive, regenerative cycle that rewards sufficiency rather than excess, that rediscovers the value of local over global, that knows that in the twenty-first century, less is more. More nourishing, more ethical and more sustainable.

Some economists, like Jason Hickel, call this concept a degrowth economy. Key steps towards it include the cancellation of global debt, the restructuring of labour—fewer hours and higher pay, with more leisure time to spend on activities such as caring for each other, nurturing the environment, and, yes, making and enjoying art—a cap on wealth to reduce inequality, and investment in the public sector. Hickel explains how the result of government commitment to these measures would not be economic meltdown, but rather social and environmental prosperity.

Other advocates of this shift include the economist Kate Raworth, whose advice is that we should become 'growth agnostics' and 'aim to thrive rather than grow'. Meanwhile, Mikaela Loach shows how only by dismantling capitalism can climate justice be achieved for people in the Global South, who will otherwise be further harmed in the drive to create renewables and carbon-capture programmes through the exploitation of their land and labour.

Of course, these radical changes are first and foremost the business of politicians, who need to work in tandem with business leaders and bankers. Is there really any place for such thinking on Planet Art?

'If you mentioned the word "degrowth" to big dealers and fair managers, they would freak out,' one Planet Art insider recently told me off the record. Nevertheless, I wrote to Art Basel, Frieze and two of the biggest galleries, and asked for their response to the notion of shifting their business model away from growth to a more sustainable alternative. None of them freaked out—but only Frieze responded on the record. I was sent a sustainability statement signposting a raft of positive initiatives, such as those recommended by the GCC (of which Frieze is a member). But there was no attempt to engage with my specific questions. These had included a request for the carbon footprint of the Frieze portfolio of art fairs; a request to hear how the organisation justified its in-person activities, given the acuity of the climate crisis—and particularly given that galleries had sold online during the pandemic; and a request that Frieze justify its decision to pursue its growth policy further, having expanded into Seoul in 2022.[113]

But elsewhere, as people like Essers and Achiampong demonstrate, there are calls for systemic change. These challenges are coming not just from those on the margins of the mainstream but also from figures much closer to the wheels of power. In July 2023, the Gallery Climate Coalition called on its members, many

of whom are from that elite cadre who fly first-class from one event to another as many of us get buses, to 'take the #Trainto-Frieze' and other international art fairs in future.[114] A month or so later, it recommended they read Hickel's book *Less is More: How Degrowth Can Save the World*.[115]

In March 2023, I attended a conference held by the Gallery Climate Coalition in London.[116] Alongside artists and curators who specialised in environmental practices, there was also a panel discussion between Frances Morris, the director of Tate Modern and as such one of the most powerful figures in the global visual art sector, and Kate Raworth, an economist at the University of Oxford's Environmental Change Institute and the author of *Doughnut Economics*, which elaborates a framework for sustainable development that balances social needs with ecological limits.

How could Raworth's ideas apply to the visual art sector, asked her interlocutor, journalist Louisa Buck, an art critic and a key actor in the Gallery Climate Coalition. Organisations, replied Raworth, had to ask themselves key questions. 'How can everybody connected to our museum thrive? How can our local habitat thrive? Is it enough to pay everyone a living wage? What if we gave them a profit share too? Can we recreate nature's generosity in our building?'

As Raworth spoke, I tried to imagine those conversations occurring around a board table governed by bankers and business tycoons as they planned to build a new museum wing, perhaps in a country where unions are banned and the distance between workers' beds are measured, or in a private gallery where paintings sell for millions but the receptionist is on the minimum wage.

Raworth continued talking. 'How is [the institution] governed? How is it owned? How it's owned is going to be profoundly connected to how it's financed. How it's financed is going to profoundly shape what finance expects and demands.' Things needed to change. 'Ask which aspects of our organisational

design are stopping us from the transformations we want to make,' she said. 'What do we need to let go of?'

What did we need to let go of? Frances Morris had some radical suggestions. 'We need to rethink the blockbuster,' she opined, alluding to the temporary shows—expensive in their carbon footprint, but lucrative in their ticket sales—which draw crowds from all over the world to see famous international artists.

Even more controversial was Morris' desire to see 'new models of collecting'. Challenging the enshrined notion that museums must collect in perpetuity, she recognised that institutions accumulate art which ends up being 'deeply private because it's hidden in the vaults.' For someone who is the guardian of an institutional art collection that should only be deaccessioned in the rarest of circumstances, this was heresy.[117] Yet Morris compared the stubborn refusal to downsize a collection to the refusal to acknowledge our own mortality. 'We are supposed to preserve work in perpetuity,' she said, 'but we are in bodies that live and die.'

The notion that we might relinquish our vice-like grip on a concept of art as everlasting—at least in its material incarnation—is important. It ties into those ephemeral conceptions of the arts institution as a space of nowhere, an architecture of disappearance, that I considered in the previous chapter. These gestures point to a visual art that is less so we can be more. Perhaps it's a performance or a poem. Perhaps it's whispered down a telephone line. Perhaps it's a story passed from one teller to another in the old oral tradition. A visual image described rather than made. Perhaps, rather than requiring multiple crates, customs forms and insurance policies, it's small enough to fold up into a pocket or fit in the artist's suitcase. When Banksy created his self-immolating painting, was he telling us that we should stop being so attached to the physical object—even as he coined millions?

To expand art's possibilities, we must contract our horizons. This does not mean shrinking into parochialism or xenophobia. We can

respect the local without denying the global. The art of the world is just a click away. We don't have to see it all in person.

Millions of artists are already figuring out new, more sustainable ways of producing work. Figuring out stuff is, after all, what artists are good at. The author Ursula K. Le Guin wrote: 'We live in capitalism. Its power seems inescapable—but then, so did the divine right of kings. Any human power can be resisted and changed by human beings. Resistance and change often begin in art.'[118]

I don't think that genuine resistance to a system that is breaking our planet and its people will be found within systems of exchange and display that depend on those systems. Like Essers, I would love to see more artists refuse to participate in these structures until they become more humane and sustainable. I am not convinced by the argument that you are better off working from within a malign organism, particularly if you profit—financially, reputationally—by association.

Few famous and established artists are making these difficult choices. Until they do, there's very little leverage on the dealers, fair managers, auction houses and non-profit institutions to change their ways. Art suffers when it is compromised like this. It risks veering perilously close to mere decoration.

However, as Dean Spade observed, the powerbrokers have the money and the guns. Artists have the numbers. As the union victories since the pandemic have proved, mass organisation works. A number of artists are starting not just to make art about social and environmental justice, but to actively live it too.

In 2022, artists in Helsinki refused to collaborate with the Museum of Contemporary Art Kiasma until it made a clear statement 'that it would refrain from cooperating with actors linked to the arms trade, the arms industry of investment activities in conflict zones'. The artists highlighted the museum's private financing by the Kiasma Support Foundation, whose board includes a businessman whose family wealth came from the arms trade

between Finland and Israel. This was unacceptable to the artists, who oppose the Israeli occupation of Palestinian territories and human rights abuses against Palestinians.[119]

The businessman released a statement saying that the strikers had unleashed a 'personal character attack based on negativity and misinformation [that] attempts to call into question the ethics of the museum', and that he 'passionately support[ed] a Two-State Solution that guarantees the rights of Palestinians and Israelis to live and work side by side in peace'.[120] However, the artists held firm, and in April 2023 the result was a new set of ethical guidelines by the Finnish National Gallery, outlawing funding from companies who manufacture oil and gas, tobacco, weapons or environmentally hazardous chemicals, as well as organisations that oppress minorities or violate human rights.[121] Such codes are becoming increasingly common in the museum world.

The Kiasma strike's success, like the victories of Gulf Labor, the Whitney Biennial refuseniks and the anti-Guggenheim cohort in Helsinki, emphasises the power of collective action by artists. 'Even though most of the artists on strike were not involved with Kiasma, the potential of saying you won't work with a museum ... it's a muscle,' Finnish-born New York–based artist Terike Haapoja tells me over Zoom one afternoon. Haapoja, who was also active in the anti-Guggenheim campaign, knows that when artists refuse to collaborate with institutions, change happens. 'Our work is what museums rely on.'[122]

That awareness of collective power is now filtering down through campaigns like the *Structurally F-cked* report on underpaid, overworked artists in the United Kingdom. In June 2023, artists including Larry Achiampong, Jade de Montserrat and Tal Shani, who was a joint winner of the Turner Prize in 2019, signed an open letter alongside British cultural luminaries such as Afua Hirsch, Asif Kapadia, Lucy Prebble, Ken Loach, Alexei Sayle, Reni Eddo-Lodge, Michael Rosen, Maxine Peake and

Gary Younge, in support of fairer, anti-racist working conditions for cleaners at the University of the Arts London. The cleaners, as so often, have been outsourced to private companies.[123] That September, the cleaners went on strike;[124] at the time of writing in early 2024, the open letter is still open to signatures, asking that the cleaners' contracts be brought back in house.

Creators and workers in the cultural sector are making connections; between the art itself and the workers who facilitate its production, exchange and display; and also between the art and those who control, fund and sometimes exploit both the sector and the wider world. The borders are increasingly porous. Readers may have noticed that in this last chapter, I have become less wedded to the term Planet Art. In the process of writing this book, I've reminded myself that the sector is not a hermetic bubble sealed off from its environment.

Right now, the conservation of our forests matters more than the conservation of our museums. If global warming continues to bite, no one will be making or enjoying art any more. But nature and art should not be in competition. They should be in synergy; mutually sustaining. What if we tried to protect our forests in perpetuity the way we have tried to protect our art? Sometimes, as Frances Morris suggested, we need to let go. Art's real power lies not in its material dimension but in that imaginative, invisible charge it lights between object and viewer, its software rather than its hardware. I've seen the Parthenon Marbles. They're terrific. But they didn't change my life, and they don't belong here in the UK. The British Museum will not fall down if it gives them back. As we have seen with the 2023 revelations of significant thefts from that collection, which went unremarked for years, museums are not always good guardians of our cultural heritage.[125]

One of the difficulties Pauliina Feodoroff faces in selling her viewing rights to museums is that they don't recognise the

immaterial nature of her offering. 'Everyone keeps asking for images,' she murmured as we spoke. She's hoping that they might accept a contract as a symbol of the work.[126]

There has long been a vogue for matter-free conceptual art—performances, DIY instructions, even Cattelan's edible, decay-prone bananas. Yet much of that 'art of absence' operates only as a prank, or as an ironic, ephemeral gesture; forgettable, power-less to effect change. The art we need more of is both lighter and heavier. Weightless in its footprint, but weighty in its impact.

If I call for an art of lessness, it's not because I think art is less important. It's more important than ever. That's why Feodoroff went to Venice. Why eco-activists have stuck themselves to oil paintings. Why billionaires want to be cultural philanthropists. Art matters to the global psyche. Where artists go, others follow. Art is a source of inspiration and imagination. The world has never needed those qualities more.

If Planet Art were to make radical changes to its social and economic structures, it would act as a clarion call to the wider world. Art isn't an ambulance. It doesn't get a free pass to break the speed limit. But if it were to slow down, shrink its footprint, share its space and resources more equitably, then it would be a real emergency service. It could help to save the world.

# POSTSCRIPT FOR PALESTINE

THE FINAL DRAFT of *Battle for the Museum* was completed on 11 October 2023, four days after Hamas' brutal attack on Israel. It was impossible then to foresee the effect of the war to come on the global culture sector.

As the weeks unfolded, it became clear that to publish a book about conflicts in the art world without engaging with this issue was not an option. The situation in Israel-Palestine has deepened existing wounds too cruelly to be ignored.

In truth, the crisis of Israel-Palestine has crackled through the art world for decades. Freedom for Palestine was, for example, key to the praxis of Decolonize This Place and its collaborators. Those who forced the resignation of Warren Kanders in 2019 were alleging the use of weapons on migrants at the Mexican border, but also possibly on Palestinians at the Gazan border.[1] Justice for Palestine likewise animated calls in 2021 to 'Strike MoMa' because board members were said to be supporters of the Israeli state and military.[2] It was a funder's family history with the Israeli military that triggered the Kiasma strike in Finland in 2022.[3] And, that same year, Documenta—ostensibly Europe's premier contemporary art festival—was engulfed in accusations both of antisemitism in certain artworks exhibited and subsequently of alleged 'structural racism and neglect', including Islamophobia, towards participating artists.[4]

The public pressure was exacerbated by the strain within the sector itself: powerful Western cultural institutions taking funding and patronage from philanthropists with ties to the state of Israel on the one hand, and artists and cultural workers critical of Israel's strategy towards the Palestinian people on the other.

187

Artist communities have founded organisations and projects dedicated to Palestine.[5] Often these are cross-disciplinary, with writers, visual artists, actors and musicians participating. Certain visual artists and art workers have supported, officially or unofficially, the Boycott, Divestment and Sanctions movement, whose call for a boycott of Israeli products, funds and commerce is partly cultural. This involvement in BDS has sometimes been in the face of government pressure—the German parliament, for instance, formally equated the anti-Zionism of BDS with antisemitism in 2019, with profoundly problematic implications for German culture.[6]

In the months since Hamas' 7 October attack on Israel, and Israel's subsequent invasion of Gaza, pro-Palestinian voices have rallied numbers to their cause more vigorously than those on the other side. Their urgency has been intensified by mounting evidence of Israel's military activity in Gaza and its consequences—the destruction of hospitals, the blockage of humanitarian aid, reports of starvation, operations performed without anaesthetic, the ever-rising death toll—which have prompted accusations of genocide sufficiently credible as to warrant investigation by the International Court of Justice.[7]

On balance, high-profile visual artists manifesting sympathy for Israel have been far fewer. Some allege an unofficial boycott of Israeli artists, particularly those who do not actively criticise the Israeli state, on the part of certain mainstream events and non-profits—although some Israelis are represented by top galleries.[8] Following Hamas' 7 October attack, there were certainly expressions of sympathy for the Israeli victims from artists and galleries, both in Israel and elsewhere.[9] There was also anger that so few in the international arts community had spoken out in condemnation of the attack.[10] However, with the mounting number of Palestinians—many of them children—killed by the Israeli army in Gaza, and with news of the wider devastation

circulating, artists and art workers have manifested their support for Palestinians,[11] with an energy echoed in the wider world.[12] The arts sector has seen a tsunami of open letters, social media statements, protests and calls to boycott institutions or—especially with regards to Germany—the state-funded output of entire countries.[13]

These two positions have rapidly polarised, creating a tension in the cultural sector that is, as of February 2024, fierce and unresolved, if not escalating.[14]

## CANCEL CULTURE

Rather than create space for the Palestinian cause, Western cultural institutions are closing it down. The pro-Palestinian movement has been pointing out that institutions which publicly supported Ukraine, as well as social movements such as Black Lives Matter and #MeToo, have refused to speak out on behalf of Palestinians in Gaza since October 2023.[15] Even worse, as I write in February 2024, the list of pro-Palestinian artists and art workers dismissed or intimidated into resigning, and the list of pro-Palestinian events cancelled, has become too long to enumerate.[16] It includes the Chinese dissident artist Ai Weiwei;[17] the Bangladeshi photographer, Shahidul Alam;[18] the Joburg-born artist Candice Breitz, who is Jewish;[19] the Palestinian artist Samia Halaby;[20] and a Palestinian film festival pulled by Bristol's Arnolfini gallery.[21] In November 2023, the entire curatorial search committee of Documenta resigned in protest at the hostility shown towards fellow member Ranjit Hoskote over his 2019 signature of a letter by the BDS movement.[22]

The cancellations have not been entirely one-sided. In Istanbul, the Mediations Biennale removed work by three of the Israeli artists selected for exhibition, Ran Slavin, Shahar Marcus and Lee Yanor.[23] And pressure is mounting: at the time of writing, thousands of artists and cultural workers have signed

a petition calling for the exclusion of the Israeli pavilion from the 2024 Venice Biennale.[24] However, the overwhelming majority of those deplatformed since October 2023 have been Palestinian or pro-Palestinian.

Why are cultural institutions so inimical to Palestine when they have been eager to embrace other social justice movements? Fear of condoning antisemitism is one reason given. Addressing the cancelling of Ai's show, Lisson Gallery said there was 'no place for debate that can be characterised as anti-Semitic or Islamophobic'.[25] The German Photography Biennale, which cancelled its 2024 exhibition four months before opening rather than continue with Alam as a curator, made a similar announcement.[26] Some fear repercussions from their governments: the Arnolfini Gallery said that it feared the film festival could be 'construed as political activity', and as such contravene British government guidelines that 'Arnolfini is legally obligated to follow.'[27] Security issues are also sometimes cited: officials at the Indiana museum that cancelled Halaby's show said there were 'concerns about guaranteeing the integrity of the exhibit for its duration',[28] while the organisers of the Biennale in Istanbul cited 'fear of mob violence should it be discovered that Israeli artworks were on display during the war'.[29]

In Germany, where cancellations have been particularly rife, the situation is exacerbated by *Staatsraison*, a national policy that says Israel's security is a founding purpose of German statehood.[30] In a country whose cultural sector is heavily dependent on state funding, institutions are especially nervous about falling foul of government, as well as haunted by the legacy of the Holocaust and the reality of rising antisemitism in a population increasingly infected by the new extreme right.[31]

The strategies of silence are not working. In New York, MoMA was obliged to close its doors one Saturday in February after 500 pro-Palestinian protesters took over their atrium. The

demonstration, which coincided with a similar event at the Brooklyn Museum,[32] is one of a raft of protests staged at US and European institutions since the war in Gaza began, including the UK's Tate Modern and the National Galleries of Scotland.[33]

However genuinely fearful museums, galleries and shows may be, their policies of cancellation spell death to the freedom of expression essential in any home of the imagination. The result is that faith in the integrity of the Western art sector, already shaky, is now vanishing rapidly. Speaking about his show's indefinite cancellation by Lisson Gallery, Ai Weiwei said: 'I grew up within this heavy political censorship. I realise now, today in the West, you are doing exactly the same.'[34]

Some allege that the refusal to allow pro-Palestinian positions is a symptom of the tokenism that poisons Western institutions' strategies for decolonisation and diversity (see Chapter 3). In an open letter written to protest the unilateral cancellation of the photography biennale due to be curated by Shahidul Alam and his colleagues, the signatories declare: 'We refuse to allow our work and our participation to be used to legitimize Western institutions who are not committed to partnering with us on equal footing.'[35] Writing to me over email, Alam himself says: 'the sad realisation that our inclusion had probably been a form of tokenism[,] and that the wider fraternity I['d] genuinely believed in probably existed only in my mind[,] leaves a bitter taste. I will continue to fight for that inclusive space, but will probably need to find new co-warriors.'[36]

Such erasures are the antithesis of a healthy culture sector. They suggest that we are too fragile and shallow to be able to speak across our differences. I don't have to agree with those whom I encounter. I do believe that elements of Ai's comments were problematic.[37] But, as I argued elsewhere at the end of 2023:

> There is anti-Semitism and there is Islamophobia: real, violent ide-
> ologies that destroy lives. There are also a million ghosts, fantasies,

191

mis-speakings and mis-perceptions of those hate crimes. We need to be able to distinguish them. We need to understand who has the power to kill us and who is expressing an opinion with which we may not agree but which does not endanger us. Otherwise, we will waste our energy fighting shadows while the real monsters thrive.[38]

What really endangers me—both as a human being who believes that negotiation is preferable to violence, and as a Jew who believes that Islamophobia and antisemitism stoke each other—is the gagging of those with whom I disagree.

STILL MAKING CONNECTIONS

Just as those 2019 protesters at the Whitney made connections between the power driving museum strategy and the power driving social inequality and injustice, so today pro-Palestinian creatives and cultural workers are highlighting the passive silence or active silencing over Gaza that emanates from many pro-Israeli companies, banks, institutions and individuals involved in the arts, despite 'the ongoing destruction of Palestinian cultural organizations in Gaza and the West Bank'.[39]

Members of the public have once more occupied the British Museum. Organised by a group called Energy Embargo for Palestine, the protesters pointed out in December 2023 that BP, with which the British Museum announced its huge new deal that month,[40] had been granted licences to explore for gas off the coast of Gaza several weeks after Israel's invasion had begun. They accused BP, among other things, of 'Investing in settler colonialism', 'Stripping Palestinian waters of their resources', and 'Fuelling the Zionist economy' in Gaza. The movement is demanding that the institution end 'its complicity with BP's climate colonialism, as it profits from the Palestinian people.'[41] (The British Museum did not respond to my request for comment.)

Once again, culture is a site where links emerge between systems of power—showing how apparently diverse oppressions inter-

sect each other, but also how different communities can reinforce each other and collaborate in building safer, healthier futures.

## ART IN AN AGE OF GENOCIDE

In December this year, it was reported that one of the few art galleries in Gaza, Eltiqa, had been destroyed by Israeli bombs.[42] Members of the Eltiqa collective had been forced to leave the area, but they had heard that locals who remained had taken paintings for wood 'to make heat and bake bread'. According to The Question of Funding, the art collective that reported their plight on Instagram, Eltiqa 'said they are sad to know that their artworks have been burnt, but they also asked what is [the] meaning of art now? Aren't peoples' lives far more important [sic]?'[43]

War is fast, urgent, deaf and deafening. It shrieks, thunders and bombs. It destroys and, to defend its destruction, it lies. It couldn't be more inimical to art. It turns art into firewood.

Truth is slow, complicated, contradictory. It whispers and stammers. It backtracks and rewrites. (This is not the same as deleting). Art—good art, art that is sustainable and sustaining, that feeds our soul and invigorates our spirit—comes from the same complex space.

When institutions shut down artists with views they find troubling, they risk becoming complicit with the warmakers. We have to ask: who profits from these silencings? *Cui bono?* The repressive regimes; the armies; the arms dealers; the bankers who fund them; the corporations who do business with them.

As the founders of the devastated Eltiqa gallery asked: what is the meaning of art now? How can art serve in an age of genocide?

I believe a painting is still a painting even as it burns to heat the fire for a loaf of bread. Its memory lingers in the smoke. It is the relic of an expression of the imagination, made at a time

when the artist was not in danger of dying; when they had enough time and money to carve out those precious hours to let their creative impulse unfold.

Art is a condition of freedom and safety. That's why our museums are full of protesters again. They know that, while culture is being bankrolled by those who are eroding our freedom and safety, it is not worth the name.

In between drafting paragraphs, I hop online and I see the photograph of the six-year-old Palestinian girl, Hind, who was trapped alive in a car, surrounded by her dead family. When she called for help, an ambulance came, believing it had negotiated safe passage with the authorities. Nearly two weeks later, Hind's body was found in the car, with the destroyed ambulance close by.[44]

Hind's bright, trusting smile is a cause for despair. But then I scroll down and I see those protestors in the British Museum, weaving their web between oppressions. I read texts and images by artists and artworkers, some individuals, some collectives. Some are notably brave, calling out banks, organisations and individuals with links to the Israeli government in a way that official media has shied away from.[45]

Meanwhile, certain arts organisations, too, are refusing to be cowed into silence or complicity.[46] So far, the majority of the institutions resisting silence are small. Their diminutive size bolsters the notion that grandiosity strangles ethics: the bigger you are, the more funding you need. The banks and corporates are waiting to welcome you with open arms.

## VISIBILITY MATTERS

In January 2022, I published an article about international museums, such as Tate and the V&A, that had made deals with state-run Chinese real estate companies to build, consult on or lend to museums in China. Those institutions, I argued, should cancel

the deals, on the grounds that China's policy towards the Uyghur population was genocidal, as a professional tribunal in London, chaired by Sir Geoffrey Nice QC, had recently found.[47] My article built on arguments made and research done by another journalist, Cristina Ruiz, who had sat through the tribunal's hearings the previous year.[48]

Our contention—that ongoing relationships with China, particularly when they involved financial profit, were extremely problematic—gained little traction in the cultural sector. There were no protests or boycotts on behalf of the Uyghur people, even though this other genocide perhaps carries the strongest ties to international art, after Palestine. China remains an enormously lucrative partner for international artists, galleries and museums.

There are many reasons for the arts' lack of attention to the Uyghurs' plight. One is that the genocide in Israel-Palestine is visible in culture, in a way the Uyghur erasure is not. China's highly powerful and centralised one-party state does its utmost to censor truthful news reporting, especially in the Uyghurs' home province of Xinjiang, where almost half a million are today confined in camps.[49] In Palestine, despite Israel's efforts to control media, news gets out thanks to outlets such as Al Jazeera, and journalists and social media commentators based within the occupied territories. A Palestinian diaspora in the creative sectors often shares concerns with a wider Arab diaspora, including powerful patrons, with cultural infrastructure in Arab states and with Muslim communities of South Asian heritage. The result is a strong, well-connected base for culture-based resistance on behalf of the Palestinians.

Art is about a manifestation of something previously unseen. Unheard. A making visible. What do we see? Where do we look? What stories do we hear? What narratives do we tell? One of the most useful texts I've read since the war on Gaza began is an article by Eyal Weizman, founder of the research group Forensic

Architecture, about the land known as the Gaza Envelope.[50] With meticulous expertise, Weizman fills in the blanks of the Western imagination as he details the process of settlement-building, alongside the determination of Israel to blur military and civilian boundaries, in this territory. As I read, I internally witnessed a landscape I'd never visited, through a history I didn't know.

Weizman's grasp of detail and his literary skills draw a picture which, once you have seen it, complicate any simple condemnation of the Hamas attack, however vicious it was. Yet Weizman describes the massacres as unjustifiable. Because he has the imaginative agility to know that life, as art, is complicated and contradictory; that borders blur and boundaries get crossed. As a British Israeli who champions the Palestinian cause, as an artist who is also an academic, an architect and, on some level, a detective, he is himself an example of such crossovers.

Visibility feeds on itself. That's why they talk about posts going viral. The Israel-Palestine conflict spreads through digital channels, both mainstream news and social media, as well as terrestrial ones. Shares beget shares. Knowledge begets knowledge. Resistance begets resistance. In 2013, a not-for-profit gallery with a focus on Arab art opened in London.[51] In its first decade, it garnered sparse media interest—but its February 2024 show of Palestinian work has sparked an article by BBC News.[52]

The flame of resistance in the cultural sector that illuminates the injustice in Gaza has been fed by, and is feeding, those fires lit for the climate; for people of colour; for Indigenous communities; for the return of goods to their countries of origin. Solidarities beget solidarities. Perhaps those artists protesting for Palestine will start also to protest for the Uyghur people. And the role of workers within cultural institutions will also be crucial—in February 2024, MoMA's own staff wrote an open letter to their museum's leadership, asking them to call for an unconditional ceasefire in Gaza and to engage meaningfully with

the strategy of culturally boycotting Israel, given what they called the wholesale destruction of 'Gaza's invaluable art, culture, and history'.[53]

Change happens because we make it happen, as we have seen again and again. In December 2023, the Berlin Senate imposed an 'anti-discrimination clause' obliging cultural institutions seeking public funding to adhere to a definition of antisemitism that encompassed various criticisms of Israel. Just one month later, the Senate withdrew the clause, following a tide of outrage from many in the international arts community, which included calls to 'Strike Germany' itself in a cultural boycott of state-funded events.[54] The fight is never over, however: in February 2024, a month after Berlin's climbdown, a policy update from Arts Council England threatened national organisations that they could be deemed in breach of their funding agreements, should individuals linked to them make the wrong kind of 'political statements'.[55]

Power is rarely relinquished without struggle. But struggle does not mean violence. We need to boycott, refuse, rage and reject when we see our imaginative and civil possibilities as artists and citizens being stolen. To return once more to Dean Spade, they have the money and the guns. 'We can't win at that.' But we have the numbers and the culture.

What is hope in an age of genocide? Elusive yet enduring—like woodsmoke from a painting.

# NOTES

## INTRODUCTION

1. *Jeff Koons*, https://jeffkoons.com/artwork/celebration/hanging-heart-0, accessed 5 April 2024
2. *Pinault Collection*, https://lesoeuvres.pinaultcollection.com/en/artwork/vintage-violence, accessed 5 April 2024
3. Rachel Spence, 'How the Hermitage Museum Artwashes Russian Aggression', *Hyperallergic*, 6 March 2022 https://hyperallergic.com/715271/how-the-hermitage-museum-artwashes-russian-aggression, accessed 25 September 2023.
4. Geraldine Kendall Adams, 'British Museum announces new £50m BP deal to fund masterplan', Museums Association, 19 December 2023, https://www.museumsassociation.org/museums-journal/news/2023/12/british-museum-announces-new-50m-bp-deal-to-fund-masterplan/#:~:text=The%20British%20Museum%20has%20announced,with%20the%20fossil%20fuel%20industry, accessed 8 January 2024.
5. 'It Is Time for International Museums to Sever Ties With China', *Hyperallergic*, 4 January 2022, https://hyperallergic.com/704030/time-for-international-museums-to-sever-ties-with-china/, accessed 28 February 2024.

## 1. HOW DID WE GET HERE?

1. Georgina Adam, 'From "wet painting" to NFTs: the art market is moving on faster and faster', *The Art Newspaper*, 2 March 2023, https://

www.theartnewspaper.com/2023/03/02/from-wet-painting-to-nfts-the-art-market-is-moving-on-faster-and-faster, accessed 17 October 2023.

2. Hilary Clarke, 'Who was in on Banksy's "self-destruct" art stunt?', CNN Style, 8 October 2018, https://edition.cnn.com/style/article/banksy-painting-questions-intl/index.html, accessed 18 August 2023.

3. Daniel Cassady, 'Christie's comes under fire for "art handler" streetwear collaboration', The Art Newspaper, 6 October 2022, https://www.theartnewspaper.com/2022/10/06/art-handlers-uproar-christies-streetwear-collaboration-highsnobiety, accessed 18 August 2023.

4. Alex Greenberger, 'Hundreds Ascend Metropolitan Museum of Art Stairs for Indigenous Peoples' Day Protest', ARTnews, 14 October 2019, https://www.artnews.com/art-news/news/decolonize-this-place-met-protest-13396, accessed 18 August 2023.

5. Megan O'Grady, 'The Artists Bringing Activism Into and Beyond Gallery Spaces', The New York Times Style Magazine, 1 October 2021, https://www.nytimes.com/2021/10/01/t-magazine/art-activism-forensic-architecture.html, accessed 18 August 2023.

6. Gareth Harris, 'Cheeky ATM installation that shows users' bank balances sells for $75,000 and will go on public display in Miami', The Art Newspaper, 2 December 2022, https://www.theartnewspaper.com/2022/12/02/cheeky-atm-installation-sells-for-75000-and-will-go-on-public-display-in-miami, accessed 17 October 2023.

7. Sarah Cascone, 'Maurizio Cattelan Is Taping Bananas to a Wall at Art Basel Miami Beach and Selling Them for $120,000 Each', Artnet News, 4 December 2019, https://news.artnet.com/market/maurizio-cattelan-banana-art-basel-miami-beach-1722516, accessed 18 August 2023.

8. Cascone, 'Maurizio Cattelan Is Taping Bananas to a Wall', Artnet News.

9. Graham Bowley, 'It's a Banana. It's Art. And Now It's the Guggenheim's Problem.', The New York Times, 18 September 2020, https://www.nytimes.com/2020/09/18/arts/design/banana-art-guggenheim.html, accessed 18 August 2023.

10. Miami-Dade County, 'Notice: County Code §2–8.9, Living Wage for County Service Contracts—Effective October 1, 2019 to September 30, 2020', https://www.miamidade.gov/smallbusiness/library/reports/2019–2020-living-wage.pdf, accessed 17 October 2023.

11. Manuel Madrid, 'Underpaid Janitors Use Basel Banana in Protest: "A Banana Is Worth More Than Us"', *Miami New Times*, 11 December 2019, https://www.miaminewtimes.com/news/art-basel-banana-becomes-protest-symbol-for-miami-janitors-11327734, accessed 21 August 2023.

12. David Attenborough speaking to Liz Bonnin, 'What Planet Are We On', BBC Podcast, 9 October 2020.

13. Reuters & Ronny Reyes, 'The new gilded age: Top 0.01% of wealthiest individuals now hold 11% of the world's wealth—up more than $400bn from 10% in 2020—while 100 million fell in to extreme poverty', *Mail Online*, 7 December 2021, https://www.dailymail.co.uk/news/article-10284667/Top-00-01-wealthy-individuals-hold-11-worlds-wealth-10–2020.html, accessed 21 August 2023.

14. Scott Reyburn, 'Five years since the $450m Salvator Mundi sale: a first-hand account of the nonsensical auction', *The Art Newspaper*, 15 November 2022, https://www.theartnewspaper.com/2022/11/15/five-years-since-the-450m-salvator-mundi-sale-a-first-hand-account-of-the-nonsensical-auction, accessed 17 October 2023.

15. UN Economic and Social Commission for West Asia (UNESCWA), '3.3 million GCC nationals living in poverty', policy brief, May 2023, https://www.unescwa.org/sites/default/files/pubs/pdf/policy-reforms-lift-three-million-gcc-nationals-poverty-english_4.pdf, accessed 17 October 2023.

16. Clare McAndrew, 'The Art Market 2023', Art Basel & UBS, 2023, p. 20, https://www.ubs.com/global/en/our-firm/art/collecting/art-market-survey/download-report-2023.html, accessed 18 October 2023.

17. Christophe Spaenjers, William N. Goetzmann & Elena Mamonova, 'A history of the art market in 35 record-breaking sales', Yale School of Management, 28 June 2016, https://som.yale.edu/news/2016/06/history-of-the-art-market-in-35-record-breaking-sales, accessed 21 August 2023.

18. Sotheby's, 'The History of Sotheby's Auction House', https://www.sothebys.com/en/about/our-history, accessed 21 August 2023.

19. Nicholas Shaxson, *Treasure Islands: Tax Havens and the Men Who Stole the World*, Vintage, 2016, pp. 76–7.

20. Spaenjers, Goetzmann & Mamonova, 'A history of the art market'.
21. Jason Hickel, *Less Is More: How Degrowth Will Save the World*, Penguin, 2020, p. 95.
22. Amah-Rose Abrams, 'Australian Tycoon Alan Bond, Who Bought Vincent van Gogh's "Irises" for Record $54 Million in 1987, Is Dead at 77', Artnet News, 8 June 2015, https://news.artnet.com/art-world/alan-bond-dies-van-gogh-305661, accessed 21 August 2023.
23. Sean French, 'Portrait of the art thief as a good man', *Observer*, 9 January 2000, https://www.theguardian.com/theobserver/2000/jan/09/featuresreview.review, accessed 21 August 2023; Doug Struck, 'Van Gogh's Portrait In Intrigue', *The Washington Post*, 29 July 1999, https://www.washingtonpost.com/archive/lifestyle/1999/07/29/van-goghs-portrait-in-intrigue/d75903d5–42f0–4072-aea1–91de937014eb/, accessed 17 October 2023.
24. Jane Martinson, 'Former Sotheby's chief admits price fixing scandal', *The Guardian*, 6 October 2000, https://www.theguardian.com/business/2000/oct/06/2, accessed 21 December 2023.
25. Nigel Rosser, 'Life goes on for key Britons', *The Standard*, 12 April 2012, https://www.standard.co.uk/hp/front/life-goes-on-for-key-britons-6335231.html, accessed 21 December 2023.
26. Andrew Osborn & Maev Kennedy, 'Sotheby's fined £13m for price-fixing scandal with Christie's', *The Guardian*, 31 October 2002, https://www.theguardian.com/uk/2002/oct/31/arts.artsnews, accessed 21 August 2023.
27. Scilla Alecci, 'From Banksy to Picasso, offshore world awash in valuable art', International Consortium of Investigative Journalists, 28 January 2022, https://www.icij.org/investigations/pandora-papers/from-banksy-to-picasso-offshore-world-awash-in-valuable-art/, accessed 18 October 2023.
28. Georgina Adam, 'The turn of the screw: will tighter regulations impact the art market?', *The Art Newspaper*, 25 November 2020, https://www.theartnewspaper.com/2020/11/25/the-turn-of-the-screw-will-tighter-regulations-impact-the-art-market, accessed 18 October 2023.
29. Maria Nizzero, 'Understanding the Art Market and Anti-Money Laundering Regulations', RUSI, 8 March 2023, https://rusi.org/pub-

lication/understanding-art-market-and-anti-money-laundering-regulations, accessed 18 October 2023.

30. Art Law Practice of Sheppard, Mullin, Richter & Hampton LLP, 'Unscroll the Scroll Painting: Inside the Chinese Art Market and Its Regulatory Landscape', *The National Law Review*, 15 April 2022, https://www.natlawreview.com/article/unroll-scroll-painting-inside-chinese-art-market-and-its-regulatory-landscape#:~:text=A%20 Relaxed%20Regulatory%20Environment&text=A%20business%20 filing%20and%20an,amended%20the%20Auction%20Administration%20Regulation, accessed 18 October 2023.

31. Marion Maneker, 'Most Successful Art Fund Trailed Inflation', *Art Market Monitor*, 26 January 2011, https://www.artmarketmonitor. com/2011/01/26/most-successful-art-fund-trailed-inflation/, accessed 28 February 2024.

32. Robert Hughes, 'Sold! The Art Market: Goes Crazy', *Time* magazine, 27 November 1989, https://newsfeed.time.com/2012/08/07/remembering-robert-hughes-author-and-art-critic/slide/sold-the-art-market-goes-crazy-monday-nov-27–1989/, accessed 18 October 2023.

33. At the time of writing, the top spot is believed to be held by Jasper Johns' Flag, reported to have sold for about $110 million in 2010. Caroline Galambosova & Nicole Ganbold, 'Top 10 Most Expensive Artworks by Living Artists (Updated)', *DailyArt Magazine*, 8 January 2024, https://www.dailyartmagazine.com/10-most-expensive-artworks-by-living-artists/, accessed 11 March 2024; Guinness World Records, 'Most expensive painting by a living artist sold in a private sale', n.d., https://www.guinnessworldrecords.com/world-records/most-expensive-painting-by-a-living-artist, accessed 11 March 2024.

34. Stephen Hicks, 'Why Art Became Ugly', The Atlas Society, 1 September 2004, https://www.atlassociety.org/post/why-art-became-ugly, accessed 21 August 2023.

35. Jongrim Ha, M. Ayhan Kose & Franziska Ohnsorge, 'Today's global economy is eerily similar to the 1970s, but governments can still escape a stagflation episode', Brookings, 1 July 2022, https://www.brookings. edu/blog/future-development/2022/07/01/todays-global-economy-is-eerily-similar-to-the-1970s-but-governments-can-still-escape-a-stagflation-episode, accessed 21 August 2023.

36. *Antiques Trade Gazette*, 'Frieze makes a splash, but for dealers it's still all about sales', 22 October 2003, https://www.antiquestradegazette.com/news/2003/frieze-makes-a-splash-but-for-dealers-it-s-still-all-about-sales/, accessed 18 October 2023; 'Klaus Weber: Public Fountain LSD Hall', http://www.k-weber.com/frameset1.html, accessed 21 August 2023.

37. Adrian Searle, 'One pair of children for sale, $6,000', *The Guardian*, 20 October 2003, https://www.theguardian.com/artanddesign/2003/oct/20/friezeartfair2003, accessed 21 August 2023.

38. Hannah McGivern, 'How the Louvre is spending its Abu Dhabi windfall', *The Art Newspaper*, 1 September 2016, https://www.theartnewspaper.com/2016/09/01/how-the-louvre-is-spending-its-abu-dhabi-windfall, accessed 21 August 2023.

39. William Morris, 'The Socialist Ideal: Art', *New Review*, January 1891, https://www.marxists.org/archive/morris/works/1891/ideal.htm.

40. Georgina Adam, *The Rise and Rise of the Private Art Museum*, Lund Humphries, 2021.

41. Alexandra Seno, 'South Korea tops global list for private art museums', *The Art Newspaper*, 19 January 2016, https://www.theartnewspaper.com/2016/01/19/south-korea-tops-global-list-for-private-art-museums, accessed 18 October 2023; Georgina Adam, 'Germany has the most private contemporary art museums in the world, new report reveals', *The Art Newspaper*, 13 June 2023, https://www.theartnewspaper.com/2023/06/13/germany-beats-us-on-number-of-private-museums-of-contemporary-art-new-report-reveals, accessed 18 October 2023.

42. Leeum was designed by Rem Koolhaas and Jean Nouvel. See Aaina Bhargava, 'Top 3 private museums in Seoul you should visit if you're going to the South Korean capital city', *Tatler* (Asia), 13 September 2023, https://www.tatlerasia.com/lifestyle/arts/private-museums-seoul-leeum-hanmi-san, accessed 18 October 2023.

43. Rachel Spence, 'Knives out for Pinault over resignation of Palazzo Grassi director', *The Art Newspaper*, 1 January 2010, https://www.theartnewspaper.com/2010/01/01/knives-out-for-pinault-over-resignation-of-palazzo-grassi-director, accessed 18 October 2023.

NOTES

pp. [31–35]

44. Georgina Adam, 'Not here to stay: what makes private museums suddenly close?', *The Art Newspaper*, 13 February 2020, https://www.theartnewspaper.com/2020/02/13/not-here-to-stay-what-makes-private-museums-suddenly-close, accessed 18 October 2023.
45. Mel Evans, *Artwash: Big Oil and the Arts*, Pluto Press, 2015; Andrew Ross, *Nice Work if You Can Get It: Life and Labour in Precarious Times*, New York University Press, 2009.
46. Evans, *Artwash*, pp. 66–74.
47. Evans, *Artwash*, p. 70.
48. Clara Paillard, 'Austerity starves our culture', *Red Pepper*, 16 May 2019, https://www.redpepper.org.uk/austerity-starves-our-culture, accessed 21 August 2023.
49. Paillard, 'Austerity starves our culture', *Red Pepper*.
50. Underminers, 'CFR accepts $12 mln from Len Blavatnik against a backlash from 56 activists and foreign policy professionals', 8 October 2019, https://www.underminers.info/publications/2019/10/8/cfr-accepts-12-mln-from-len-blavatnik-against-a-backlash-of-56-activists-and-foreign-policy-professionals, accessed 21 August 2023.
51. Billie Anania, 'Art Museums Touted as Community Investments Are Actually Fueling Gentrification', Truthout, 5 September 2021, https://truthout.org/articles/art-museums-touted-as-community-investments-are-actually-fueling-gentrification, accessed 21 August 2023.
52. Hrag Vartanian, 'Protesters Occupy Brooklyn Museum Atrium, Demanding Decolonization Commission', *Hyperallergic*, 30 April 2018, https://hyperallergic.com/440426/protesters-occupy-brooklyn-museum-atrium-demanding-decolonization-commission, accessed 21 August 2023.
53. Ayodeji Rotinwa, 'As the market for their artists booms, African galleries take control by expanding to the West', *The Art Newspaper*, 20 April 2021, https://www.theartnewspaper.com/2021/04/20/as-the-market-for-their-artists-booms-african-galleries-take-control-by-expanding-to-the-west, accessed 21 August 2023.
54. Hannah McGivern, 'Are Abu Dhabi, Shenzhen and Doha the new culture capitals? A new study says so', *The Art Newspaper*, 28 February 2023, https://www.theartnewspaper.com/2023/02/28/are-abu-dhabi-

shenzhen-and-doha-the-new-culture-capitals-a-new-study-says-so, accessed 19 October 2023.

55. Natasha Degen, 'The art market in the 21st century', Grove Art Online, 28 March 2019, https://www.oxfordartonline.com/groveart/view/10.1093/gao/9781884446054.001.0001/oao-9781884446054-e-2000000147, accessed 21 August 2023.

56. *Artlyst*, 'China Steals Global Art Market Dominance From USA', 20 March 2012, https://artlyst.com/news/china-steals-global-art-market-dominance-from-usa/#:~:text=China%20overtook%20the%20US%20for,by%203%25%20to%2034%25., accessed 18 October 2023.

57. Clare McAndrew, 'The Art Market 2022', Art Basel & UBS, 2022, p. 29, https://www.ubs.com/global/en/our-firm/art/collecting/art-market-survey/download-report-2022.html, accessed 21 August 2023.

58. Sotheby's, 'The History of Sotheby's Auction House'.

59. Christie's, 'Hong Kong', https://www.christies.com/locations/salerooms/hong-kong, accessed 21 August 2023.

60. Ai Weiwei, 'Ai Weiwei: "China's art world does not exist"', *The Guardian*, 10 September 2012, https://www.theguardian.com/artanddesign/2012/sep/10/ai-weiwei-china-art-world, accessed 18 October 2023.

61. *The Atlantic*, 'Hong Kong: The Most Business-Friendly City in the World', 16 May 2012, https://www.theatlantic.com/business/archive/2012/05/hong-kong-the-most-business-friendly-city-in-the-world/257304, accessed 21 August 2023.

62. *Artdaily*, 'ART HK 08 Celebrates Inaugural Success', 22 May 2008, https://artdaily.cc/news/24368/ART-HK-08-Celebrates-Inaugural-Success, accessed 21 August 2023.

63. Kate Brown & Eileen Kinsella, 'Hong Kong Is the Undisputed Capital of the Asian Art World. Does Beijing's New Crackdown Mean It's Destined to Lose the Title?', Artnet News, 5 June 2020, https://news.artnet.com/market/hong-kong-art-world-crackdown-1878939, accessed 21 August 2023.

64. Jonathan Watts, 'Olympic artist attacks China's pomp and propaganda', *The Guardian*, 9 August 2007, https://www.theguardian.com/world/2007/aug/09/china.artnews, accessed 18 October 2023.

65. Interview with the author, Miami, December 2015.

66. *Artdaily*, 'ART HK 08 Celebrates Inaugural Success'.

67. Robert Rich, 'The Great Recession', Federal Reserve History, 22 November 2013, https://www.federalreservehistory. org/essays/ great-recession-of-200709, accessed 21 August 2023.

68. Lesley Wroughton & Francois Murphy, 'IMF warns of financial meltdown', Reuters, 11 October 2008, https://www.reuters.com/article/us-financial3/imf-warns-of-financial-meltdown-idUSTRE49A36 O20081011, accessed 21 August 2023.

69. Gautam Mukunda, 'The Social and Political Costs of the Financial Crisis, 10 Years Later', *Harvard Business Review*, 25 September 2018, https://hbr.org/2018/09/the-social-and-political-costs-of-the-financial-crisis-10-years-later, accessed 21 August 2023.

70. Jeanna Smialek, 'The Financial Crisis Cost Every American $70,000, Fed Study Says', Bloomberg, 13 August 2018, https://www.bloomberg.com/news/articles/2018–08–13/the-financial-crisis-cost-every-american-70–000-fed-study-says?leadSource=uverify%20wall, accessed 18 October 2023.

71. The Investopedia Team, 'How the 2008 Housing Crash Affected the American Dream', *Investopedia*, 28 September 2021, https://www.investopedia.com/ask/answers/062515/how-was-american-dream-impacted-housing-market-collapse-2008.asp#:~:text=The%20Crash,homes%2C%20according%20to%20CNN%20Money, accessed 18 October 2023.

72. Sarah Burd-Sharps & Rebecca Rasch, 'Impact of the US Housing Crisis on the Racial Wealth Gap Across Generations', Social Science Research Council, report commissioned by the American Civil Liberties Union, June 2015, p. 3, https://www.aclu.org/sites/default/files/field_document/discrimlend_final.pdf, accessed 21 August 2023.

73. Marimuthu Sivakumar, '2008 Global Economic Crisis and Its Impacts on India's Exports and Imports', MPRA Paper No. 40950, 30 August 2012, pp. 7–8, https://mpra.ub.uni-muenchen.de/40950/1/MPRA_paper_40950.pdf, accessed 25 January 2024.

74. Georgina Adam, 'Why did India's art boom go bust?', BBC Culture, 10 February 2014, https://www.bbc.com/culture/article/20140210-why-did-indias-art-boom-go-bust, accessed 18 October 2023.

75. Kabir Jhala, 'Are young art collectors buying at India Art Fair?', *The Art Newspaper*, 10 February 2023, https://www.theartnewspaper.com/2023/02/10/india-art-fair-2023-young-collectors, accessed 18 October 2023.

76. Jay Bainbridge & Tony J. Carrizales, 'Global Homelessness in a Post-Recession World', *Journal of Public Management & Social Policy*, Vol. 24, No. 1, June 2017, p. 85, https://core.ac.uk/download/pdf/231127858.pdf, accessed 21 August 2023.

77. Shimelse Ali, 'Impact of the Financial Crisis on Africa', Carnegie Endowment for International Peace, 15 April 2009, https://carnegieendowment.org/2009/04/15/impact-of-financial-crisis-on-africa-pub-22995, accessed 21 August 2023.

78. Ruth Alexander, 'Dollar benchmark: The rise of the $1-a-day statistic', BBC News, 9 March 2012, https://www.bbc.co.uk/news/magazine-17312819, accessed 21 August 2023.

79. Sarah Gilbert, 'Portraits of people living on a dollar a day—in pictures', *The Guardian*, 5 June 2014, https://www.theguardian.com/society/gallery/2014/jun/05/portraits-of-people-living-on-a-dollar-a-day-in-pictures, accessed 21 August 2023.

80. Dionne Brand, *The Blue Clerk: Ars Poetica in 59 Versos*, Duke University Press, 2018, p. 110.

81. Georgina Adam, 'Art market: Recession on the horizon—but only for some', *Financial Times*, 4 October 2008, https://www.ft.com/content/e2c9d93e-90e4-11dd-8abb-0000779fd18c, accessed 21 August 2023.

82. Clare McAndrew, 'The Art Market 2022', Art Basel & UBS, p. 24.

83. Eileen Kinsella, 'Art Market Back on Solid Ground', ARTnews, 7 September 2010, https://www.artnews.com/art-news/news/art-market-back-on-solid-ground-933, accessed 21 August 2023.

84. Anna Brady, 'Rolling with the punches: how the art market bounced back', *The Art Newspaper*, 4 September 2018, https://www.theartnewspaper.com/2018/09/04/rolling-with-the-punches-how-the-art-market-bounced-back, accessed 21 August 2023.

85. Clare McAndrew, 'The Art Market 2022', Art Basel & UBS, p. 24.

86. Clare McAndrew, 'The Art Market 2023', Art Basel & UBS, p. 20.

87. UVW Union, 'Sotheby's Official Letter to Suspend Workers After

Protesting', 3 July 2015, https://www.uvwunion.org.uk/en/news/2015/07/sothebys-official-letter-to-suspend-workers-after-protesting, accessed 21 August 2023.

88. Laura Noonan, Cale Tilford, Richard Milne, Ian Mount & Peter Wise, 'Who went to jail for their role in the financial crisis?', *Financial Times*, 20 September 2018, https://ig.ft.com/jailed-bankers, accessed 21 August 2023.

89. BBC News, 'Occupy London protests in financial district', 15 October 2011, https://www.bbc.co.uk/news/uk-15322134, accessed 21 August 2023.

90. Sophie Perryer, 'Deutsche Bank's fall from grace: how one of the world's largest lenders got into hot water', *World Finance*, n.d., https://www.worldfinance.com/banking/deutsche-banks-fall-from-grace-how-one-of-the-worlds-largest-lenders-got-into-hot-water, accessed 18 October 2023.

91. Karen Freifeld et al., 'Deutsche Bank agrees to $7.2 billion mortgage settlement with U.S.', Reuters, 23 December 2016, https://www.reuters.com/article/us-deutsche-bank-mortgages-settlement-idUSK-BN14C041, accessed 18 October 2023; Jackie Wattles, 'Deutsche Bank finalizes $7.2 billion settlement', CNN Business, 17 January 2017, https://money.cnn.com/2017/01/17/news/economy/deutsche-bank-fine/, accessed 21 December 2023.

92. Sophie Perryer, 'Deutsche Bank's fall from grace', *World Finance*.

93. Marcus Baram, 'The journalist who revealed the secrets of Trump's relationship with Deutsche Bank', *Fast Company*, 18 February 2020, https://www.fastcompany.com/90464228/the-journalist-who-revealed-the-secrets-of-trumps-relationship-with-deutsche-bank, last accessed 18 October 2023.

94. Catherine G. Wagley, 'A Closer Look at Deutsche Bank, Frieze Art Fair's Biggest Sponsor', *Hyperallergic*, 13 February 2020, https://hyperallergic.com/542675/deutsche-bank-frieze-art-fair, accessed 21 August 2023.

95. Enrico, 'Interview with Roman Ondák, Deutsche Bank's Artist of the Year 2012', Vernissage TV, 17 October 2011, https://vernissage.tv/2011/10/17/interview-with-roman-andak-deutsche-banks-artist-of-the-year-2012/, accessed 19 October 2023.

96. Jackie Wullschlager, 'Frieze Art Fair 2011', *Financial Times*, 14 October 2011, https://www.ft.com/content/380e94d0-f653-11e0-86dc-00144 feab49a, accessed 19 October 2023.

97. Occupy Museums, https://occupymuseums.org/occupy-museums, accessed 21 August 2023.

98. Art F City, Tumblr, https://tumblr.artfcity.com/post/11652516894/ occupy-museums-speaking-out-in-front-of-the, accessed 21 August 2023.

99. James Panero, 'Commune plus one', *The New Criterion*, Vol. 30, No. 4, December 2011, p. 22, https://newcriterion.com/issues/2011/12/commune-plus-one, accessed 21 August 2023.

100. Brian Boucher, 'Occupy Museums Targets MoMA Trustees', *Art in America*, 17 January 2012, https://www.artnews.com/art-in-america/ features/occupy-moma-58661, accessed 21 August 2023.

101. Jasmine Liu, 'Whitney Museum Workers Surprise 2022 Biennial Guests With Union Protest', *Hyperallergic*, 30 March 2022, https:// hyperallergic.com/721305/whitney-museum-workers-surprise-2022-biennial-guests-with-union-protest, accessed 21 August 2023.

102. Oliver Basciano, '"It's artwashing": can galleries wean themselves off Russian oligarch loot?', *The Guardian*, 17 March 2022, https://www. theguardian.com/artanddesign/2022/mar/17/artwashing-art-galleries-russian-oligarch-money, accessed 25 September 2023; Rachel Spence, 'How the Hermitage Museum Artwashes Russian Aggression', *Hyperallergic*, https://hyperallergic.com/715271/how-the-hermitage-museum-artwashes-russian-aggression, 6 March 2022, accessed 25 September 2023.

## 2. DECOLONISE THIS PHILANTHROPY

1. Peter Eliscu, 'Demilitarize the Whitney: Fire Warren Kanders!', YouTube, 10 May 2019, https://www.youtube.com/watch?v=fv7YA2U3vsM&t=52s, accessed 21 December 2023.

2. Jillian Steinhauer, 'The Whitney Biennial: 75 Artists Are In, and One Dissenter Steps Out', *The New York Times*, 25 February 2019, https:// www.nytimes.com/2019/02/25/arts/design/2019-whitney-biennial.html, accessed 2 September 2023.

3. Eileen Kinsella, 'Hal Foster, Claire Bishop, and More Than 120 Other Intellectuals Call for the Removal of Warren Kanders From the Whitney's Board', Artnet News, 5 April 2019, https://news.artnet.com/art-world/whitney-museum-warren-kanders-1510198, accessed 2 September 2023.

4. Michael Kimmelman, 'A New Whitney', *The New York Times*, 19 April 2015, https://www.nytimes.com/interactive/2015/04/19/arts/artsspecial/new-whitney-museum.html, accessed 2 September 2023.

5. Ariella Budick, 'New Whitney Museum's inaugural show "America Is Hard to See"', *Financial Times*, 1 May 2015, https://www.ft.com/content/8c4f3484-ecc0–11e4-a81a-00144feab7de, accessed 2 September 2023.

6. Edwin Heathcote, 'New Whitney Museum's inaugural show "America Is Hard to See"', *Financial Times*, 1 May 2015, https://www.ft.com/content/8c4f3484-ecc0–11e4-a81a-00144feab7de, accessed 2 September 2023.

7. FitchRatings, 'Fitch Affirms Whitney Museum of American Art, NY at "AA"; Outlook Stable', 3 October 2019, https://www.fitchratings.com/research/us-public-finance/fitch-affirms-whitney-museum-of-american-art-ny-at-aa-outlook-stable-03–10–2019, accessed 24 October 2023; *Candid*, 'Whitney Museum Receives $131 Million Gift', Philanthropy News Digest, 20 March 2008, https://philanthropynewsdigest.org/news/whitney-museum-receives-131-million-gift#:~:text=The%20Whitney%20Museum%20of%20American, the%20New%20York%20Times%20reports, accessed 24 October 2023; 'Leonard Lauder', *Forbes* profile, https://www.forbes.com/profile/leonard-lauder/?sh=742bbfb17354, accessed 24 October 2023.

8. Robin Pogrebin & Elizabeth A. Harris, 'Warren Kanders Quits Whitney Board After Tear Gas Protests', *The New York Times*, 25 July 2019, https://www.nytimes.com/2019/07/25/arts/whitney-warren-kanders-resigns.html, accessed 2 September 2023.

9. Robin Pogrebin & Matthew Goldstein, 'Leon Black to Step Down as MoMA Chairman', *The New York Times*, 26 March 2021, https://www.nytimes.com/2021/03/26/arts/design/leon-black-moma-chairman.html, accessed 2 September 2023.

10. Cristina Ruiz, 'Sackler Trust charity in UK suspends all new gifts', *The*

*Art Newspaper*, 25 March 2019, https://www.theartnewspaper. com/2019/03/25/sackler-trust-charity-in-uk-suspends-all-new-gifts, accessed 24 October 2023.

11. *Hyperallergic*, 'About Us', https://hyperallergic.com/about, accessed 2 September 2023.

12. Maya Averbuch & Elisabeth Malkin, 'Migrants in Tijuana Run to U.S. Border, but Fall Back in Face of Tear Gas', *The New York Times*, 25 November 2018, https://www.nytimes.com/2018/11/25/world/ americas/tijuana-mexico-border.html, accessed 24 October 2023.

13. Jasmine Weber, 'A Whitney Museum Vice Chairman Owns a Manufacturer Supplying Tear Gas at the Border', *Hyperallergic*, 27 November 2018, https://hyperallergic.com/472964/a-whitney-museum-vice-chairman-owns-a-manufacturer-supplying-tear-gas-at-the-border, accessed 2 September 2023.

14. Anna Feigenbaum, 'The profitable theatrics of riot control', Al Jazeera, 2 May 2015, http://america.aljazeera.com/opinions/2015/5/the-profitable-theatrics-of-riot-control.html, accessed 2 September 2023.

15. Jon Swaine et al., 'Baltimore protests: police in riot gear disperse hundreds defying 10pm curfew', *The Guardian*, 29 April 2015, https:// www.theguardian.com/us-news/2015/apr/29/baltimore-protests-police-in-riot-gear-disperse-hundreds-defying-10pm-curfew, accessed 24 October 2023.

16. Decolonize This Place, https://decolonizethisplace.org/faxxx-1, accessed 2 September 2023.

17. Harvard GSD, 'International Womxn's Week Keynote Address: Nitasha Dhillon', YouTube, 11 April 2022, https://www.youtube.com/ watch?v=bMfHfZ1keB8, accessed 24 October 2024.

18. Decolonize This Place, 'After Kanders, Decolonization Is the Way Forward', *Hyperallergic*, 30 July 2019, https://hyperallergic.com/511683/ decolonize-this-place-after-kanders, accessed 2 September 2023.

19. Quoted in Mikaela Loach, *It's Not That Radical: Climate Action to Transform Our World*, DK, 2023, p. 26.

20. Harvard GSD, 'International Womxn's Week Keynote Address: Nitasha Dhillon'.

21. Decolonize This Place, 'The Crisis of the Whitney', https://decolonizethisplace.org/9weeksofartinaction2, accessed 2 September 2023.

22. Decolonize This Place, 'The Crisis of the Whitney'.

23. John Berger, *Hold Everything Dear: Dispatches on Survival and Resistance*, Verso, 2006.

24. Berger, *Hold Everything Dear*.

25. Colin Moynihan, 'Protests at the Whitney Over a Board Member Whose Company Sells Tear Gas', *The New York Times*, 18 May 2019, https://www.nytimes.com/2019/05/18/arts/whitney-protests.html, accessed 24 October 2023.

26. Jillian Steinhauer, 'An Artist Honors Tamir Rice, One Orange Object at a Time', *The New York Times*, 29 July 2018, https://www.nytimes.com/2018/07/29/arts/design/tamir-rice-cleveland-triennial-orange-rakowitz.html, accessed 2 September 2023.

27. Steinhauer, 'The Whitney Biennial', *The New York Times*.

28. 'Artists Withdraw from Whitney Biennial As Backlash Builds Against Warren Kanders [Updated]', *Artforum*, 19 July 2019, https://www.artforum.com/news/artists-withdraw-from-whitney-biennial-as-backlash-builds-against-warren-kanders-80360, accessed 2 September 2023.

29. 'A Letter from Artists in the Whitney Biennial', *Artforum*, 19 July 2019, https://www.artforum.com/slant/a-letter-from-artists-in-the-whitney-biennial-80361, accessed 2 September 2023.

30. Andrew Edgecliffe-Johnson, 'Tear gas company boss on the benefits of "less-lethal" weapons', *Financial Times*, 12 January 2020, https://www.ft.com/content/0b79bfc6-32b8-11ea-9703-eea0cae3f0de, accessed 2 September 2023.

31. Mckenzie Sadeghi, 'Fact check: It's true tear gas is a chemical weapon banned in war', USA Today News, 6 June 2020, https://eu.usatoday.com/story/news/factcheck/2020/06/06/fact-check-its-true-tear-gas-chemical-weapon-banned-war/3156448001, accessed 2 September 2023.

32. ChemTel Inc, 'Safety Data Sheet: acc. to OSHA HCS (29 CFR 1910.1200)', 7 December 2015, pp. 4–5, https://sds.chemtel.net/web-clients/safariland/finished_goods/Defense%20Technology%201072%20-%20Spede-Heat%20Continuous%20Discharge%20Chemical%20Grenade%20-%20CS%20-%20US.pdf, accessed 28 February 2024.

33. Zachary Small, 'Forensic Architecture Says It Has Found Bullet Linking Whitney Vice Chair to Violence in Gaza, Withdraws from Biennial', *Hyperallergic*, 20 July 2019, https://hyperallergic.com/510367/forensic-architecture-biennial-withdrawal, accessed 2 September 2023.

34. United Nations Human Rights Council, 'Report of the UN Commission of Inquiry on the 2018 protests in the OPT', https://www.ohchr.org/sites/default/files/Documents/HRBodies/HRCouncil/CoIOPT/A_HRC_40_74.pdf, pp. 20, 22, accessed 25 October 2023.

35. Alex Greenberger, 'After Months of Protests, Warren B. Kanders Resigns from Whitney Board", ARTnews, 25 July 2019, https://www.artnews.com/art-news/news/warren-kanders-resigns-whitney-13036/, accessed 28 February 2024.

36. Edgecliffe-Johnson, 'Tear gas company boss on the benefits', *Financial Times*.

37. Warren B. Kanders, Letter to the Board of Trustees of the Whitney Museum, 25 July 2019, https://int.nyt.com/data/documenthelper/1509-warren-kanders-resignation-whitney/41cf3263664a16cf1a29/optimized/full.pdf#page=1, accessed 2 September 2023.

38. Verso Books blog, 'Kanders Must Go: An Open Letter from Theorists, Critics, and Scholars [Updated list of signatories]', 29 April 2019, https://www.versobooks.com/blogs/4295-kanders-must-go-an-open-letter-from-theorists-critics-and-scholars-updated-list-of-signatories, accessed 2 September 2023.

39. Hrag Vartanian, Zachary Small & Jasmine Weber, 'Whitney Museum Staffers Demand Answers After Vice Chair's Relationship to Tear Gas Manufacturer Is Revealed', *Hyperallergic*, 30 November 2018, https://hyperallergic.com/473702/whitney-tear-gas-manufacturer-is-revealed, accessed 2 September 2023.

40. Pogrebin & Harris, 'Warren Kanders Quits Whitney Board'.

41. Sinéad Murphy, *The Art Kettle*, Zer0 Books, 2012, pp. 4–5.

42. Vartanian, Small & Weber, 'Whitney Museum Staffers Demand Answers', *Hyperallergic*.

43. Edgecliffe-Johnson, 'Tear gas company boss on the benefits', *Financial Times*.

44. Hrag Vartarian, 'Michael Rakowitz Discusses Withdrawing from the

2019 Whitney Biennial, and His Leonard Cohen Problem', *Hyperallergic*, 17 May 2019, https://hyperallergic.com/500947/michael-rakowitz-whitney-biennial-leonard-cohen, accessed 2 September 2023.

45. Adam Weinberg, 'A Letter to Staff and Trustees from Adam', 2 December 2018, https://drive.google.com/file/d/1CwKKMz-Dy9qcKa_uZVO wg4pZSruSINU8/view, accessed 2 September 2023.

46. One particularly dazzling example of this neutering concerns a campaign by the Gulf Labor Coalition to improve conditions for migrant workers charged with building new Western museums in the United Arab Emirates. On hearing that the GLC was organising a boycott of the Guggenheim's new branch in Abu Dhabi, the New York museums asked activists to cease that strategy and channel their anger into works of art instead.

47. Whitney Museum of American Art, 'From Our Director: We Stand with Black Communities', https://whitney.org/we-stand-with-black-communities, accessed 2 September 2023.

48. 'Leonard Lauder', Forbes, https://www.forbes.com/profile/leonard-lauder/?sh=43ef11b57354, accessed 2 September 2023.

49. Savanna Strott & Riley Rogerson, 'Case Closed?', Investigative Reporting Workshop, 17 February 2022, https://investigativereport-ingworkshop.org/investigation/case-closed, accessed 2 September 2023.

50. Zachary Small, 'A Closer Look Into the Whitney Museum's Board', *Hyperallergic*, 7 May 2019, https://hyperallergic.com/486055/a-closer-look-into-the-whitney-museums-board, accessed 2 September 2023.

31. Phillip Mattera, 'Citigroup', Corporate Research Project, 7 December 2020, https://www.corp-research.org/citigroup, accessed 2 September 2023.

## 3. LABOUR OF LOSS

1. Tate, 'Equality, Diversity and Inclusion', https://www.tate.org.uk/about-us/working-at-tate/diversity-inclusion, accessed 2 September 2023.

2. Vincent Noce, 'Controversy swirls around Centre Pompidou ahead of 2025 closure', *The Art Newspaper*, 8 December 2023, https://www.theartnewspaper.com/2023/12/08/staff-strikes-rock-centre-pompidou-ahead-of-2025-closure, accessed 27 February 2024.

3. Hannah McGivern & Nancy Kenney, '"There is no fast track back to normal": museums confront economic fallout of the pandemic', *The Art Newspaper*, 24 April 2020, https://www.theartnewspaper.com/2020/04/24/there-is-no-fast-track-back-to-normal-museums-confront-economic-fallout-of-the-pandemic, accessed 2 September 2023.

4. Gareth Harris, 'Wave of museum educator redundancies worldwide sparks open letter', *The Art Newspaper*, 23 April 2020, https://www.theartnewspaper.com/2020/04/23/wave-of-museum-educator-redundancies-worldwide-sparks-open-letter, accessed 26 October 2023.

5. India Stoughton, 'Economic value of museums and galleries on the rise', ArtsProfessional, 23 August 2022, https://www.artsprofessional.co.uk/news/economic-value-museums-and-galleries-rise, accessed 26 October 2023.

6. Museums Association, 'Redundancies in the museums sector after one year of Covid: A review of Museums Association Redundancy Tracker data', June 2021, https://media.museumsassociation.org/app/uploads/2021/06/11083312/Redundancy-Report-June–2021.pdf, accessed 26 October 2023.

7. American Alliance of Museums & Wilkening Consulting, 'National Snapshot of COVID-19 Impact on United States Museums', 15–28 October 2020, https://www.aam-us.org/wp-content/uploads/2020/11/AAMCOVID-19SnapshotSurvey-1.pdf, accessed 2 September 2023.

8. American Alliance of Museums & Wilkening Consulting, 'Measuring the Impact of COVID-19 on People in the Museum Field', 9–17 March 2021, https://www.aam-us.org/wp-content/uploads/2021/04/Measuring-the-Impact-of-COVID-19-on-People-in-the-Museum-Field-Report.pdf, accessed 2 September 2023.

9. The Art Newspaper, 'The Art Newspaper Live: Funding Matters | How can museums recover after Covid-19?', YouTube, 26 June 2020, https://www.youtube.com/watch?v=ADwKFkmBLtQ&list=PLX7lSF2Aw38V1TUYo7VwiI6Liw5WVph0G, accessed 2 September 2023.

10. Sarah Cascone, 'The Victoria and Albert Museum Will Cut a Fifth of Its Curatorial Staff as Part of a Sweeping Round of Layoffs', Artnet News, 26 February 2021, https://news.artnet.com/art-world/victoria-albert-museum-layoffs-1947403, accessed 2 September 2023.

11. Hannah McGivern & Nancy Kenney, "'There is no fast track back to normal": museums confront economic fallout of the pandemic', *The Art Newspaper*, 24 April 2020, https://www.theartnewspaper.com/2020/04/24/there-is-no-fast-track-back-to-normal-museums-confront-economic-fallout-of-the-pandemic, accessed 2 September 2023.

12. Much of the following analysis is based on Mel Evan's book *Artwash: Big Oil and the Arts* (Pluto Press, 2015).

13. Mel Evans, *Artwash: Big Oil and the Arts*, Pluto Press, 2015, p. 67.

14. Ibid., p. 10.

15. 'Fund museums to keep them free', Letter to *The Guardian*, 21 June 2007, https://www.theguardian.com/news/2007/jun/21/leadersandreply.mainsection1, accessed 2 September 2023.

16. Rachel Spence, 'With the threat of cuts, unions get militant in UK museums—and their membership is growing rapidly', *The Art Newspaper*, 17 November 2022, https://www.theartnewspaper.com/2022/11/17/with-the-threat-of-cuts-unions-get-militant-in-uk-museums, accessed 2 September 2023.

17. Ben Quinn, 'Questions raised about UK arts donations of Leonard Blavatnik', *The Guardian*, 16 May 2022, https://www.theguardian.com/culture/2022/may/16/questions-raised-about-uk-arts-donations-of-leonard-blavatnik, accessed 26 October 2023.

18. 'Oxford University must stop selling its reputation to Vladimir Putin's associates', Letter to *The Guardian*, 3 November 2015, https://www.theguardian.com/education/2015/nov/03/oxford-university-must-stop-selling-its-reputation-to-vladimir-putin-associates, accessed 2 September 2023.

19. The Associated Press, 'OxyContin maker Purdue pleads guilty to charges related to opioid crisis', 24 November 2020, https://www.cbc.ca/news/health/purdue-opioid-epidemic-guilty-1.5814318, accessed 2 September 2023.

20. Victoria Stapley-Brown, 'Philanthropy, but at what price? US museums wake up to public's ethical concerns', *The Art Newspaper*, 28 August 2019, https://www.theartnewspaper.com/2019/08/28/philanthropy-but-at-what-price-us-museums-wake-up-to-publics-ethical-concerns, accessed 2 September 2023.

21. Tyler Walicek, 'A Unionization Wave Is Reshaping Museums and Cultural Institutions Across the US', Truthout, 27 November 2021, https://truthout.org/articles/a-unionization-wave-is-reshaping-museums-and-cultural-institutions-across-the-us, accessed 2 September 2023. Arguably, that 'private money' is actually public, because in the US, donors can write off their tax, meaning that lost tax revenue is propping up museums.

22. Maida Rosenstein, Zoom interview with the author, 6 September 2022.

23. Robin Pogrebin, 'Museum Boss Salaries: Reduced but Still an Issue Amid Wider Cutbacks', The New York Times, 18 August 2020, https://www.nytimes.com/2020/08/18/arts/design/museum-leader-salaries-pay-disparity.html, accessed 2 September 2023.

24. Pogrebin, 'Museum Boss Salaries', The New York Times.

25. 'Arts + All Museums Salary Transparency 2019_View Only', https://docs.google.com/spreadsheets/d/14_cn3afoas7NhKvHWaFKqQGka-ZS5rvL6DFxzGqXQa6o/htmlview?usp=sharing#, accessed 2 September 2023.

26. Maida Rosenstein, Zoom interview with the author, 6 September 2022.

27. 'Arts + All Museums Salary Transparency'.

28. David Hunn, 'Firm running Botanical Garden gift shop had rocky start at Science Center', St. Louis Post-Dispatch, 1 April 2014, https://www.stltoday.com/news/local/metro/firm-running-botanical-garden-gift-shop-had-rocky-start-at-science-center/article_86480acb-b6e4-541b-ac4a-0010d0d0bd7f.html, accessed 2 September 2023.

29. Museums Association, 'Struggling to strike a balance', 28 September 2015, https://www.museumsassociation.org/museums-journal/analysis/2015/09/01102015-museums-and-galleries-are-struggling-to-strike-a-balance, accessed 2 September 2023.

30. Tate, 'Governance', https://www.tate.org.uk/about-us/governance, accessed 2 September 2023.

31. Tate Press Office, email interview with author, 4 October 2023.

32. Clara Paillard, 'Austerity starves our culture', Red Pepper, 16 May 2019, https://www.redpepper.org.uk/austerity-starves-our-culture, accessed 2 September 2023.

33. Hannah Ellis-Petersen, 'Petition against privatisation of new V&A

staff contracts reaches 40,000', *The Guardian*, 1 February 2016, https://www.theguardian.com/artanddesign/2016/feb/01/petition-protest-privatisation-v-and-a-staff-contracts-40000, accessed 2 September 2023.

34. Polly Toynbee, 'After Carillion, outsourcing looks like a dogma that's run out of road', *The Guardian*, 26 March 2018, https://www.theguardian.com/commentisfree/2018/mar/26/carillion-outsourcing-public-servants-jobs, accessed 2 September 2023.

35. Claire Selvin, 'British Museum Workers Issue Support for Former Trustee Ahdaf Soueif, Who Cited Opposition to BP Funding in Resignation', ARTNews, 19 July 2019, https://www.artnews.com/artnews/news/british-museum-workers-bp-ahdaf-soueif-13007/, accessed 27 October 2023.

36. Ahdaf Soueif, 'On Resigning from the British Museum's Board of Trustees', *London Review of Books* blog, 15 July 2019, https://www.lrb.co.uk/blog/2019/july/on-resigning-from-the-british-museum-s-board-of-trustees, accessed 2 September 2023.

37. Damien Gayle, 'National Gallery staff strike shuts down most exhibitions', *The Guardian*, 11 August 2015, https://www.theguardian.com/artanddesign/2015/aug/11/national-gallery-staff-strike-exhibitions-privatisation, accessed 2 September 2023.

38. Hannah McGivern, '2018 in museums: big ethics questions dominate the field', *The Art Newspaper*, 10 December 2018, https://www.theartnewspaper.com/2018/12/10/2018-in-museums-big-ethics-questions-dominate-the-field, accessed 2 September 2023.

39. Clara Paillard, Zoom interview with the author, 30 November 2022.

40. Hannah McGivern & Nancy Kenney, 'Museums 2020: the year of crashing revenues and anti-racism disputes', *The Art Newspaper*, 27 November 2020, https://www.theartnewspaper.com/2020/11/27/museums-2020-the-year-of-crashing-revenues-and-anti-racism-disputes, accessed 2 September 2023.

41. Mona Chalabi, 'Museum art collections are very male and very white', *The Guardian*, 21 May 2019, https://www.theguardian.com/news/datablog/2019/may/21/museum-art-collections-study-very-male-very-white, accessed 2 September 2023; Alex Greenberger, 'White Cubes: Do Exhibitions at U.S. Museums Reflect Calls for Diversity?',

ARTnews, 5 August 2019, https://www.artnews.com/art-news/news/u-s-museums-exhibitions-diversity-survey-13065, accessed 2 September 2023.

42. @StephanieYeboah, Twitter, 6 June 2020, https://twitter.com/Stephanie Yeboah/status/1269384193823444993?s=20, accessed 2 September 2023.

43. Maida Rosenstein, Zoom interview with the author, 6 September 2022.

44. *Art Forum*, 'Museum Leadership Remains Predominantly White in 2018, Study Finds', 29 January 2019, https://www.artforum.com/news/museum-leadership-remains-predominantly-white-in-2018-study-finds-78507, accessed 2 September 2023.

45. Jillian Steinhauer, 'A crisis in community reach: MoMA's arts educators on the consequences of their contract cuts', *The Art Newspaper*, 9 July 2020, https://www.theartnewspaper.com/2020/07/09/a-crisis-in-community-reach-momas-arts-educators-on-the-consequences-of-their-contract-cuts, accessed 2 September 2023.

46. Robin Pogrebin, 'Museum Boss Salaries: Reduced but Still an Issue Amid Wider Cutbacks', *The New York Times*, 18 August 2020, https://www.nytimes.com/2020/08/18/arts/design/museum-leader-salaries-pay-disparity.html, accessed 2 September 2023.

47. Steven Warwick, Zoom interview with the author, 23 August 2022.

48. Amy Traub, Catherine Ruetschlin, Laura Sullivan, Tatjana Meschede, Lars Dietrich & Thomas Shapiro, 'The Racial Wealth Gap: Why Policy Matters', Demos, 21 June 2016, https://www.demos.org/research/racial-wealth-gap-why-policy-matters, accessed 2 September 2023; Bloomberg, 'Bridging the Black wealth gap in the UK', 8 October 2021, https://www.bloomberg.com/company/stories/bridging-the-black-wealth-gap-in-the-uk, accessed 2 September 2023.

49. Carla Kidd, 'Household wealth by ethnicity, Great Britain: April 2016 to March 2018', Office for National Statistics, 23 November 2020, https://www.ons.gov.uk/peoplepopulationandcommunity/personalandhouseholdfinances/incomeandwealth/articles/householdwealthbyethnicitygreatbritain/april2016tomarch2018, accessed 2 September 2023.

50. Steven Warwick, Zoom interview.

51. A Better Guggenheim, 'Letter to the Board', https://abetterguggenheim.com/letter-to-board, accessed 3 September 2023; Hakim Bishara, 'Guggenheim Employees Call for Removal of Three Top Executives', *Hyperallergic*, https://hyperallergic.com/588488/a-better-guggenheim-removal-letter, accessed 3 September 2023.

52. Robin Pogrebin, 'Guggenheim's Top Curator Is Out as Inquiry Into Basquiat Show Ends', *The New York Times*, 8 October 2020, https://www.nytimes.com/2020/10/08/arts/design/guggenheim-investigation-nancy-spector.html, accessed 26 October 2023.

53. Julia Jacobs, 'Director of the Guggenheim to Step Down', *The New York Times*, 8 July 2022, https://www.nytimes.com/2022/07/08/arts/design/director-guggenheim-richard-armstrong-steps-down.html, accessed 3 September 2023.

54. Trupti Rami, 'The Instagram Account "Change the Museum" Is Doing Just That', *Vulture*, 15 July 2020, https://www.vulture.com/2020/07/change-the-museum-instagram.html, accessed 3 September 2023.

55. Carol Pogash, 'Its Top Curator Gone, SFMOMA Reviews Its Record on Race', 22 July 2020, https://www.nytimes.com/2020/07/22/arts/design/sfmoma-gary-garrels-resignation.html, accessed 3 September 2023.

56. Torey Akers, 'Are US museums becoming more inclusive? New surveys of workers and trustees provide modest hope', *The Art Newspaper*, 16 November 2022, https://www.theartnewspaper.com/2022/11/16/mellon-foundation-black-trustee-alliance-art-museums-surveys-diversity, accessed 3 September 2023.

57. Zarina Muhammad, 'ideas for a new art world', The White Pube, 3 April 2020, https://thewhitepube.co.uk/art-thoughts/ideasforanewartworld, accessed 3 September 2023.

58. The White Pube, Twitter post, 11 August 2020, https://twitter.com/TheWhitePube/status/1293226752911839232, accessed 27 October 2023; The White Pube, Instagram post, 12 August 2020, https://www.instagram.com/p/CDyTSmvlPPg/?hl=en&img_index=1, accessed 27 October 2023.

59. Muhammad, 'ideas for a new art world', The White Pube.

60. Muhammad, 'ideas for a new art world', The White Pube.

61. Liam Sweeney et al., 'Art Museum Staff Demographic Survey: 2022', Mellon Foundation & Ithaka S+R, 2022, pp. 3, 16, 18, https://assets.ctfassets.net/nslp74meuw3d/6gnnNJOBeDbYImaDPNnyT9/3221a84 6b1706bd73c552b2eb5931b5e/art_museum_staff_dem_survey_2022.pdf, accessed 26 October 2023.

62. Lise Ragbir, 'I Was a Museum's Black Lives Matter Hire', *Hyperallergic*, 2 March 2023, https://hyperallergic.com/804872/i-was-a-museums-black-lives-matter-hire-eunice-belidor, accessed 3 September 2023.

63. Ragbir, 'I Was a Museum's Black Lives Matter Hire', *Hyperallergic*.

64. Dean Spade, Carleton School of Journalism and Communication, YouTube, '2022 Attallah Lecture: Should social movement work be paid?', 22 September 2022, https://www.youtube.com/watch?v=9Pv1 GHbEFnE, accessed 3 September 2023.

65. Spade, '2022 Attallah Lecture'.

66. William Morris, 'The Socialist Ideal: Art', *New Review*, January 1891, https://www.marxists.org/archive/morris/works/1891/ideal.htm, accessed 3 September 2023.

67. Andrew Ross, Zoom interview with the author, 14 August 2022.

68. Tom Seymour, 'State of the unions: why US museum workers are mobilising against their employers', *The Art Newspaper*, 2 February 2022, https://www.theartnewspaper.com/2022/02/02/state-of-the-unions-a-new-renaissance-at-us-museums, accessed 3 September 2023; Spence, 'With the threat of cuts, unions get militant', *The Art Newspaper*; Walicek, 'A Unionization Wave Is Reshaping Museums', Truthout.

69. Spence, 'With the threat of cuts, unions get militant', *The Art Newspaper*; Walicek, 'A Unionization Wave Is Reshaping Museums', Truthout.

70. Spence, 'With the threat of cuts, unions get militant', *The Art Newspaper*.

71. Geoff Tily, 'Our 150 years show that stronger unions mean a better economy', TUC, 4 September 2018, https://www.tuc.org.uk/blogs/our-150-years-show-stronger-unions-mean-better-economy, accessed 3 September 2023.

72. Spence, 'With the threat of cuts, unions get militant', *The Art Newspaper*.

73. Maida Rosenstein, Zoom interview with the author, 6 September 2022.

74. Stephen Ashe, 'Why I'm talking to white trade unionists about racism', *Open Democracy*, 6 September 2019, https://www.opendemocracy.net/en/opendemocracyuk/why-im-talking-white-trade-unionists-about-racism, accessed 3 September 2023.

75. Spence, 'With the threat of cuts, unions get militant', *The Art Newspaper*.

76. My account is based on the following report: Jasmine Liu, 'Whitney Museum Workers Surprise 2022 Biennial Guests With Union Protest', *Hyperallergic*, 30 March 2022, https://hyperallergic.com/721305/whitney-museum-workers-surprise-2022-biennial-guests-with-union-protest, accessed 3 September 2023.

77. Hakim Bishara, 'Spreadsheet Highlights Major Income Disparities at Cultural Institutions', 29 April 2020, *Hyperallergic*, https://hyperallergic.com/560132/spreadsheet-highlights-major-income-disparities-at-cultural-institutions, accessed 3 September 2023.

78. Bishara, 'Spreadsheet Highlights Major Income Disparities at Cultural Institutions', *Hyperallergic*.

79. Anoosh Chakelian, 'Will pay rises cause inflation?', *The New Statesman*, https://www.newstatesman.com/economy/2022/12/pay-rises-cause-inflation, accessed 3 September 2023.

80. International Council of Museums, 'Museum Definition', https://icom.museum/en/resources/standards-guidelines/museum-definition, accessed 3 September 2023.

80. Steven Warwick, Zoom interview.

82. Tate Press Office, email interview.

83. Spence, 'With the threat of cuts, unions get militant', *The Art Newspaper*; Steven Warwick, email exchange with the author, March 2024.

84. Ibid.

85. Stephan Salisbury, 'Philly art museum hires big law firm as staff seeks recognition of union', *The Philadelphia Inquirer*, 10 June 2020, https://www.inquirer.com/news/philadelphia-museum-of-art-labor-union-morgan-lews-20200610.html, accessed 27 October 2023.

86. Richard W. Hurd & Jill K. Kriesky, 'The Rise and Demise of PATCO: Reconstructed', *Industrial and Labor Relations Review*, 40(1), 1986, pp. 115–22, https://ecommons.cornell.edu/server/api/core/bitstreams/

d3bfb24f-c999-4431-969f-a2259235bda9/content; Julia Simon & Kenny Malone, 'Looking Back On When President Reagan Fired The Air Traffic Controllers', NPR, 5 August 2021, https://www.npr.org/2021/08/05/1025018833/looking-back-on-when-president-reagan-fired-air-traffic-controllers, accessed 3 September 2023.

87. Ben Davis, 'As Its Workers Organize, the Philadelphia Museum of Art Management Turns to an Infamous Anti-Union Law Firm', Artnet News, 11 June 2020, https://news.artnet.com/opinion/morgan-lewis-philadelphia-museum-of-art-union-1884207, accessed 3 September 2023.

88. Vanessa O'Connell, 'Big Law's $1,000-Plus an Hour Club', The Wall Street Journal, 23 February 2011, https://www.wsj.com/articles/SB10001424052748704071304576160362028728234, accessed 27 October 2023.

89. Cultural Workers United, 'Cultural Institutions Cashed In, Workers Got Sold Out', October 2021, pp. 3, 5, https://afscmeatwork.org/system/files/afscme-cwu_accountability-report.pdf, accessed 27 October 2023.

90. Ibid., p. 6.

91. Eileen Kinsella, 'Why Did So Many Workers Get Laid Off From U.S. Museums When They Received So Much Federal Aid? A New Report Crunches the Numbers', Artnet News, 14 October 2021, https://news.artnet.com/art-world/museums-ppp-funding-laid-off-workers-2020523, accessed 27 October 2023.

92. Maida Rosenstein, Zoom interview with the author, 6 September 2022.

93. Cultural Workers United, 'Cultural Institutions Cashed In, Workers Got Sold Out', p. 3.

94. Spence, 'With the threat of cuts, unions get militant', The Art Newspaper.

95. Clara Paillard, Zoom interview with the author, 30 November 2022; Clara Paillard, email exchange with the author, 6 February 2024.

96. Spence, 'With the threat of cuts, unions get militant', The Art Newspaper.

97. Liam Kelly, '"No Contract, No Matisse": Philadelphia Museum of Art Workers Win First Contract After Strike', Labor Notes, 17 November 2022, https://labornotes.org/2022/11/no-contract-no-matisse-philadelphia-museum-art-workers-win-first-contract-after-strike, accessed 3 September 2023.

98. Zachary Small, 'Whitney Museum Reaches Agreement With Unionized Workers', 6 March 2023, https://www.nytimes.com/2023/03/06/arts/design/whitney-museum-union-contract.html, accessed 3 September 2023.

99. Tessa Solomon, 'The Whitney Union Ratifies Contract, Ending More than a Year of Bargaining', ARTnews, 6 March 2023, https://www.artnews.com/art-news/news/the-whitney-union-reaches-tentative-contract-1234659966, accessed 3 September 2023.

100. Maida Rosenstein, Zoom interview with the author, 6 September 2022.

101. W.A.G.E., https://wageforwork.com/about#top, accessed 3 September 2023.

102. Elaine Velie, 'Is Your Organiation Adequately Paying Artists?'. *Hyperallergic*, 7 June 2023, https://hyperallergic.com/825784/is-your-organization-adequately-paying-artists-wage/, accessed 30 October 2023.

103. Industria, *Structurally F-cked: an inquiry into artists' pay and conditions in the public sector in response to the Artist Leaks data*, a-n The Artists Information Company, 2023, p. 38, https://static.a-n.co.uk/wp-content/uploads/2023/03/Structurally-F%E2%80%93cked.pdf, accessed 27 October 2023.

104. UK Government Low Pay Commission, 'The National Minimum Wage in 2023', 31 March 2023, https://www.gov.uk/government/publications/the-national-minimum-wage-in-2023/the-national-minimum-wage-in-2023, accessed 30 October 2023.

105. Meilan Solly, 'Wealth Is a Strong Predictor of Whether an Individual Pursues a Creative Profession', *Smithsonian Magazine*, 2 May 2019, https://www.smithsonianmag.com/smart-news/wealth-strong-predictor-whether-individual-pursues-creative-profession-180972072, accessed 3 September 2023.

106. Industria, *Structurally F-cked*, p. 7.

107. Ben Quinn, 'Artists in UK public sector making far below minimum wage, survey finds', 12 March 2023, https://www.theguardian.com/culture/2023/mar/12/artists-in-uk-public-sector-making-far-below-minimum-wage-survey-finds, accessed 30 October 2023.

108. Nina Paszkowski, Zoom interview with the author, 12 January 2023.

109. It's worth noting that Cologne has long been a hub of European visual culture past and present, as testified by its glorious medieval cathedral, featuring stained-glass windows by the contemporary painter Gerhardt Richter, as well as its avant-garde art scene, so embedded that the city saw the world's first art fair dedicated to modern and contemporary art open here in 1967.

110. Barry Caffrey & Chelsea Coates, 'PCS union staff at British Museum strike over half term', BBC News, 14 February 2023, https://www.bbc.co.uk/news/uk-england-london-64636374, accessed 3 September 2023.

111. PCS press officer, Zoom interview with the author, 17 February 2023.

112. BBC News, 'What are the Elgin Marbles and how did Britain get them?', 28 November 2023, https://www.bbc.co.uk/news/entertainment-arts-30342462, accessed 21 December 2023.

113. Barry Caffrey & Chelsea Coates, 'PCS union staff at British Museum strike over half term'; BBC Two, *Strike: Inside the Unions*, Episode 1, 25 May 2023, https://www.bbc.co.uk/iplayer/episode/p0fd5nkp/strike-inside-the-unions-series-1-episode-1, accessed 30 October 2023.

114. Morris, 'The Socialist Ideal: Art'.

115. Morris, 'The Socialist Ideal: Art'.

116. Lola Olufemi, *Feminism, Interrupted: Disrupting Power*, Pluto Press, 2020, p. 84.

117. Lola Olufemi, 'She wants to make something', in Industria, *Structurally F-cked*, p. 5.

118. Helena Horton, 'BBC will not broadcast Attenborough episode over fear of 'rightwing backlash', *The Guardian*, 10 March 2023, https://www.theguardian.com/media/2023/mar/10/david-attenborough-bbc-wild-isles-episode-rightwing-backlash-fears, accessed 30 October 2023; Robert Dex, 'BBC denies David Attenborough censorship claims', *Evening Standard*, 10 March 2023, https://www.standard.co.uk/news/uk/bbc-denies-david-attenborough-censorship-claims-wild-isles-b1066434.html, accessed 30 October 2023.

119. Tropical Commons, 'Forensic Architecture use pioneering methods

to investigate and present crimes against humanity and the environment', 8 September 2018, https://tropicalcommons.co/en/2018/09/08/forensic-architecture-investigate-and-present-crimes-against-humanity-and-the-environment, accessed 3 September 2023.

120. Naomi Rea, 'Environmental Artist Tomás Saraceno Successfully Flies a Solar-Powered Hot Air Balloon Over Argentina, Breaking Six World Records', Artnet News, 29 January 2020, https://news.artnet.com/art-world/tomas-saraceno-bts-aerocene-1763607, accessed 3 September 2023.

121. Hrag Vartanian, 'Michael Rakowitz Discusses Withdrawing from the 2019 Whitney Biennial, and His Leonard Cohen Problem', *Hyperallergic*, 17 May 2019, https://hyperallergic.com/500947/michael-rakowitz-whitney-biennial-leonard-cohen, accessed 3 September 2023.

122. Greta Thunberg, '"You did not act in time": Greta Thunberg's full speech to MPs', *The Guardian*, 23 April 2019, https://www.theguardian.com/environment/2019/apr/23/greta-thunberg-full-speech-to-mps-you-did-not-act-in-time, accessed 3 September 2023.

4. BEHIND THE BILBAO EFFECT

1. Rachel Spence, 'Richard Serra films, Kunstmuseum Basel—"hewn from light"', *Financial Times*, 15 June 2017, https://www.ft.com/content/803223bc-50e8-11e7-a1f2-db19572361bb, accessed 4 January 2024.

2. Guy Hedgecoe, 'Bilbao's Guggenheim Museum celebrates its 25th anniversary', BBC News, 31 October 2022, https://www.bbc.co.uk/news/world-europe-63426939, accessed 15 August 2023.

3. Helen Crane, 'Bilbao mayor wins award for transforming declining city', *The Guardian*, 11 January 2013, https://www.theguardian.com/public-leaders-network/2013/jan/11/guggenheim-museum-bilbao-tourism-arts, accessed 15 August 2023.

4. Sam Jones, 'Guggenheim effect: how the museum helped transform Bilbao', *The Guardian*, 31 October 2022, https://www.theguardian.com/world/2022/oct/31/guggenheim-effect-how-the-museum-helped-transform-bilbao, accessed 15 August 2023; Arantxa Rodriguez & Elena

Martínez, 'Restructuring Cities: Miracles and Mirages in Urban Revitalization in Bilbao', in Frank Moulaert, Arantxa Rodriguez & Erik Swyngedouw (eds), *The Globalized City: Economic Restructuring and Social Polarization in European Cities*, Oxford University Press, 2003.

5. Rowan Moore, 'The Bilbao effect: how Frank Gehry's Guggenheim started a global craze', *The Guardian*, 1 October 2017, https://www.theguardian.com/artanddesign/2017/oct/01/bilbao-effect-frank-gehry-guggenheim-global-craze, accessed 15 August 2023.

6. Jörg Plöger, 'Bilbao City Report', Centre for Analysis of Social Exclusion, London School of Economics, 2007, p. 10, http://eprints.lse.ac.uk/3624/1/Bilbao_city_report_(final).pdf, accessed 15 August 2023.

7. Plöger, 'Bilbao City Report', p. 12.

8. *Argia*, 'The workers at the largest auditorium in Bilbao have gone on strike', 2 January 2018, https://www.argia.eus/albistea/the-workers-at-the-largest-auditorium-in-bilbao-have-gone-on-strike, accessed 15 August 2023.

9. elDiario.es, 'Limpiadoras del Guggenheim desconvocan la huelga indefinida tras un acuerdo para una subida salarial del 20%', 21 March 2022, https://www.eldiario.es/bizkaia/limpiadoras-guggenheim-desconvocan-huelga-indefinida-acuerdo-subida-salarial-20_1_8848421.html, accessed 15 August 2023.

10. Maialen Ferreira, 'Una subida salarial del 20% pone fin a casi 300 días de huelga de las limpiadoras del Museo Guggenheim', *El Diario*, 21 March 2022, https://www.eldiario.es/euskadi/subida-salarial-20-acaba-300-dias-huelga-limpiadoras-museo-guggenheim_1_8847845.html, accessed 31 October 2023.

11. Moore, 'The Bilbao effect', *The Guardian*.

12. Mabel O. Wilson, 'Rendering the Labor Invisible: The Architecture of the Guggenheim's Global Network', in Terike Haapoja, Andrew Ross & Michael Sorkin (eds), *The Helsinki Effect: Public Alternatives to the Guggenheim Model of Culture-Driven Development*, Terreform Urban Research, 2016, p. 96.

13. Moore, 'The Bilbao effect', *The Guardian*.

14. Rachel Lee Harris, 'Bilbao Museum Official Sentenced', *The New York Times*, 29 November 2009, https://www.nytimes.com/2009/11/30/

arts/design/30arts-BILBAOMUSEUM_BRF.html, accessed 15 August 2023.

15. Dale Fuchs, 'Theft and financial blunders take shine off Bilbao's Guggenheim', *The Guardian*, 15 December 2008, https://www.theguardian.com/world/2008/dec/15/spain-bilbao-guggenheim-basquenews, accessed 15 August 2023.

16. Ibid.

17. 'Interview with Thomas Krens', *CLOG*, Vol. 13 (Guggenheim), 23 February 2015.

18. Gareth Harris, 'British Museum rekindles relationship with Zayed National Museum after loan deal ended last year', *The Art Newspaper*, 21 June 2018, https://www.theartnewspaper.com/2018/06/21/british-museum-rekindles-relationship-with-zayed-national-museum-after-loan-deal-ended-last-year, accessed 31 October 2023.

19. Alan Taylor, 'The Opening of the Louvre Abu Dhabi', *The Atlantic*, 8 November 2017, https://www.theatlantic.com/photo/2017/11/the-opening-of-the-louvre-abu-dhabi/545333, accessed 15 August 2023.

20. Al Arabiya News, 'Louvre Abu Dhabi license extended until 2047', 3 December 2021, https://english.alarabiya.net/life-style/art-and-culture/2021/12/03/Louvre-Abu-Dhabi-license-extended-until-2047, accessed 15 August 2023.

21. *Artforum*, 'Construction of Long-Delayed Guggenheim Abu Dhabi to Begin Soon, Says Richard Armstrong', 26 April 2019, https://www.artforum.com/news/construction-of-long-delayed-guggenheim-abu-dhabi-to-begin-soon-says-richard-armstrong-79571, accessed 15 August 2023.

22. John Defterios, 'The art of living: Abu Dhabi adds cultural big-hitters to Saadiyat island project', CNN, 28 January 2014, https://edition.cnn.com/2014/01/28/business/abu-dhabi-art-of-building-louvre-guggenheim-saadiyat/index.html, accessed 15 August 2023.

23. *Champ of the Camp* documentary film, dir. Mahmoud Kaabour, 2013.

24. Katie McQue, 'Up to 20,000 Asian migrant workers die in the Gulf every year, claims report', *The Guardian*, 11 March 2022, https://www.theguardian.com/global-development/2022/mar/11/up-to-10000-asian-migrant-workers-die-in-the-gulf-every-year-claims-report, accessed 31 October 2023.

25. Asian Migrant Centre, 'United Arab Emirates', https://www.asianmigrantcentre.org/united-arab-emirates, accessed 15 August 2023.

26. Katie McQue, 'Up to 10,000 Asian migrant workers die in the Gulf every year'.

27. Nick McGeehan, Zoom interview with the author, 29 November 2022.

28. Michelle Buckley, 'Construction Work, "Bachelor" Builders and the Intersectional Politics of Urbanisation in Dubai', in Abdulhadi Khalaf, Omar AlShehabi & Adam Hanieh (eds), *Transit States: Labour, Migration and Citizenship in the Gulf*, Pluto Press, p. 142.

29. Gulf Labor, 'Over 130 Artists Call for Guggenheim Boycott over Migrant Worker Exploitation', 16 March 2011, https://gulflabour.org/2011/for-immediate-release-100-international-artists-call-for-a-boycott-of-the-guggenheim-abu-dhabi, accessed 15 August 2023.

30. Emirates News Agency, 'TDIC and Guggenheim Foundation Issue Joint Statement on Labour Values for Guggenheim Abu Dhabi Museum', 22 September 2010, https://wam.ae/en/details/1395228752945, accessed 15 August 2023.

31. The monitor first appointed by the TDIC was Mott MacDonald, a multi-national consultancy with financial interests in the UAE (e.g. Mott MacDonald, 'Mott MacDonald appointed for Saadiyat Island's new power and water distribution systems', press release, 11 July 2006, https://www.mottmac.com/en-US/article/205/mott-macdonald-appointed-for-saadiyat-islands, accessed 5 January 2024). See also Andrew Ross, 'Leveraging the Brand: A History of Gulf Labor', in Andrew Ross (ed.), *The Gulf: High Culture/Hard Labor*, OR Books, 2015, p. 18; Gulf Labor, 'Over 130 Artists Call for Guggenheim Boycott over Migrant Worker Exploitation'.

32. Nicolai Ouroussoff, 'Abu Dhabi Guggenheim Faces Protest', *The New York Times*, 16 March 2011, https://www.nytimes.com/2011/03/17/arts/design/guggenheim-threatened-with-boycott-over-abu-dhabi-project.html, accessed 11 August 2023.

33. Mostafa Heddaya, 'Protesters Rain Down Thousands of Bills in Guggenheim Rotunda', *Hyperallergic*, 30 March 2014, https://hyperallergic.com/117512/protesters-rain-down-thousands-of-bills-in-guggenheim-rotunda, accessed 15 August 2023.

34. Hrag Vartanian, 'Gulf Labor and Other Arts Groups Occupy Venice's Guggenheim #GuggOccupied', *Hyperallergic*, 8 May 2015, https://hyperallergic.com/205465/breaking-gulf-labor-and-other-arts-groups-occupy-venices-guggenheim-guggoccupied, accessed 15 August 2023.

35. Patrick Butler, 'UK food bank charity reports record take-up amid cost of living crisis', *The Guardian*, 26 April 2023, https://www.theguardian.com/society/2023/apr/26/uk-food-bank-charity-reports-record-take-up-amid-cost-of-living-crisis, accessed 15 August 2023.

36. @just.stopoil, Instagram, 3 May 2023, https://www.instagram.com/p/CryeMY-ufgY, accessed 15 August 2023.

37. UK Department for Business & Trade, Kevin Hollinrake MP and Huw Merriman MP, 'Strikes Bill becomes law', press release, 20 July 2023, https://www.gov.uk/government/news/strikes-bill-becomes-law, accessed 31 October 2023; Stephen Russell, 'Striking out—the erosion of workers' human rights in the UK emboldens authoritarian regimes around the world', Bond, 14 February 2023, https://www.bond.org.uk/news/2023/02/striking-out-the-erosion-of-workers-human-rights-in-the-uk-emboldens-authoritarian-regimes-around-the-world, accessed 15 August 2023; Pippa Crerar & Kiran Stacey, 'Union fury as Rishi Sunak unveils anti-strike laws for "minimum service levels"', *The Guardian*, 5 January 2023, https://www.theguardian.com/uk-news/2023/jan/05/uk-ministers-announce-anti-strike-legislation, accessed 15 August 2023.

38. Daniel Boffey, 'Nurses to cut short strike as court rules second day of action unlawful', *The Guardian*, 27 April 2023, https://www.theguardian.com/society/2023/apr/27/nurses-to-cut-short-strike-as-court-rules-second-day-of-action-unlawful, accessed 15 August 2023.

39. Glenn Carrick & David Batty, 'In Abu Dhabi, they call it Happiness Island. But for the migrant workers, it is a place of misery', *The Observer*, 22 December 2023, https://www.theguardian.com/world/2013/dec/22/abu-dhabi-happiness-island-misery, accessed 15 August 2023.

40. Ross, *The Gulf*.

41. Paula Chakravartty & Nitasha Dhillon, 'Gulf Dreams for Justice: Migrant Workers and New Political Futures', in Ross, *The Gulf*, p. 51.

42. Glenn Carrick & David Batty, 'In Abu Dhabi, they call it Happiness Island. But for the migrant workers, it is a place of misery', *Observer*, 22 December 2023, https://www.theguardian.com/world/2013/dec/22/abu-dhabi-happiness-island-misery, accessed 15 August 2023.

43. Al Jazeera, 'Dubai workers hold rare strike for more wages', 20 May 2013, https://www.aljazeera.com/economy/2013/5/20/dubai-workers-hold-rare-strike-for-more-wages, accessed 15 August 2023; Reuters, 'Dubai's Arabtec awarded $643 mln Louvre Abu Dhabi contract', 8 January 2013, https://www.reuters.com/article/emirates-louvre-arabtec-idUKL5E9C807G20130108/, accessed 5 January 2024.

44. Glenn Carrick & David Batty, 'In Abu Dhabi, they call it Happiness Island', *Observer*.

45. Nardello & Co., 'Report of the Independent Investigator into Allegations of Labor and Compliance Issues During the Construction of the NYU Abu Dhabi Campus on Saadiyat Island, United Arab Emirates', 16 April 2015, pp. 8, 32–5, https://www.nardelloandco.com/wp-content/uploads/information/nyu-abu-dhabi-campus-investigative-report.pdf, accessed 15 August 2023.

46. Nardello & Co., 'Report', p. 37.

47. Nardello & Co., 'Report', p. 38.

48. The Construction Index, 'Balfour Beatty quits Middle East JVs', 21 February 2017, https://www.theconstructionindex.co.uk/news/view/balfour-beatty-quits-middle-east#:~:text=Dutco%20Balfour%20Beatty%20LLC%20was,between%20Balfour%20Beatty%20and%20Dutco, accessed 21 December 2023.

49. David Batty, 'NYU set to compensate thousands of migrant workers on Abu Dhabi complex', *The Guardian*, 24 April 2015, https://www.theguardian.com/global-development/2015/apr/24/nyu-compensate-thousands-migrant-workers-abu-dhabi-complex-nardello-report, accessed 15 August 2023; MEED, 'Abu Dhabi cancels Guggenheim museum tender', 18 October 2011, https://www.meed.com/abu-dhabi-cancels-guggenheim-museum-tender, accessed 15 August 2023.

50. MEED, 'Abu Dhabi cancels Guggenheim museum tender', 18 October 2011, https://www.meed.com/abu-dhabi-cancels-guggenheim-museum-tender/, accessed 5 January 2024.

51. Nardello & Co., 'Report', pp. 19–20, 47.

52. Sarah Cascone, 'After Delays, Protests, and a Pandemic, the Guggenheim Abu Dhabi Has a New Date for Its Debut: 2026', Artnet, 21 September 2021, https://news.artnet.com/art-world/guggenheim-abu-dhabi-201 1351, accessed 11 August 2023; Abu Dhabi Department of Culture & Tourism, 'Guggenheim Abu Dhabi Set for Completion by 2025', 29 September 2021, https://dct.gov.ae/en/media.centre/news/guggenheim.abu.dhabi.set.for.completion.by.2025..aspx, accessed 8 March 2024; Solomon R. Guggenheim Foundation, email exchange with the author, 9 June 2023.

53. Andrew Ross, Zoom interview with the author, 14 August 2022.

54. Email to the author from the Solomon R. Guggenheim Foundation, 9 June 2023.

55. Solomon R. Guggenheim Foundation, email to the author, 9 June 2023.

56. Email exchange with Guggenheim spokesperson 23 October 2024.

57. Nick McGeehan, email exchange with the author, 5 October 2023.

58. Jason Hickel, *Less Is More: How Degrowth Will Save the World*, Penguin, 2020.

59. Colleen de Bellefonds, 'Is Art for Rent in France?', *U.S. News & World Report*, 17 June 2019, https://www.usnews.com/news/best-countries/articles/2019–06–17/museums-use-of-partnerships-stirs-controversy-across-france, accessed 5 January 2024.

60. Nick McGeehan, email exchange with the author.

61. Tamara Qiblawi, 'Swiss journalists detained in Abu Dhabi', CNN, 13 November 2017, https://edition.cnn.com/2017/11/13/middleeast/swiss-journalists-detained-abu-dhabi/index.html, accessed 5 January 2024.

62. Louvre, 'The Louvre Abu Dhabi', n.d., https://www.louvre.fr/en/the-louvre-in-france-and-around-the-world/the-louvre-abu-dhabi, accessed 5 January 2024.

63. Ross, *The Gulf*, p. 31.

64. Letter from Richard Armstrong to ITUC & Human Rights Watch, https://gulflabour.org/wp-content/uploads/2016/06/Richard-

Armstrong-to-ITUC-and-HRW-05_20_2016.pdf, accessed 15 August 2023.

65. Ross, *The Gulf*, p. 11.
66. Nardello & Co., 'Report', pp. 5, 17; Ross, *The Gulf*, p. 37.
67. Ross, *The Gulf*, p. 73.
68. Ibid., p. 36.
69. Ross, *The Gulf*, p. 32.
70. Human Rights Watch, 'UAE: Human Rights Watch Official Refused Entry', 24 January 2014, https://www.hrw.org/news/2014/01/24/uae-human-rights-watch-official-refused-entry, accessed 15 August 2023; Zoë Schlanger, 'Under Surveillance in Abu Dhabi: A Reporter's Saga of Being Followed, Bribed, and Recruited as a Spy', *Newsweek*, 30 March 2015, https://www.newsweek.com/under-surveillance-abu-dhabi-reporters-saga-being-followed-bribed-and-317627, accessed 15 August 2023; Human Rights Watch, 'UAE: Tolerance Narrative a Sham', 1 October 2021, https://www.hrw.org/news/2021/10/01/uae-tolerance-narrative-sham-0, accessed 5 January 2024.
71. Andrew Ross, Zoom interview with the author, 14 August 2022.
72. Chris Arsenault, 'Workers' rights campaigners voice concerns over UAE ban of U.S. academic', Reuters, 19 March 2015, https://www.reuters.com/article/trafficking-middle-east-workers-idINKBN0MF2BO20150319, accessed 15 August 2013.
73. Sally Weale, 'How one UK university confronted its sexual harassment problem', *The Guardian*, 8 December 2017, https://www.theguardian.com/education/2017/dec/08/universities-forced-to-confront-sexual-harassment-problems, accessed 31 October 2023.
74. Sara Ahmed in an interview with Maya Binyam, 'You Pose a Problem: A Conversation with Sara Ahmed', *The Paris Review*, 14 January 2022, https://www.theparisreview.org/blog/2022/01/14/you-pose-a-problem-a-conversation-with-sara-ahmed, accessed 15 August 2023.
75. James Baldwin in an interview with Studs Terkel, 'An interview with James Baldwin' (1961), in Fred L. Standley & Louis H. Pratt (eds), *Conversations with James Baldwin*, University Press of Mississippi, 1989.
76. Building and Wood Workers' International, 'Statement of Concern Regarding the Guggenheim Project in Helsinki', December 2016,

https://gulflabour.org/wp-content/uploads/2016/12/BWI-Statement-on-Guggenheim-Helsinki.pdf, accessed 16 August 2023.

77. Nina Siegal, 'Guggenheim Helsinki Museum Plans Are Rejected', *The New York Times*, 30 November 2016, https://www.nytimes.com/2016/11/30/arts/design/guggenheim-helsinki-museum-plans-are-rejected.html, accessed 17 August 2023.

78. Reuters, 'Guggenheim proposes $178 mln Helsinki museum', 10 January 2012, https://www.reuters.com/article/uk-finland-guggenheim-idUSLNE80902R20120110, accessed 16 August 2023.

79. Reuters, 'Guggenheim proposes $178 mln Helsinki museum'.

80. Siegal, 'Guggenheim Helsinki Museum Plans Are Rejected', *The New York Times*.

81. Eero Vassinen, 'Helsinki rejects Guggenheim museum proposal', Reuters, 3 May 2012, https://www.reuters.com/article/idUSLNE84200720120503, accessed 17 August 2023.

82. Anna Ercanbrack, 'Six museum designs make Helsinki Guggenheim shortlist', Reuters, 2 December 2014, https://www.reuters.com/article/idUSKCN0JG1XT20141202, accessed 17 August 2023.

83. Yle News, 'Helsinki City Council rejects Guggenheim project', 2 May 2012, https://yle.fi/a/3–6078379, accessed 17 August 2023.

84. Haapoja, Ross & Sorkin (eds), *The Helsinki Effect*, pp. 8–9.

85. Haapoja, Ross & Sorkin (eds), *The Helsinki Effect*, pp. 7–8. The narratives around the Guggenheim projects in Bilbao, Abu Dhabi and Helsinki illustrate how specific each locale is: Bilbao suffering in post-industrial decline, Abu Dhabi with its tiny resident population and autocratic regime, and Helsinki with its history of embedded cultural and social progressiveness, where too many people felt they had something to lose.

86. Sarah Cascone, 'Fake Guggenheim Website Announces Sustainable Design Competition for Abu Dhabi Branch', Artnet, 28 March 2014, https://news.artnet.com/art-world/fake-guggenheim-website-announces-sustainable-design-competition-for-abu-dhabi-7891, accessed 17 August 2023.

87. Haapoja, Ross & Sorkin (eds), *The Helsinki Effect*, p. 127.

88. Lola Olufemi, *Feminism, Interrupted: Disrupting Power*, Pluto Press, 2020, p. 84.

89. Haapoja, Ross & Sorkin (eds), *The Helsinki Effect*, p. 132.
90. New Museum of Architecture & Design, 'About ADM', n.d., https://www.admuseo.fi/eng-site/about, accessed 1 October 2023; Kaarina Gould (CEO of the Foundation for the Finnish Museum of Architecture and Design, and Chair of the New Museum of Architecture and Design), email exchange with the author, 4 October 2023.
91. Rima Sabina Aouf, 'White Arkitekter and K2S Architects set to revitalize Helsinki's Makasiiniranta waterfront', *Dezeen*, 5 December 2022, https://www.dezeen.com/2022/12/05/white-arkitekter-k2s-architects-win-competition-helsinki-makasiiniranta-waterfront-architecture/, accessed 1 November 2023.
92. Jari Tanner, 'Finland's conservative party picks ministers for right-wing coalition government', Associated Press, 18 June 2023, https://apnews.com/article/finland-election-government-conservatives-6181afe57b38e016723c4c586933edd2, accessed 1 November 2023.
93. New Museum of Architecture & Design, 'About ADM'.
94. Kaarina Gould, email to the author, 11 October 2023.
95. Sofia Karim, 'Essays on Architecture', 27 January 2020, https://www.sofiakarim.co.uk/post/essays-on-architecture, accessed 17 August 2023.
96. Adrienne Rich, 'Women and Honor: Some Notes on Lying' (1975), in Adrienne Rich, *On Lies, Secrets, and Silence: Selected Prose 1966–1978*, W. W. Norton, 1979.
97. Sofia Karim, 'Essays on Architecture', 27 January 2020, https://www.sofiakarim.co.uk/post/essays-on-architecture, accessed 17 August 2023.
98. Nardello & Co., 'Report', p. 54.
99. Pauliina Feodoroff, Zoom interview with the author, 11 October 2023.

## 5. DECARBONISE AND DEGROW

1. Nicholas Nehamas, 'About 77,000 people attended Art Basel in Miami Beach this year', *Miami Herald*, 9 December 2015, https://www.miamiherald.com/entertainment/visual-arts/art-basel/article48436040.html, accessed 8 January 2024.
2. Narges Banks, 'How Brands Can Benefit from Arts Patronage, BMW Culture Lead Thomas Girst Explains', Forbes, 25 June 2020, https://

www.forbes.com/sites/nargessbanks/2020/06/25/bmw-art-basel-ninth-art-journey/?sh=1e7fdd4c3a2e, accessed 20 September 2023.

3. World Meteorological Organization, 'Global temperatures set to reach new records in next five years', 17 May 2023, https://public.wmo.int/en/media/press-release/global-temperatures-set-reach-new-records-next-five-years, accessed 25 September 2023.

4. Jason Hickel, *Less Is More: How Degrowth Will Save the World*, Penguin, 2020, p. 115.

5. There is a raft of arguments employed by institutions to justify taking money from fossil fuel sponsors. These include financial necessity, particularly at a time when public funding is paltry, and the fact that society still relies on fossil fuels so heavily that it is hypocritical to demonise their producers. But today, the environmental crisis is too acute for such views to hold water. A temperature rise beyond 1.5C above pre-industrial levels, now expected at least once during the mid-2020s, would cause irreversible damage to ice sheets, permafrost, sea levels and coral reefs. Furthermore, there is a wealth of evidence that the oil industry has exacerbated global warming by its failure to heed climate science—indeed its manufacture of faux-science—for decades. Such behaviour surely makes it an inappropriate partner for cultural organisations.

6. To take the Shell example: a-n, 'Shell dropped by Van Gogh Museum after 18 years of sponsorship', 30 August 2018, https://www.a-n.co.uk/news/shell-dropped-van-gogh-museum-18-years-sponsorship, accessed 25 September 2023; *Frieze*, 'After Years of Environmental Protests, Shell Ends National Gallery Sponsorship', 19 October 2018, https://www.frieze.com/article/after-years-environmental-protests-shell-ends-national-gallery-sponsorship, accessed 25 September 2023; Claire Selvin, 'Amid Climate Activists' Calls for Divestment, London's Southbank Centre Severs Ties with Shell', ARTnews, 10 March 2020, https://www.artnews.com/art-news/news/southbank-centre-shell-sponsorship-ends-1202680566, accessed 25 September 2023.

7. Matthew Taylor, 'Hundreds of teachers boycott Science Museum show over Adani sponsorship', *The Guardian*, 15 July 2022, https://www.the-guardian.com/culture/2022/jul/15/hundreds-of-teachers-boycott-science-museum-over-adani-sponsorship, accessed 23 January 2024;

Science Museum, 'Energy Revolution: The Adani Green Energy Gallery', https://www.sciencemuseum.org.uk/see-and-do/energy-revolution-adani-green-energy-gallery, accessed 23 January 2024.

8. When I requested a carbon footprint from the Bienal de São Paulo, its team replied with a statement drawing my attention to the efforts they have made, since 2010, to reduce their emissions. These include the construction of a rainwater collection reservoir to supply water to selected toilets in the Bienal Pavilion, the recycling of equipment, the use of LED lamps, and a 'rigorous policy of offsetting carbon emissions through tree planting' which has seen 93 tonnes of $CO_2$ neutralised in each edition through the planting of 550 trees. The Bienal plans to improve its waste recycling systems even though these practices are little used in Brazil. The statement also said that the Bienal 'acknowledges that its most significant challenge lies in managing the environmental impact of the substantial number of flights associated with each edition of the Bienal' and that it is 'still investigating innovative approaches to address this issue.' There's little doubt that the Bienal's efforts to reduce its carbon emissions are intense, impressive and made in good faith. Furthermore, its longstanding, respected presence as a leading cultural institution in the Global South has been crucial to building a cultural infrastructure in Brazil and South America as a whole.

9. Julie's Bicycle, 'The Art of Zero', April 2021, https://juliesbicycle.com/wp-content/uploads/2022/01/ARTOFZEROv2.pdf, accessed 25 September 2023.

10. David Crouch, 'The Swedish 15-year-old who's cutting class to fight the climate crisis', *The Guardian*, 1 September 2018, https://www.theguardian.com/science/2018/sep/01/swedish-15-year-old-cutting-class-to-fight-the-climate-crisis, accessed 25 September 2023.

11. Pete Ogden & Chandler Green, '2019 in Review: The Year the World Began to Wake Up to the Climate Emergency', United Nations Foundation, 19 December 2019, https://unfoundation.org/blog/post/2019-in-review-year-world-began-wake-up-climate-emergency, accessed 25 September 2023; Coral Davenport, 'Major Climate Report Describes a Strong Risk of Crisis as Early as 2040', *The New York*

*Times*, 7 October 2018, https://www.nytimes.com/2018/10/07/climate/ipcc-climate-report-2040.html, accessed 25 September 2023.

12. Mikaela Loach, *It's Not That Radical: Climate Action to Transform Our World*, Dorling Kindersley, 2023; Rishika Pardikar, 'Global North Is Responsible for 92% of Excess Emissions', *Eos*, 28 October 2020, https://eos.org/articles/global-north-is-responsible-for-92-of-excess-emissions, accessed 8 January 2024.

13. Stockholm Center for Freedom, 'Turkey plunges to 165th place among 180 countries in RSF's press freedom index', 3 May 2023, https://stockholmcf.org/turkey-plunges-to-165th-place-among-180-countries-in-rsfs-press-freedom-index, accessed 25 September 2023.

14. Rachel Spence, 'Istanbul Biennial: best of times, worst of times', *Financial Times*, 20 September 2013, https://www.ft.com/content/841411a2-204a-11e3-9a9a-00144feab7de, accessed 25 September 2023; Hrag Vartanian, 'You Can Never Be Complicit Enough for the Turkish Art World', *Hyperallergic*, 10 August 2023, https://hyperallergic.com/838873/you-can-never-be-complicit-enough-for-the-turkish-art-world, accessed 25 September 2023.

15. Kaelen Wilson Goldie, 'Private pleasure', *The National*, 11 June 2010, https://www.thenationalnews.com/arts-culture/art/private-pleasures-1.520113, accessed 25 September 2023.

16. Bolton & Quinn public relations firm, email to the author, 20 July 2023.

17. Rachel Spence, 'Istanbul Biennial: eco-warriors outdone by dissidents', *Financial Times*, 27 September 2019, https://www.ft.com/content/9ca227ce-db9a-11e9-9c26-419d783e10e8, accessed 25 September 2023.

18. Greta Thunberg, *No One Is Too Small to Make a Difference*, Penguin, 2021.

19. KoçSistem, https://kocsistem.com.tr/en/fields-of-operation/, accessed 2 November 2023; KoçDigital, https://www.kocdigital.com/en-us/industries/index.html, accessed 2 November 2023.

20. Anny Shaw & Gareth Harris, 'Art world faces up to the reality of climate crisis', *The Art Newspaper*, 3 October 2019, https://www.theartnewspaper.com/2019/10/03/art-world-faces-up-to-the-reality-of-climate-crisis, accessed 25 September 2023.

21. Eileen Kinsella & Naomi Rea, 'As Jetsetters Prepare to Descend on the Eroding Shores of Miami, Art Basel Awkwardly Tries to Address Climate Change', Artnet News, 2 December 2019, https://news.art-net.com/market/miami-basel-combat-climate-change-1718745, accessed 25 September 2023.

22. Julie's Bicycle, 'The Art of Zero', pp. 7–8.

23. Carol Rasmussen, 'Emission Reductions from Pandemic Had Unexpected Effects on Atmosphere', Jet Propulsion Laboratory, 9 November 2021, https://www.jpl.nasa.gov/news/emission-reductions-from-pandemic-had-unexpected-effects-on-atmosphere, accessed 25 September 2023.

24. Carol Rasmussen, 'Local Lockdowns Brought Fast Global Ozone Reductions, NASA Finds', NASA, 9 June 2021, https://www.nasa.gov/feature/jpl/local-lockdowns-brought-fast-global-ozone-reductions-nasa-finds, accessed 25 September 2023.

25. IEA, 'CO2 Emissions in 2022', March 2023, https://iea.blob.core.windows.net/assets/3c8fa115-35c4-4474-b237–1b00424c8844/CO2Emissionsin2022.pdf, p. 3, accessed 8 January 2024.

26. Sky News, '10 most costly climate change-related disasters in 2022 revealed', 30 December 2022, https://news.sky.com/story/10-most-costly-climate-change-related-disasters-in-2022-revealed-12774943, accessed 25 September 2023.

27. Julie's Bicycle, 'About JB', n.d., https://juliesbicycle.com/about-us/about-jb/, accessed 8 January 2024.

28. Louisa Buck, 'Green horsewoman of the environmental apocalypse declares climate emergency at Tate', *The Art Newspaper*, 4 April 2019, https://www.theartnewspaper.com/2019/04/04/green-horsewoman-of-the-environmental-apocalypse-declares-climate-emergency-at-tate, accessed 25 September 2023.

29. Tate, *Power to Change*, https://www.tate.org.uk/whats-on/tate-modern/power-change, accessed 25 September 2023.

30. Gallery Climate Coalition, 'Our Story', n.d., https://galleryclimatecoalition.org/story/, accessed 8 January 2024.

31. Gallery Climate Coalition, 'Targets & Commitments', n.d., https://galleryclimatecoalition.org/coalition-commitments/, accessed 8 January 2024.

32. Julie's Bicycle, 'Putting a Price on Carbon: From Offsets to True Value', 2020, https://juliesbicycle.com/wp-content/uploads/2022/01/JB-Offsetting-Report-ExecSum.pdf, accessed 25 September 2023; Danny Chivers & Aoife Fannin, *Decarbonisation Action Plan: For non-profits and institutions*, 2023, p. 71, https://galleryclimatecoalition.org/usr/library/documents/main/gcc-non-profit-and-institution-dap-2023-final.pdf, accessed 2 November 2023.

33. Danny Chivers & Aoife Fannin, *Decarbonisation Action Plan*, p. 72.

34. Art to Acres, https://www.arttoacres.org, accessed 25 September 2023; Art + Climate Action, https://www.artandclimateaction.org/about, accessed 25 September 2023; Art/Switch, https://www.artswitch.org/about-artswitch, accessed 25 September 2023; Galleries Commit, https://www.galleriescommit.com/about, accessed 25 September 2023; Artists Commit, https://www.artistscommit.com/reports, accessed 25 September 2023; Ki Culture, https://www.kiculture.org, accessed 25 September 2023.

35. Julie's Bicycle, 'Spotlight: Transitioning to Net Zero', 21 April 2022, https://juliesbicycle.com/our-work/arts-council-programme-draft/the-spotlight-programme/, accessed 2 November 2023; Julie's Bicycle, 'Spotlight Programme Participants', 9 June 2021, https://juliesbicycle.com/news-opinion/spotlight-programme-participants/, accessed 2 November 2023.

36. Gallery Climate Coalition, 'Our Members', n.d., https://galleryclimatecoalition.org/our-members/, accessed 9 January 2023; Gallery Climate Coalition, 'Campaigns', n.d., https://galleryclimatecoalition.org/campaigns/, accessed 8 March 2024.

37. Reena Devi, 'Is Oil States' Pivot Towards Art and Culture Succeeding?', *Ocula*, 28 August 2023, https://ocula.com/magazine/art-news/oil-states-pivot-towards-art-and-culture, accessed 25 September 2023; Bea Mitchell, 'China plans to become "museum powerhouse" by 2035', Blooloop, https://blooloop.com/museum/news/china-museum-powerhouse, accessed 25 September 2023.

38. Li Shuo, 'Is China really leading the clean energy revolution? Not exactly', *The Guardian*, 6 July 2023, https://www.theguardian.com/commentisfree/2023/jul/06/china-clean-energy-revolution-coal-power, accessed 25 September 2023.

39. Devorah Lauter, 'The Centre Pompidou's Landmark Agreement with Saudi Arabia Is More Complicated Than It Seems', *Art in America*, 12 May 2023, https://www.artnews.com/list/art-in-america/features/centre-pompidous-saudi-arabia-alula-deal-explained-1234667640/politics-and-art, accessed 25 September 2023.

40. Ibid.

41. Solomon R. Guggenheim Foundation, email exchange with the author, 18 September 2023.

42. Gallery Climate Coalition, 'Active Membership', https://galleryclimatecoalition.org/active-membership/, accessed 10 January 2024.

43. Hauser & Wirth, 'Sustainability at Hauser & Wirth', https://www.hauserwirth.com/sustainability, accessed 10 January 2024.

44. Kunsthal Gent, 'User's Manual draft #1.2', https://kunsthal.gent/assets/files/MANUAL1.2ENG_versie30_09.pdf, accessed 10 January 2024.

45. Bienal de São Paulo, email to the author, 13 July 2023.

46. Sutton, 'Sustainable Travel Plan', August 2022, emailed to the author and available at https://acrobat.adobe.com/id/urn:aaid:sc:us:6f5c82a4-f77d-4bad-98fc-2a52a33ac943, accessed 23 January 2024.

47. La Biennale di Venezia, 'Art (2022): Simone Leigh', https://www.labiennale.org/en/art/2022/milk-dreams/simone-leigh, accessed 10 January 2024.

48. La Biennale di Venezia, 'Art (2022): Ali Cherri', https://www.labiennale.org/en/art/2022/milk-dreams/ali-cherri, accessed 10 January 2024.

49. Swedish Government, 'Sami in Sweden', 16 January 2023, https://sweden.se/life/people/sami-in-sweden, accessed 10 January 2024; Northern Norway, 'The Sami', https://nordnorge.com/en/tema/the-sami-are-the-indigenous-people-of-the-north/, accessed 10 January 2024; 'The Sámi in Finland', https://www.samediggi.fi/sami-info/?lang=en, accessed 10 January 2024.

50. Shaldon Ferris, 'The Hidden Costs of "Green" Wind Energy on the Sámi', Cultural Survival, 1 June 2022, https://www.culturalsurvival.org/publications/cultural-survival-quarterly/hidden-costs-green-wind-energy-sami, accessed 25 September 2023.

51. Jackie Wullschläger, 'Venice Biennale meets the moment with outstanding pavilions', *Financial Times*, 23 April 2022, https://www.ft.

com/content/08416acb-b1b0–4026-aab4-aecbbeb7bccf, accessed 10 January 2024.

52. Roberto Cicutto, 'The Biennale Arte 2022 Closes with Over 800,000 Tickets', La Biennale di Venezia, 26 November 2022, https://www.labiennale.org/en/news/biennale-arte-2022-closes-over-800000-tickets, accessed 25 September 2023.

53. 'Flight carbon footprint calculator', https://calculator.carbonfootprint.com/calculator.aspx?lang=en-GB&tab=3, accessed 25 September 2023; Tariff, 'How Many Trees Would Offset My Business?', 6 July 2022, https://www.tariff.com/news-and-insights/how-many-trees-would-offset-my-business, accessed 25 September 2023.

54. La Biennale di Venezia, '59th International Art Exhibition: Biennale Arte 2022, The Milk of Dreams', 2022, https://www.labiennale.org/en/art/2022/59th-exhibition, accessed 8 March 2024.

55. Bobby Hristova, 'Janis Monture appointed 1st Indigenous CEO of Canadian Museums Association', CBC News, 14 February 2023, https://www.cbc.ca/news/canada/hamilton/janis-monture-canadian-museums-association-1.6746639, accessed 25 September 2023; Joe Hernandez, 'Cynthia Chavez Lamar becomes the first Native woman to lead a Smithsonian museum', NPR, 20 January 2022, https://www.npr.org/2022/01/20/1074489213/cynthia-chavez-lamar-becomes-the-first-native-woman-to-lead-a-smithsonian-museum, accessed 25 September 2023.

56. Pauliina Feodoroff, Zoom interview with the author, 11 October 2023.

57. Al Jazeera, 'Sami activist protests in front of Norwegian parliament over wind turbines', 11 September 2023, https://www.aljazeera.com/news/2023/9/11/sami-activist-protests-in-front-of-norwegian-parliament-over-wind-turbines, accessed 25 September 2023; Euronews Green, '"Respect existence or expect resistance": Protests in Norway against wind farm on Sami land', 2 June 2023, https://www.euronews.com/green/2023/06/02/respect-existence-or-expect-resistance-protests-in-norway-against-wind-farm-on-sami-land, accessed 25 September 2023. As of early 2024, although some activists have been charged over the protests, a partial deal has also been reached with the government, guaranteeing reindeer herders annual compensation, addi-

tional grazing space, and a veto on any future expansion to Norway's largest wind farm; at the time of writing, talks continue about the other wind farm that has come under protest. (Reuters, 'Dispute over Norway wind farm continues despite partial deal', 19 December 2023, https://www.reuters.com/business/energy/dispute-over-norway-wind-farm-continues-despite-partial-deal-2023-12-19/, accessed 11 March 2024; euronews with Associated Press, 'Sámi rights activists in Norway charged over protests against wind farm affecting reindeer herding', euronews, 19 January 2024, https://www.euronews.com/2024/01/19/sami-rights-activists-in-norway-charged-over-protests-against-wind-farm-affecting-reindeer, accessed 11 March 2024.)

58. Zoe Cohen, Zoom interview with the author, 26 September 2022.

59. Emily Collis, 'Police arrest 51 Just Stop Oil protesters at Kingsbury Oil Terminal', *The Birmingham Mail*, 15 September 2022, https://www.birminghammail.co.uk/black-country/police-arrest-51-just-stop-25024119, accessed 25 September 2023.

60. Art Basel, https://www.basel.com/en/events/art-basel, accessed 25 September 2023.

61. Art Basel, 'Art Basel concludes highly successful return of its June edition', https://www.artbasel.com/stories/art-basel-concludes-highly-successful-return-of-its-june-edition?lang=en, accessed 25 September 2023.

62. *The Art Newspaper*, 'From anti-Putin Pussy power to Chance the Rapper's new track: the latest gossip from Art Basel', 17 June 2022, https://www.theartnewspaper.com/2022/06/17/from-anti-putin-pussy-power-to-chance-the-rappers-new-track-the-latest-gossip-from-art-basel, accessed 25 September 2023.

63. Louisa Buck, 'Jetting away with it: the challenge of parting the super-rich from their private planes', *The Art Newspaper*, 4 August 2023, https://www.theartnewspaper.com/2023/08/04/jetting-away-with-it-the-challenge-of-parting-the-super-rich-from-their-private-planes, accessed 25 September 2023.

64. NetJets, 'NetJets + Art Basel', https://www.netjets.com/en-gb/art-basel-2023, accessed 25 September 2023.

65. Irina Ivanova, 'Private flights have boomed since the pandemic. Are

taxpayers picking up the tab?', CBS News, 2 May 2023, https://www.cbsnews.com/news/climate-change-private-jets-carbon-emissions-tax/#, accessed 25 September 2023.

66. Michelle Baran, 'How Much Does Flying on a Private Jet *Actually* Cost? (It Might Surprise You)', *Afar*, 16 August 2023, https://www.afar.com/magazine/how-much-does-a-private-jet-cost, accessed 25 September 2023.

67. Patrick Radden Keefe, 'How Larry Gagosian Reshaped the Art World', *The New Yorker*, 24 July 2023, https://www.newyorker.com/magazine/2023/07/31/larry-gagosian-profile, accessed 25 September 2023.

68. UBS, 'UBS and Art Basel', under 'UBS celebrates its 26$^{th}$ year as Global Lead Partner of Art Basel', 11 June 2019, https://www.ubs.com/global/en/media/display-page-ndp/en-20190611-art-basel.html, accessed 3 November 2023.

69. Deutsche Bank, 'Deutsche Bank extends its partnership with Frieze', 13 October 2021, https://www.db.com/news/detail/20211013-deutsche-bank-extends-its-partnership-with-frieze?language_id=1, accessed 3 November 2023.

70. Banking on Climate Chaos, 'Fossil Fuel Finance Report 2023', 2023, pp. 6–7, https://www.bankingonclimatechaos.org/wp-content/uploads/2023/08/BOCC_2023_vF.pdf, accessed 10 January 2024.

71. Anna Ratcliff, 'Carbon emissions of richest 1 percent more than double the emissions of the poorest half of humanity', Oxfam, 21 September 2020, https://www.oxfam.org/en/press-releases/carbon-emissions-richest-1-percent-more-double-emissions-poorest-half-humanity, accessed 25 September 2023.

72. Stuti Mishra, 'Deforestation of Amazon down by a third in 2023 after Bolsonaro's defeat, says Brazil government', *The Independent*, 7 July 2023, https://www.independent.co.uk/climate-change/news/brazil-amazon-deforestation-lula-bolsonaro-b2371102.html, accessed 25 September 2023.

73. Loach, *It's Not That Radical*, p. 131.

74. Mary Corrigall, 'The impact of Covid-19 on the global art market', Investec, 25 January 2022, https://www.investec.com/en_za/focus/investec-cape-town-art-fair/the-impact-of-covid-19-on-the-global-

art-market.html, accessed 25 September 2023; Worldometer, 'GDP by Country', https://www.worldometers.info/gdp/gdp-by-country, accessed 25 September 2023.

75. Art Basel press release, 'The Art Basel and UBS Global Art Market Report', 16 March 2021, https://www.artbasel.com/stories/art-market-report-2021, accessed 22 September 2023.

76. Tim Schneider, 'Virtual Art Fairs Were Seen as a Lifeline in the Lockdown Era. A New Study Shows They Are Failing New York's Art Market', Artnet News, 18 November 2020, https://news.artnet.com/market/new-york-art-market-online-viewing-rooms-1924575, accessed 22 September 2023.

77. Art Basel, Press Release, 19 June 2022, https://d2u3kfwd92fzu7.cloudfront.net/ABB22%20I%20Show%20Report%20I%20June%2019%20I%20E_.pdf, accessed 25 September 2023.

78. Clare McAndrew, 'The Art Market 2020', Art Basel & UBS, 2020, p. 229, https://d2u3kfwd92fzu7.cloudfront.net/The_Art_Market_2020-1.pdf, accessed 22 September 2023.

79. Ibid.

80. *Maui Now*, 'Maui wildfire recovery: Resources and updates for Sept. 6', 6 September 2023, https://mauinow.com/2023/09/06/maui-wildfire-recovery-resources-and-updates-for-sept-6/, accessed 10 January 2024.

81. Nick Beake & Alice Cuddy, 'Huge devastation found in remote regions after Morocco quake', BBC News, 10 September 2023, https://www.bbc.co.uk/news/live/world-africa-66765971, accessed 22 September 2023.

82. United Nations News, 'Hottest July ever signals "era of global boiling has arrived" says UN chief', 27 July 2023, https://news.un.org/en/story/2023/07/1139162#, accessed 22 September 2023.

83. Nicola Jones, 'When will global warming actually hit the landmark 1.5°C limit?', *Nature*, 19 May 2023, https://www.nature.com/articles/d41586-023-01702-w, accessed 22 September 2023.

84. ArtTactic Forecaster, https://artforecaster.com/about, accessed 22 September 2023.

85. Arun Kakar, 'What Sold at Frieze Seoul and The Armory Show 2023',

Artsy, 11 September 2023, https://www.artsy.net/article/artsy-editorial-sold-frieze-seoul-armory-2023, accessed 22 September 2023.

86. Hyunsu Yim, 'Frieze Art Fair returns to South Korea, offering boost to Asia's art market', Reuters, 6 September 2023, https://www.reuters.com/lifestyle/frieze-art-fair-returns-south-korea-offering-boost-asias-art-market-2023–09–06, accessed 22 September 2023.

87. Georgina Adam, 'Why did India's art boom go bust?', BBC Culture, 10 February 2014, https://www.bbc.com/culture/article/20140210-why-did-indias-art-boom-go-bust, accessed 22 September 2023.

88. Frieze Seoul, 'Second Edition of Frieze Soul Captivates City', press release, 10 September 2023, emailed to author and available at https://acrobat.adobe.com/id/urn:aaid:sc:us:16609ab2-9103-49c3-a263-98ca0130b6c1, accessed 23 January 2024.

89. Clare McAndrew, 'The Art Market 2023', Art Basel & UBS, 2023, p. 136, https://theartmarket.artbasel.com/download/The-Art-Basel-and-UBS-Art-Market-Report-2023.pdf, accessed 25 September 2023.

90. Action Aid, 'Climate change and poverty', 9 February 2023, https://www.actionaid.org.uk/our-work/emergencies-disasters-humanitarian-response/climate-change-and-poverty, accessed 22 September 2023; David Rising, 'What Does the "Global South" Actually Mean?', Time, 7 September 2023, https://time.com/6311526/global-south-what-is-it, accessed 22 September 2023.

91. Hickel, Less Is More, p. 9.

92. As an alternative to the terms 'Global South' and 'Global North', which make the two entities sound equal in population or geographic size, some prefer 'Majority World' and 'Minority World', terms generally recognised as having been coined by Shahidul Alam (see Chapter 4). Charles Shafaieh, 'Shahidul Alam on the Majority World', Harvard Design Magazine, 50, Spring/Summer 2022, https://www.harvarddesignmagazine.org/articles/hahidul-alam-on-the-majority-world/, accessed 28 February 2024.

93. Clare McAndrew, 'The Art Market 2023', pp. 57, 63–4.

94. Liza Essers, Zoom interview with the author, 17 August 2023.

95. See International Monetary Fund, 'South Africa's Economy Loses Momentum Amid Record Power Cuts', 15 June 2023, https://www.

imf.org/en/News/Articles/2023/06/15/cf-south-africas-economy-loses-momentum-amid-record-power-cuts, accessed 25 September 2023.

96. Liza Essers, Zoom interview with the author.

97. Anny Shaw, 'The art world still favours the rich—how do we fix that?', *The Art Newspaper*, 11 September 2023, https://www.theartnewspaper.com/2023/09/11/the-art-world-still-favours-the-rich, accessed 22 September 2023.

98. Ibid.

99. Jack Maidment, 'The Elgin Marbles are going nowhere: British Museum says controversial objects WON'T be removed from display after receiving warning from Government', *Mail Online*, 27 September 2020, https://www.dailymail.co.uk/news/article-8777415/Oliver-Dowden-issues-statue-warning-museums-galleries.html, accessed 25 September 2023; University of Leeds, 'The government's 'anti-woke' agenda and the future of the arm's length principle—Ed Vaizey', 27 October 2021, https://ahc.leeds.ac.uk/fine-art/events/event/2272/the-government-s-anti-woke-agenda-and-the-future-of-the-arm-s-length-principle-ed-vaizey, accessed 25 September 2023; Geraldine Kendall Adams, 'Museum governance "synonymous with privileges for politicians"', Museums Association, 24 June 2022, https://www.museumsassociation.org/museums-journal/news/2022/06/museum-governance-synonymous-with-privileges-for-politicians, accessed 25 September 2023.

100. Ben Quinn, 'Artists in UK public sector making far below minimum wage, survey finds', *The Guardian*, 12 March 2023, https://www.theguardian.com/culture/2023/mar/12/artists-in-uk-public-sector-making-far-below-minimum-wage-survey-finds, accessed 25 September 2023; Gemma Tipton, 'If art is such big business, why do so many artists earn so little?', *The Irish Times*, 1 March 2014, https://www.irishtimes.com/culture/if-art-is-such-big-business-why-do-so-many-artists-earn-so-little-1.1707099, accessed 25 September 2023.

101. Anny Shaw, 'How serious are the dangers of market sponsorship of museum exhibitions?', *The Art Newspaper*, 27 January 2020, https://www.theartnewspaper.com/2020/01/27/how-serious-are-the-dan-

gers-of-market-sponsorship-of-museum-exhibitions, accessed 25 September 2023; Julia Halperin, 'Almost one third of solo shows in US museums go to artists represented by five galleries', *The Art Newspaper*, 2 April 2015, https://www.theartnewspaper.com/2015/04/02/almost-one-third-of-solo-shows-in-us-museums-go-to-artists-represented-by-five-galleries, accessed 25 September 2023.

102. Rachel Spence, 'Corporate sponsors have a golden grip on the art world', *Financial Times*, 20 August 2019, https://www.ft.com/content/7d029864-ad36–11e9-b3e2–4fdf846f48f5, accessed 25 September 2023.

103. Rhea Nayyar, 'Climate Activists Crash Hamptons Museum Gala with Calls to "Tax the Rich"', *Hyperallergic*, 7 July 2023, https://hyperallergic.com/833958/climate-activists-crash-hamptons-parrish-art-museum-gala-with-calls-to-tax-the-rich, accessed 25 September 2023.

104. Banking on Climate Chaos, 'Fossil Fuel Finance Report 2023'.

105. Louisa Loveluck, Sarah Dadouch & Kareem Fahim, 'In Libya's flood-shattered east, a disaster of "mythic proportions"', *The Washington Post*, 14 September 2023, https://www.washingtonpost.com/world/2023/09/14/libya-flood-death-toll-derna-news/, accessed 11 January 2024.

106. Euronews Green, 'Libya, Greece, Brazil: Climate-driven storms cause catastrophic flooding around the world', 13 September 2023, https://www.euronews.com/green/2023/09/13/libya-greece-brazil-climate-driven-storms-cause-catastrophic-flooding-around-the-world, accessed 11 January 2024.

107. Art Basel, 'Discover the public program for the second edition of Paris+ par Art Basel', 10 July 2023, https://www.artbasel.com/stories/public-program-paris-plus-art-basel-2023-tuileries-louvre-iena-beaux-arts-pompidou-institut-france?lang=en, accessed 25 September 2023.

108. Art Price, 'The Weekly News Art Fix' , emailed to the author 4 September 2023. and available at https://acrobat.adobe.com/id/urn:aaid:sc:US:b00445fb-bbb6-4ecf-94f6-c86e79349f89 Accessed 22 March 2023.

109. Matthew Goldstein, 'A Giacometti for a Cezanne: Jeffrey Epstein's

Role in a Pricey Art Deal', *The New York Times*, 5 October 2023, https://www.nytimes.com/2023/10/05/business/jeffrey-epstein-leon-black-art-deal.html, accessed 3 November 2023.

110. Robin Pogrebin & Matthew Goldstein, 'Leon Black to Step Down as MoMA Chairman', *The New York Times*, 26 March 2021, https://www.nytimes.com/2021/03/26/arts/design/leon-black-moma-chairman.html, accessed 3 November 2023; Museum of Modern Art, 'Officers and trustees', n.d., https://www.moma.org/about/trustees, accessed 3 November 2023.

111. Naomi Klein, *Hot Money*, Penguin, 2021, p. 31.

112. Christie's private sales team, email to the author, 26 August 2023.

113. Frieze Press Office, email exchange with the author, 20 July–24 October 2023.

114. Gallery Climate Coalition, Instagram post, 27 July 2023, https://www.instagram.com/p/CvND4HboFPr/, accessed 23 January 2024.

115. Gallery Climate Coalition, Instagram post, 4 September 2023, https://www.instagram.com/p/CwxGteiIbs0/, accessed 23 January 2024.

116. Gallery Climate Coalition, 'Announcing a Two Day Symposium: Climate Crisis >> Art Action', 8 February 2023, https://galleryclimatecoalition.org/news/75-announcing-a-two-day-symposium-climate-crisis/, accessed 11 January 2024.

117. Henry Lydiate, 'Deaccessioning Public Collections', *Art Monthly*, Vol. 348, Jul./Aug. 2011, https://artquest.org.uk/artlaw-article/deaccessioning-public-collections, accessed 25 September 2023.

118. Ursula K. Le Guin, 'Speech in Acceptance of the National Book Foundation Medal for Distinguished Contribution to American Letters', 19 November 2014, https://www.ursulakleguin.com/nbf-medal, accessed 3 November 2023.

119. Kiasma_strike, 'Strike over—Kiasma_strike accepts outcome of negotiations', press release, 28 April 2023, https://kiasmastrike.art/28-4-2023-en-1, accessed 3 November 2023.

120. Elaine Velie, '70+ Artists Strike Finnish Museum Over Supporter's Ties to Israeli Military', Hyperallergic, 1 December 2022, https://hyperallergic.com/784801/artists-strike-finnish-museum-over-supporters-ties-toisraeli-military/, accessed 3 November 2023.

121. Finnish National Gallery, 'Financial Responsibility', n.d., https://www.kansallisgalleria.fi/en/taloudellinenvastuumme, accessed 3 November 2023; Kiasma-strike, 'Strike over'.

122. Terike Haapoja, Zoom interview with the author, 12 June 2023.

123. 'Artists, journalists, and art workers call on UAL to treat cleaners fairly', Google Forms petition, https://docs.google.com/forms/d/e/1FAIpQLSf359i_msTCUoKEZMgxZy4ef1YNjewjVhg9O8Pui1SkQWv6Zw/viewform, accessed 11 March 2024; Gareth Harris, '"Such folk are treated like shit": artists urge University of Arts London to improve cleaners' working conditions', The Art Newspaper, 28 April 2023, https://www.theartnewspaper.com/2023/04/28/such-folk-are-treated-like-shit-artists-urge-university-of-the-arts-london-to-improve-cleaners-working-conditions#, accessed 23 January 2024.

124. GMB, 'University of the Arts London cleaners strike from today', 6 September 2023, https://www.gmbsouthern.org.uk/ual-cleaners-strike-today, accessed 3 November 2023.

125. Paul Glynn, Emma Saunders & Sean Seddon, 'What we know about the British Museum thefts so far', BBC News, 26 August 2023, https://www.bbc.co.uk/news/entertainment-arts-66543589, accessed 11 March 2024.

126. Pauliina Feodoroff, Zoom interview with the author.

POSTSCRIPT FOR PALESTINE

1. Zachary Small, 'Warren Kanders Resigns From Whitney Museum Board After Months of Controversy and Protest [UPDATED]', Hyperallergic, 25 July 2019, https://hyperallergic.com/511052/warren-kanders-resigns/, accessed 15 February 2024.

2. IIAAF, 'Free Palestine/Strike MoMA: A Call to Action', Social Text, 21 May 2021, https://socialtextjournal.org/free-palestine-strike-moma-a-call-to-action/, accessed 15 February 2024.

3. Elaine Velie, '70+ Artists Strike Finnish Museum Over Supporter's Ties to Israeli Military', Hyperallergic, 1 December 2022, https://hyperallergic.com/784801/artists-strike-finnish-museum-over-supporters-ties-toisraeli-military/, accessed 3 November 2023.

4. Alex Greenberger, 'Documenta's Anti-Semitism Controversy Explained: How a German Art Show Became the Year's Most Contentious Exhibition', ARTnews, 22 July 2022, https://www.artnews.com/art-news/news/what-is-documenta-15-antisemitism-controversy-1234635001/, accessed 15 February 2024; e-flux, 'Censorship Must Be Refused: Letter from lumbung community', 27 July 2022, https://www.e-flux.com/notes/481665/censorship-must-be-refused-letter-from-lumbung-community, accessed 15 February 2024.

5. Artists for Palestine UK, 'About', https://artistsforpalestine.org.uk/about-us/, accessed 15 February 2024; Irish Artists for Palestine, 'Mission Statement', https://irishartistsforpalestine.com, accessed 15 February 2024; Tadamon!, '500 Artists Against Israeli Apartheid', 25 February 2010, https://www.tadamon.ca/archive/post/5824/, accessed 15 February 2024.

6. Katrin Bennhold, 'German Parliament Deems B.D.S. Movement Anti-Semitic', The New York Times, 17 May 2019, https://www.nytimes.com/2019/05/17/world/europe/germany-bds-anti-semitic.html, accessed 15 February 2024.

7. Oliver Holmes, 'World court's interim ruling on genocide in Gaza: key takeaways', The Guardian, 26 January 2024, https://www.theguardian.com/world/2024/jan/26/world-courts-interim-ruling-on-genocide-in-gaza-key-takeaways-icj-israel, accessed 15 February 2024.

8. Based on my own observation and off-record conversations.

9. Bezalel News, 'Michal Rovner presents her work "Signaling" in front of Bezalel', 5 December 2023, https://www.bezalel.ac.il/en/news/655238, accessed 15 February 2024; Lévy Gorvy Dayan, Instagram post, 19 October 2023, https://www.instagram.com/p/Cyl2kxQOscQ/, accessed 15 February 2024.

10. Katya Kazakina, '"Where Are You, People?" The Art World's Deafening Silence After the Hamas Attack in Israel', Artnet News, 12 October 2023, https://news.artnet.com/market/art-institutional-voices-silent-on-israel-2374092, accessed 15 February 2024; A Hug from the Art World, Instagram post, 11 October 2023, https://www.instagram.com/p/CyQ6NowrbZG/, accessed 15 February 2024.

11. Rhea Nayyar, 'Leading Artists and Scholars Call for Immediate

Ceasefire in Gaza', *Hyperallergic*, 19 October 2023, https://hyperaller-gic.com/851479/artists-and-scholars-call-for-immediate-ceasefire-in-gaza/, accessed 15 February 2024.

12. *The Guardian*, 'Pro-Palestine protests take place in cities around the world—video', 5 November 2023, https://www.theguardian.com/world/video/2023/nov/05/pro-palestine-protests-take-place-in-cities-around-the-world-video, accessed 15 February 2024.

13. Alex Greenberger, 'Hundreds of Artists Say They Won't Show at German Institutions with "McCarthyist Policies" on Palestine', ARTnews, 11 January 2024, https://www.artnews.com/art-news/news/strike-germany-call-artists-sign-protest-palestine-1234692733/, accessed 15 February 2024.

14. Maya Pontone, 'Pro-Palestine Protesters Disrupt Tania Bruguera Performance in Berlin', *Hyperallergic*, 12 February 2024, https://hyper-allergic.com/871569/pro-palestine-protesters-disrupt-tania-bruguera-performance-in-hamburger-bahnhof-berlin/, accessed 15 February 2024; Alex Greenberger, 'Pace Gallery Closes New York Flagship Space for the Day After Being Vandalized with Pro-Palestine Messages', ARTnews, 27 January 2024, https://www.artnews.com/art-news/news/pace-closes-new-york-gallery-palestine-messages-michal-rovner-1234694427/, accessed 15 February 2024.

15. Tessa Solomon, 'More Than 1,000 Artists Boycott Bristol's Arnolfini Center Amid Palestine Censorship Controversy', ARTnews, 14 December 2023, https://www.artnews.com/art-news/news/amid-palestine-controversy-artists-boycott-bristols-arnolfini-1234689935/, accessed 15 February 2024.

16. See a literal list covering just the first six weeks after Hamas' attack: Irene Katz Connelly, 'A timeline of cultural events canceled since Hamas' attack on Israel', *Forward*, 2 November 2023, https://forward.com/culture/567702/palestinian-cultural-events-cancelled-censorship-israel/, accessed 15 February 2024.

17. Nadia Khomami, 'London gallery delays Ai Weiwei show over Israel–Hamas tweet', *The Guardian*, 15 November 2023, https://www.the-guardian.com/artanddesign/2023/nov/15/ai-weiwei-defends-

free-speech-uk-gallery-holds-up-show-israel-hamas-tweet, accessed 15 February 2024.

18. Catherine Hickley, 'German photo biennial cancelled after curator's posts are deemed antisemitic', *The Art Newspaper*, 22 November 2023, https://www.theartnewspaper.com/2023/11/22/german-photo-biennial-cancelled-after-curators-posts-are-deemed-antisemitic, accessed 15 February 2024.

19. Philip Oltermann, '"A frenzy of judgement": artists Candice Breitz on her German show being pulled over Gaza', *The Guardian*, 7 December 2023, https://www.theguardian.com/artanddesign/2023/dec/07/a-frenzy-of-judgement-artist-candice-breitz-on-her-german-show-being-pulled-over-gaza, accessed 15 February 2024.

20. Aubrey Wright, 'IU Eskenazi art museum cancels Palestinian artist's exhibition', Indiana Public Media, 11 January 2024, https://indianapublicmedia.org/news/iu-eskenazi-art-museum-cancels-palestinian-artists-exhibition.php#, accessed 15 February 2024.

21. Bea Swallow, 'Arnolfini gallery cancels Palestine film festival events', 22 November 2023, https://www.bbc.co.uk/news/uk-england-bristol-67496228, accessed 15 February 2024.

22. Alex Greenberger, 'Poet Ranjit Hoskote Resigns from Documenta 16 Selection Committee: "I Have Been Subjected to a Kangaroo Court"', ARTnews, https://www.artnews.com/art-news/news/ranjit-hoskote-resigns-documenta-16-selection-committee-bds-letter-israel-india-1234686467/, accessed 15 February 2024; Artnet News, 'Documenta Is in Full Meltdown as Curatorial Search Committee Resigns En Masse', 17 November 2023, https://news.artnet.com/art-world-archives/documenta-search-committee-resigns-2395778, accessed 15 February 2024.

23. Hagay Hacohen, 'Israeli art canceled at international Istanbul show', *The Jerusalem Post*, 4 November 2023, https://www.jpost.com/israel-news/culture/article-771480, accessed 15 February 2024.

24. Chad de Guzman, 'Thousands of Artists Want Israel Excluded From the Prestigious Venice Biennale', *Time* magazine, 27 February 2024, https://time.com/6835477/venice-biennale-israel-exclusion-artists-petition-palestinians-genocide/, accessed 11 March 2024.

25. Geraldine Kendall Adams, 'Cultural institutions accused of censorship over Israel–Palestine war', Museums Association, 7 December 2023, https://www.museumsassociation.org/museums-journal/news/2023/12/cultural-institutions-accused-of-censorship-over-israel-palestine-war/, accessed 15 February 2024.

26. Daniel Cassady, 'German Photography Biennial Cancelled After Curator's Social Media Posts Are Called "Antisemitic"', ARTnews, 22 November 2023, https://www.artnews.com/art-news/news/biennale-fur-aktuelle-fotografie-cancelled-freedom-fo-speech-and-anti-semitism-1234687537/#!, accessed 15 February 2024.

27. Arnolfini, 'Update from Arnolfini', 21 November 2023, https://arnolfini.org.uk/app/uploads/2023/11/Update-from-Arnolfini-21-November-2023.pdf, accessed 15 February 2024.

28. PEN America, 'Cancellation of Samia Halaby Exhibition at Indiana University Represents "An Alarming Affront to Free Expression", says PEN America', 12 January 2024, https://pen.org/press-release/cancellation-of-samia-halaby-exhibition-at-indiana-university-represents-an-alarming-affront-to-free-expression-says-pen-america/, accessed 15 February 2024.

29. Hagay Hacohen, 'Israeli art canceled at international Istanbul show', *The Jerusalem Post*.

30. William Noah Glucroft, 'Germany's unique relationship with Israel', *Deutsche Welle*, 15 October 2023, https://www.dw.com/en/israel-and-germanys-reason-of-state-its-complicated/a-67094861, accessed 15 February 2024.

31. Hanno Hauenstein, 'Germany Is Known for its Heavily Funded, Thriving Art Scene. But a Slew of Cancellations Is Threatening That Reputation', ARTnews, 12 December 2023, https://news.artnet.com/art-world/germany-cancellations-2407316, accessed 15 February 2024.

32. Rhea Nayyar, 'MoMA Shutters as 500+ Protesters Infiltrate Atrium in Support of Palestine', *Hyperallergic*, 10 February 2024, https://hyperallergic.com/871345/moma-shutters-as-500-protesters-infiltrate-atrium-in-support-of-palestine/, accessed 15 February 2024.

33. Maya Pontone, 'Activists Occupy Tate Modern to Demand Permanent Ceasefire in Gaza', *Hyperallergic*, 27 November 2023, https://hyperallergic.com/858557/activists-occupy-tate-modern-to-demand-perma-

nent-ceasefire-in-gaza/, accessed 15 February 2024. Laura Pollock, 'National Galleries of Scotland: Palestine activists take over museum', *The National*, 26 January 2024, https://www.thenational.scot/news/ 24077544.national-galleries-scotland-palestine-activists-take-museum/, accessed 15 February 2024.

34. Sky News, 'Exiled Chinese artist Ai Weiwei: "Censorship in West exactly the same as Mao's China"', 4 February 2024, https://news.sky.com/story/exiled-chinese-artist-ai-weiwei-censorship-in-the-west-is-exactly-the-same-as-maos-china-13063751, accessed 15 February 2024.

35. Nepal Picture Library, Instagram post, 16 January 2024, https://www.instagram.com/p/C2KqfrqKyge/?img_index=1, accessed 15 February 2024.

36. Shahidul Alam, email to the author, 13 February 2024.

37. Nadia Khomami, 'London gallery delays Ai Weiwei show over Israel–Hamas tweet', *The Guardian*.

38. Rachel Spence, 'The Art World Is Succumbing to the Pressure of Ostracising Those Who Support Palestine', *The Wire*, 5 December 2023, https://thewire.in/culture/art-world-succumbing-pressure-ostracising-support-palestine, accessed 15 February 2024.

39. Maya Pontone, 'Activists Occupy Tate Modern to Demand Permanent Ceasefire in Gaza', *Hyperallergic*; Art Workers for Palestine Scotland, Instagram post, 10 February 2024, https://www.instagram.com/p/C3KvTPQNXo0/?img_index=2, accessed 15 February 2024.

40. Geraldine Kendall Adams, 'British Museum announces new £50m BP deal to fund masterplan', Museums Association, 19 December 2023, https://www.museumsassociation.org/museums-journal/news/2023/12/british-museum-announces-new-50m-bp-deal-to-fund-masterplan/, accessed 15 February 2024.

41. Energy Embargo for Palestine, Instagram post, 11 February 2024, https://www.instagram.com/p/C3NTtdOoeL-/?img_index=5, accessed 15 February 2024.

42. Alex Greenberger, 'Gaza Gallery That Appeared in Documenta Was "Destroyed by Israeli Forces"', ARTnews, 20 December 2023, https://www.artnews.com/art-news/news/eltiqa-gallery-gaza-destroyed-documenta-15–1234690729/, accessed 15 February 2024.

43. The Question of Funding Collective, Instagram post, 20 December 2023, https://www.instagram.com/p/C1FSoNtoudP/?img_index=1, accessed 15 February 2024.

44. Emine Sinmaz, "'I'm so scared, please come': Hind Rajab, six, found dead in Gaza 12 days after cry for help', *The Observer*, 10 February 2024, https://www.theguardian.com/world/2024/feb/10/im-so-scared-please-come-hind-rajab-six-found-dead-in-gaza-12-days-after-cry-for-help, accessed 15 February 2024.

45. Art Workers for Palestine Scotland, Instagram post, 13 February 2024, https://www.instagram.com/p/C3SssJhtFTe/?img_index=1, accessed 15 February 2024.

46. Maya Pontone, 'Pro-Palestine Protesters Disrupt Tania Bruguera Performance in Berlin', *Hyperallergic*.

47. Rachel Spence, 'It Is Time for International Museums to Sever Ties With China', *Hyperallergic*, 4 January 2022, https://hyperallergic.com/704030/time-for-international-museums-to-sever-ties-with-china/, accessed 15 February 2024; Tom Cheshire, 'China guilty of committing genocide against Uyghur people, tribunal finds', Sky News, 9 December 2021, https://news.sky.com/story/china-guilty-of-committing-genocide-against-uyghur-people-tribunal-finds-12490720, accessed 15 February 2024.

48. Cristina Ruiz, 'Business as usual for European museums operating in China, despite genocide ruling', *The Art Newspaper*, 20 December 2021, https://www.theartnewspaper.com/2021/12/20/business-as-usual-for-western-museums-operating-in-china-despite-genocide-ruling, accessed 15 February 2024.

49. Maya Wang, 'China's "Beautiful Xinjiang" Continues to Oppress Uighurs', Human Rights Watch, 13 September 2023, https://www.hrw.org/news/2023/09/13/chinas-beautiful-xinjiang-continues-oppress-uighurs, accessed 15 February 2024.

50. Eyal Weizman, 'Exchange Rate', *London Review of Books*, Vol. 45, No. 21, 2 November 2023, https://www.lrb.co.uk/the-paper/v45/n21/eyal-weizman/exchange-rate, accessed 15 February 2024.

51. Rachel Spence, 'Cultural links', *Financial Times*, 11 January 2013,

https://www.ft.com/content/5a55cdfe-54d2–11e2-a628–00144feab49a, accessed 15 February 2024.

52. Sara Monetta, 'Exhibition of Palestinian art opens in central London', BBC News, 8 February 2024, https://www.bbc.co.uk/news/uk-england-london-68204012, accessed 15 February 2024.

53. Valentina Di Liscia, 'MoMA Workers Urge Museum to Address Israel's Attacks on Palestine', *Hyperallergic*, 13 February 2024, https://hyperallergic.com/871709/moma-workers-open-letter-urges-museum-to-address-israels-attacks-on-palestine/, accessed 15 February 2024.

54. Marissa Cetin, 'Berlin Senate scraps controversial "anti-discrimination clause" for arts funding amid protests', *DJ Mag*, 23 January 2024, https://djmag.com/news/berlin-senate-scraps-controversial-anti-discrimination-clause-arts-funding-amid-protests, accessed 15 February 2024.

55. Nadia Khomami, 'Arts Council England mired in row over "political statements" warning', *The Guardian*, 14 February 2024, https://www.theguardian.com/culture/2024/feb/14/arts-council-england-mired-row-political-statements-warning?CMP=share_btn_link, accessed 15 February 2024.

# INDEX

# INDEX

# INDEX

# INDEX

# INDEX

# INDEX

# INDEX

# INDEX

# INDEX

# INDEX

# INDEX

# INDEX

# INDEX